THE
BOOK COVER

150 YEARS OF BATSFORD DESIGN

PAUL DIMOND

BATSFORD

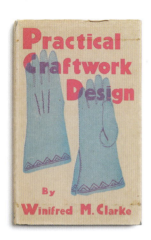
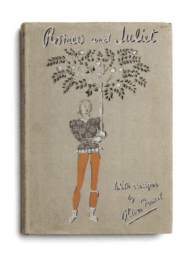
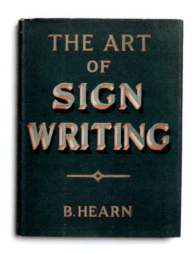
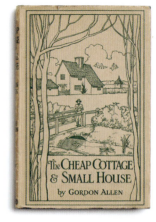
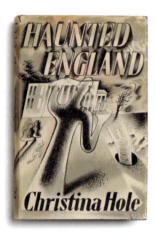
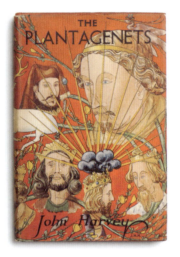
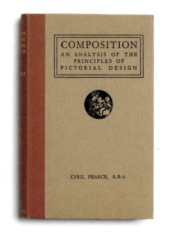
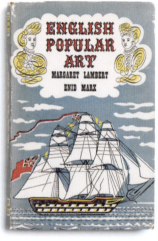

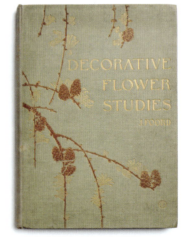

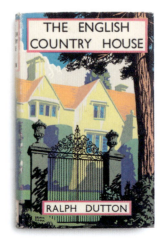

CONTENTS

FOREWORD 4

INTRODUCTION 6

THE BOOKS 8

INDEX 174

ACKNOWLEDGEMENTS 176

FOREWORD

Polly Powell, Batsford's current custodian

The book publisher B. T. Batsford has a long and distinguished history. Founded in 1843, when Queen Victoria was on the throne and Italy hadn't even yet achieved unification, the company's early beginnings in the middle of the 19th century must have been thrilling and precarious in equal measure. Publishing books, at the best of times, involves a certain amount of gamble and the conviction of those early publishers paid dividends.

The company steadily built up a reputation for publishing good books that made commercial sense. In due course, the success of its publishing programme allowed it to buy its own headquarters located in a Georgian townhouse off Manchester Square in London and to open its own bookshop. Uniquely, it has managed to stay in business, through various challenging times, to the present day. This is quite some achievement – it is now the oldest independent trade (niche) publisher in the UK.

I have been involved with Batsford for 20 years, a mere weekend during the years of its long and distinguished history. During that short time, we have sought to retain the best things about Batsford, not least its reputation for innovative design and outstanding book jackets and covers. And, it is good to know that we have carried on creating good books that sell well. The colouring books by Millie Marotta, first published in 2013, have now sold over 10,000,000 copies worldwide, bringing the Batsford name once again to the fore. This success has also facilitated the purchase of a Georgian townhouse in Bloomsbury, London, as the company's headquarters, as well as a shop and gallery in Hackney, in order to ensure Batsford's future.

Today, no serious collector of book design could be without a good example of a 1930s jacket by Brian Cook, perhaps *Cathedrals of England* or *Landscapes of England*. But there is only one person who has collected an astonishing library of the very best of Batsford design and that is Paul Dimond. While he may have underplayed his introduction of the collection to us, we were to discover that it was enormous and ravishing, assembled over four decades with his international perspective recognising our unique craft in the heritage of British book making. This book celebrates Paul's collection and the talented people who have over the years contributed to the beauty and longevity of Batsford books.

→ A selection of Batsford book covers
from the last 20 years, showcasing
Batsford's ongoing commitment to
beautiful book design

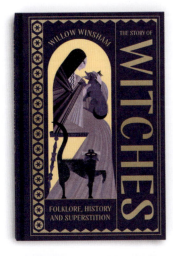
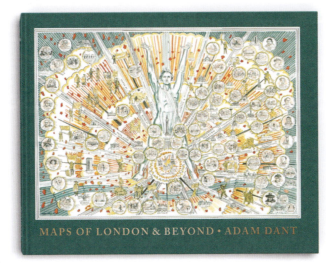
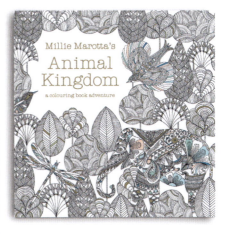
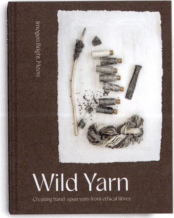

INTRODUCTION

Eoghan O'Brien, Batsford's Art Director

Since 1843, the world has transformed beyond recognition – generation after generation, time and time again, on an unimaginable scale. Yet, throughout these 182 years, Batsford has stood as a remarkable record, capturing the spirit of creativity that defines each era and moment in time.

Over the years, the essential function of a book's cover has not really changed much. From a leather-bound tome to an airport paperback, a cover's primary job is simple: paper is relatively delicate and pages need to be kept in order. From a practical perspective, some sort of cover and binding is required.

So how did the modern book cover emerge? Up until the early 19th century, it wasn't uncommon for books to be issued as unbound sheets, for which customers would commission their own bindings in a style that suited their personal libraries. But in the decades that followed, publishers would bind their own books for sale and cases were decorated with foil stamping, embossing and other hand-tooled binding techniques, covered in paper wrappers.

↑ Before printing, bindings were decorated with hand-tooled foil stamping and embossing

By the early 20th century, dust jackets were commonplace, though their purpose was primarily to protect the ornate bindings underneath. As design tastes evolved and, crucially, printing technology advanced, book covers became more sophisticated, transforming from purely functional protective layers into a new marketing tool.

In this way, the book cover quickly became an art form in itself – one that balanced aesthetics with practical purpose, through the medium of printing. The cover not only needed to protect the book but also had to catch the eye of potential readers and convey the essence of the material within. Thus, the book cover as we know it was born.

Early printed covers often featured typographic designs with simple decorative elements in one or two colours, limited by the printing processes available. However, by the 1920s, new technologies were emerging and with them new possibilities for design. At Batsford, Brian

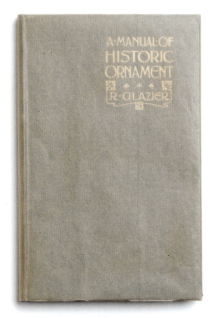

↑ A rare Batsford plain glassine jacket, designed to protect the cover from dust and fingerprints

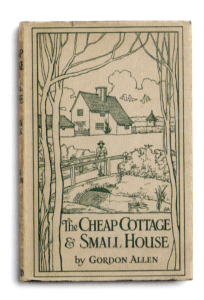

↑ An example of a one-colour printed illustrated dust jacket from 1919

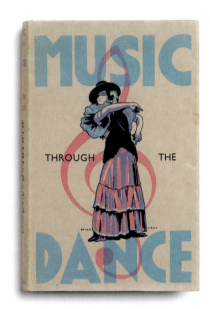

↑ Here, three-colour screenprinting (black, blue, pink) techniques allow a fourth colour (purple) to be achieved

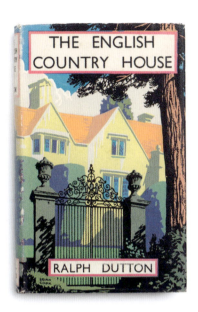

↑ Four translucent, watercolour inks are used in the Jean Berté process to produce up to 14 colours

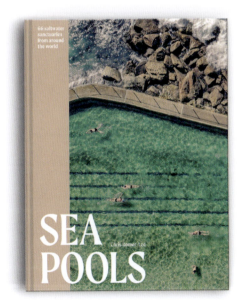

↑ Printing high quality photography directly onto a book's case and embossing can now be achieved on a single machine, as seen here on Batsford's award winning *Sea Pools*, 2023

Cook (see pages 164–173) was pioneering the Jean Berté watercolour printing process, which allowed for up to 14 colours to be reproduced. This led to a striking style of illustration unmatched in its vibrancy at the time.

Offset printing introduced even more colour and detail and soon it was common to print directly onto a book's hardback case, with no need for a dust jacket at all. Today, modern printing and digital tools are revolutionising book cover design once again, giving a book an identity beyond the printed form.

Yet the art of the cover remains as captivating as ever, a canvas for the contemporary, providing all manner of artists, illustrators, photographers and designers the opportunity to collaborate with writers and editors and continue that irrepressible spirit of creativity into the 21st century.

THE BOOKS

No fan of Batsford history can ignore as a source the definitive *A Batsford Century: The Record of a Hundred Years of Publishing and Bookselling 1843–1943*, edited by Hector Bolitho and published in 1943, with Rex Whistler's jacket. In his foreword to this chronicle in June 1943, Harry Batsford writes that 'if our story is set deep in the soil, it is equally rooted in craftsmanship'. He continues 'We have thus been rooted in England and English life, even if we have accepted books from abroad, illustrated the work of many countries and sent our products all over the world'. He also wrote that back in 1917 after Herbert Batsford died, his uncle's friend Professor A E Richardson wrote of him that as well as his delight in books he was 'more than an ordinary publisher, he was primarily a patron of the arts and did more than most men to strengthen the position of architects with the public'.

Most of Bolitho's book is built in direct quotation from notes given to him about the firm's history, officers and authors by Directors Harry Batsford, William Hanneford-Smith and Charles Fry. These notes are candid, atmospheric and entertaining reading and convey an air akin to an informal but revealing oral history. A chapter of Bolitho's book is dedicated to recording the friendships the firm developed with so many of their authors.

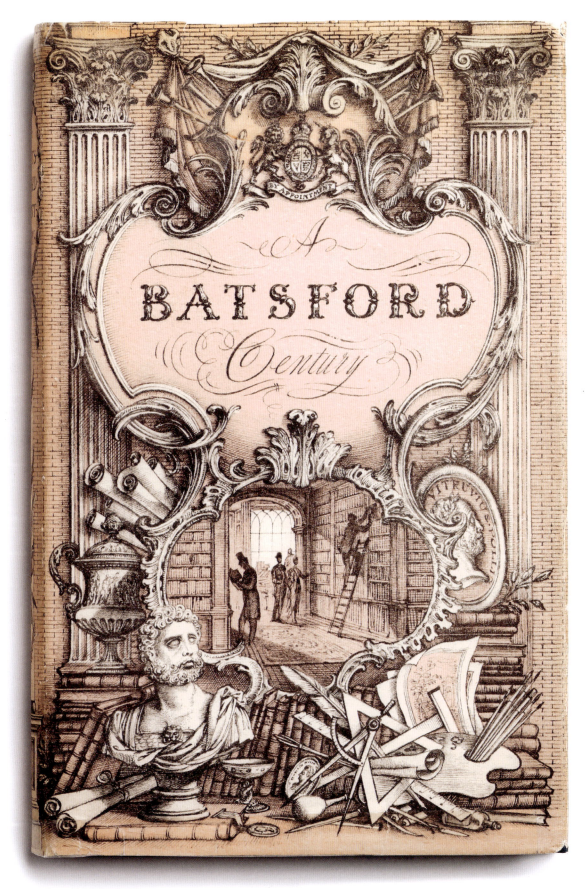

A Batsford Century
edited by Hector Bolitho, 1943

Gothick Architecture (new edition)
Raphael and Arthur Brandon, 1849
—
This work of two volumes was originally published by David Bogue but was sold by Bradley Thomas Batsford from the new shop at 52 High Holborn. At that time, Holborn was the booksellers' quarter of London. Raphael was a Gothic Revival architect and writer who collaborated with his brother, Arthur.

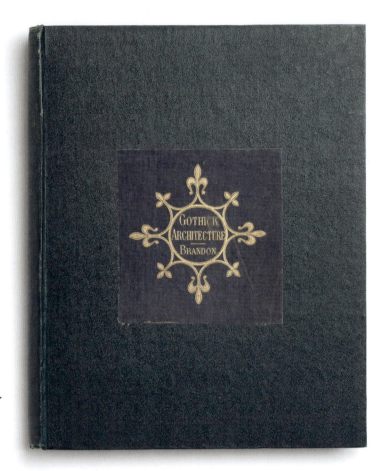

Details of Gothic Architecture
James Kellaway Colling, 1856
—
In his preface to this work, Colling states that rather than 'interfere' with the Brandons' earlier work he would endeavour to elucidate such features as were only partially developed by them. Harry Batsford described Colling's work as of a 'good, solid standard'. At the turn of the century, Colling was 'a frail little old bent figure almost at the end of his resources', and Harry Batsford's uncle Herbert induced RIBA to open a fund for Colling and purchase his delightful sketchbooks.

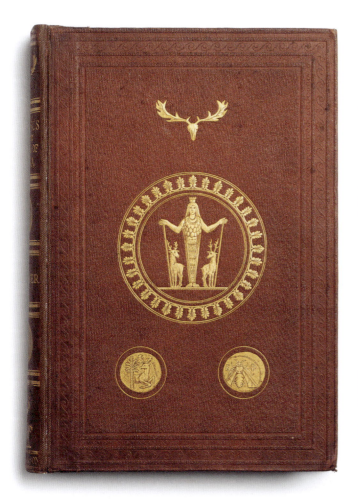

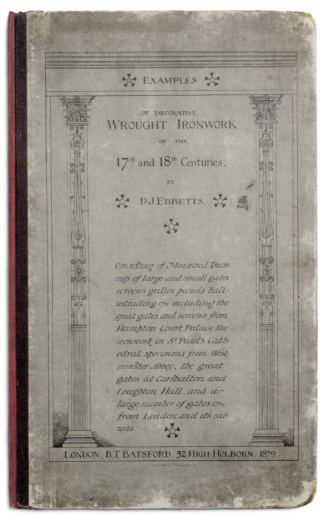

Ephesus and the Temple of Diana
Edward Falkener, 1862

—

In the early 1860s, Batsford were selling books mainly on architecture, civil, military and naval engineering, chemistry, geology, mathematics and mining. This book was published by Day & Son of Lincoln's Inn Fields, lithographers to the Queen, and was bound by Bone & Son of Fleet Street. A green sticker inside the cover shows Batsford as scientific booksellers.

Examples of Decorative Wrought Ironwork of the 17th and 18th Centuries
Daniel John Ebbetts, 1879

—

Ebbetts' introduction refers to the exuberance of invention displayed then in the design of wrought ironwork, with gracefulness and lightness of detail. Among the 16 plates of his drawings, photo-lithographed by C F Kell of Holborn, are screens of St Paul's Cathedral, the gates at Westminster Abbey and Hampton Court Palace and a panel from Great Ormond Street.

**Model Houses for the Industrial Classes
(second edition)**
Professor Banister Fletcher, 1877

—

Banister Fletcher's *Model Houses* was first published in 1871. This edition had an extra section added entitled 'Sanitary Hints, or How to Keep your Home Healthy'.

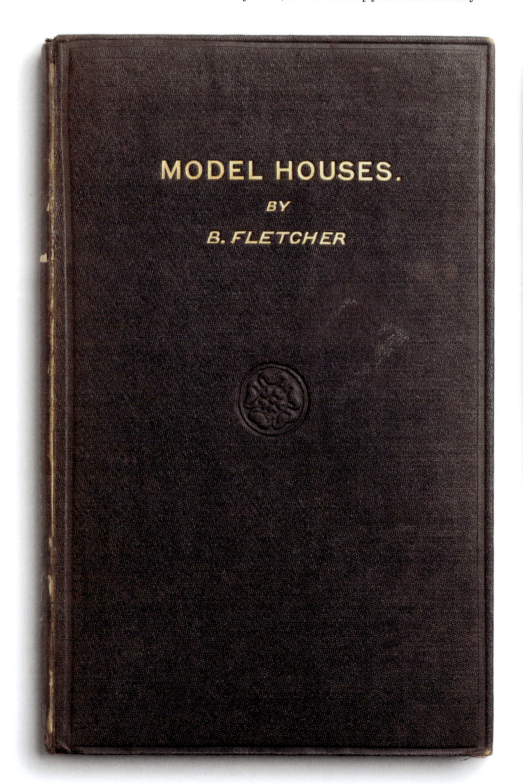

MODEL HOUSES

FOR THE

INDUSTRIAL CLASSES.

BEING

A REVIEW OF THE DEFECTS OF EXISTING MODEL LODGING-HOUSES, AND CONTAINING
REGISTERED DESIGNS FOR MODEL HOUSES FROM WHICH BUILDINGS
HAVE BEEN ERECTED BY THE AUTHOR:

TOGETHER WITH

REGISTERED PLANS FOR THE ADAPTATION OF EXISTING
DWELLING-HOUSES FOR LETTING IN FLATS.

ALSO

MANY USEFUL HINTS TO INVESTORS IN SMALL HOUSE PROPERTY ON PURCHASING
AND MANAGEMENT

AND

A GENERAL VIEW OF THE NECESSARY CLAUSES WHICH SHOULD BE CONTAINED IN A
NEW ACT OF PARLIAMENT.

BY

BANISTER FLETCHER,

(Fellow of the Royal Institute of British Architects.)

AUTHOR OF

"DILAPIDATIONS," "ARBITRATIONS," "COMPENSATIONS," AND "QUANTITIES."

SECOND EDITION:

TO WHICH IS ADDED

"SANITARY HINTS, OR HOW TO KEEP YOUR HOME HEALTHY."

LONDON:
B. T. BATSFORD, 52, HIGH HOLBORN.
1877.

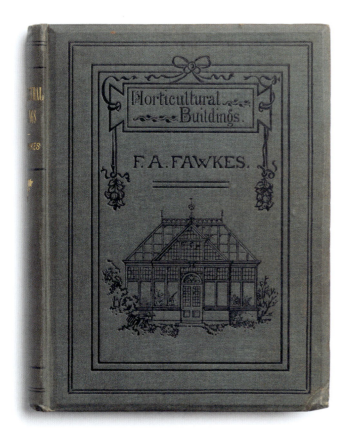

Horticultural Buildings
Frank Attfield Fawkes, 1881
—

This was published jointly with the *Journal of Horticulture*. Fawkes was originally an electrical engineer, joining a Chelmsford business run by Colonel Rookes Crompton, adjacent to horticultural builder T H P Dennis. Their glasshouse services were advertised as 'art with economy'. Fawkes returned to Batsford in 1896 with *Architect's Joinery and its Ornamentation*, a revised and enlarged edition of his joinery catalogues, including numerous testimonials and 82 plates. In 1901, he tipped in a slip announcing a 10 per cent price increase to all mouldings.

The Towers and Steeples Designed by Sir Christopher Wren
Sir Andrew Thomas Taylor, 1881
—

This book won architect Taylor a second RIBA Medal. In 1883 he moved to practise architecture in Montreal, where he worked on buildings for McGill University, before returning to London on retirement in 1904. There, he moved into politics as a London Councillor and chaired the Slade Committee at UCL 1911–37, where Batsford author Roger Fry taught art history and Rex Whistler was a student.

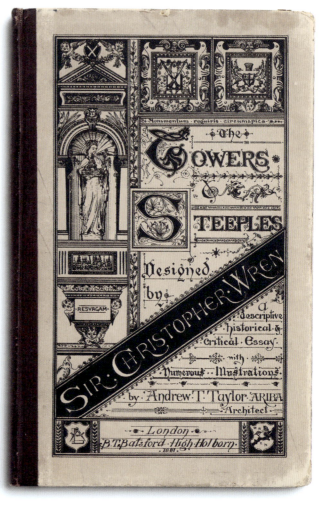

Modern Ornamentation
Christopher Dresser, 1886
—

Born in Scotland in 1834, Dresser was an influential 19th-century industrial designer and theorist. In 1862, he published *The Art of Decorative Design* and was well on his way to influencing the Aesthetic Movement. He was affiliated with Japonisme and undertook an extensive tour of Japan in 1876–77 in partnership with Charles Holme. As Dresser and Holme, they imported Japanese products and Dresser became an influential ceramics designer. This book comprises his original designs for textile fabrics and ornamentation in wood, metal and pottery and for wall and ceiling decoration.

Handbook of Coloured Ornament
1890
—

A listed but unedited collection of 36 colour plates of ornament, from Egyptian to Renaissance, 'printed in colours and gold'.

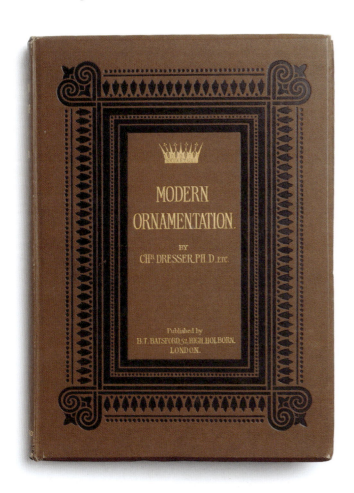

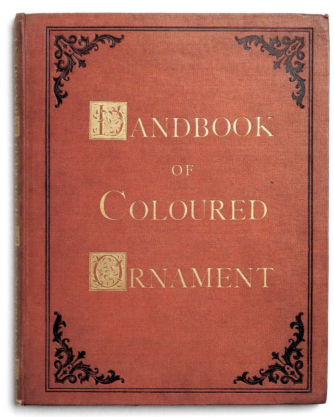

Stable Building and Stable Fitting
Byng Giraud, 1891
—
A handbook for architects, builders and horse owners, with trade advertisements.

Taste and Economy in Decoration and Furniture
E Knight, 1893
—
The author was a partner in the firm of Cooper and Holt, Upholsterers and Decorators, in Bunhill Row London. Their advertisements are on two of the seven advertising pages at the rear. It would appear that the book was commissioned by them, with their name on colour page illustrations of room settings done by Cassell & Company.

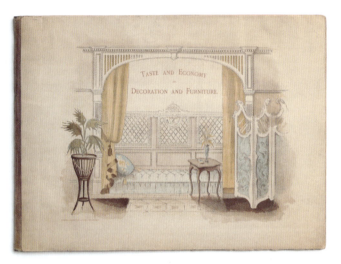

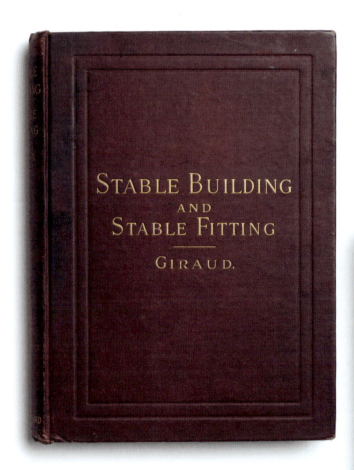

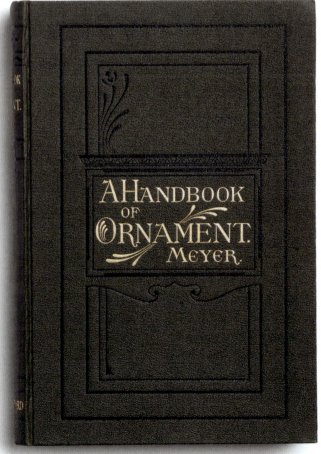

A Handbook of Ornament (third English edition)
Franz Sales Meyer, 1894
—
The author was a professor at the School of Applied Art in Karlsruhe, Germany.

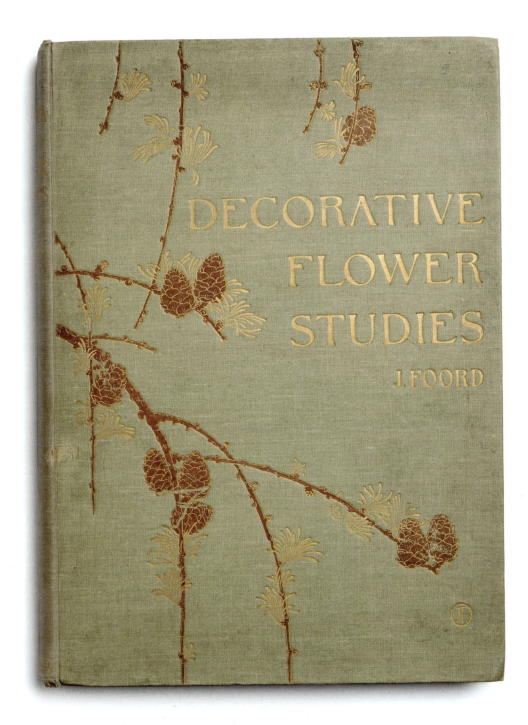

Decorative Flower Studies
Jeanie Foord, 1901
—

This was the first of two series of colour plant and flower studies by Scottish artist Jeanie Foord, who included full commentary on all her studies. In her preface to the first volume, she wrote that she had treated the subjects from the artist's point of view, rather than the botanist's or the horticulturalist's, while endeavouring to keep to botanical accuracy and a purely naturalistic line. Introducing Foord's later volume in 1906, Lewis F Day (an artist, industrial designer and fellow Batsford author), praised the author's drawings as nearer to what he wanted as a designer than other prints, which were often too pictorial or vague or lacked information. Foord's prints in both volumes were reproduced in Paris by the *pochoir* process, in which hand cut stencils are used to build up layers of colour and texture, giving the artist total control. The prints reflected the Japonisme and Art Nouveau styles of the period. In turn, Foord's prints would have influenced designers in stained glass and other applications.

Lewis F Day

Decorative artist and designer Lewis Foreman Day was an important figure in the Arts and Crafts Movement. His own first craft was glass painting, before he set up his design studio in 1873. He was a prolific writer on design and ornament, and was a council member of the RSA from 1877 until his death in 1910. Batsford published some 20 of Day's books. The long relationship between Day and Batsford that developed was described by Day's biographer as 'one of the most important relationships in his professional life'.* The bond between the two was described by Hector Bolitho as 'the beginning of a tradition. It is a strange relationship that grows up between author and publisher: a relationship of temperament and quarrel, loyalty and sentiment'.**

Harry Batsford himself wrote in *A Batsford Century*: 'The relations between Day and my family were of the happiest. They never had a word of written agreement, and Day paid a tribute to that relationship by designing a special endpaper, with the cyphers LFD, his own initials, and BTB, my grandfather's, interlaced and continuously repeated. We used the design as an endpaper to all his books, as a symbol of the spirit which should, and which often does, guide the work that author and publisher do together'.

*ptm *Lewis Foreman Day (1845–1910)* by Joan Maria Hansen, 2007

**A Batsford Century*, 1943

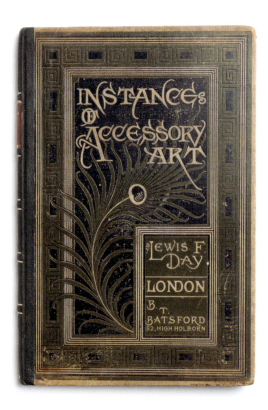

Instances of Accessory Art
Lewis F Day, 1880

—

With colour photolithographs by the proprietors of *The British Architect*, Day's work shows his original designs and suggestive examples of ornament, with practical and critical notes. Two of the 30 sections of the book are on Japanese drawing and Japanese design, reflecting the strong influence of Japonisme at the time.

Every-Day Art
Lewis F Day, 1882

—

Following *Instances of Accessory Art*, this was a series of essays on 'the arts not fine', subjects including ornament, taste, 'The Art of the Fashion-monger' and 'Ladies and Amateurs', profusely illustrated by the author.

Nature in Ornament (third edition)
Lewis F Day, 1896

—

This book has 123 plates and 192 illustrations.

Ornamental Design (fourth edition)
Lewis F Day, 1897

—

This book comprises three textbooks on the Anatomy of Pattern, the Planning of Ornament and the Application of Ornament.

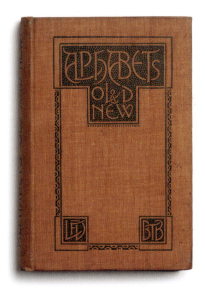
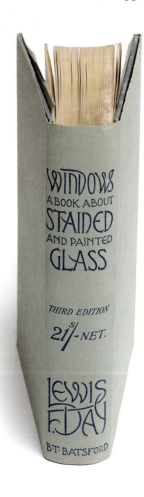

Alphabets Old and New
Lewis F Day, 1898

—

Day writes an essay on art in the alphabet. Among 178 illustrations are three alphabets by his friend Walter Crane. The cover here shows the LFD and BTB cyphers.

Windows: A Book About Stained and Painted Glass (third edition)
Lewis F Day, 1909

—

Described by Joan Maria Hansen as Day's masterwork, this book reflected the author's years of study of this subject, which lasted to the end of his life. In his preface to the third edition, Day declares his resistance to colour illustrations, the 'cost of doing that thoroughly well puts it out of the question – even if a rendering of stained glass which would satisfy those who know and care were to be got in colour printing. That has yet to be proved'.

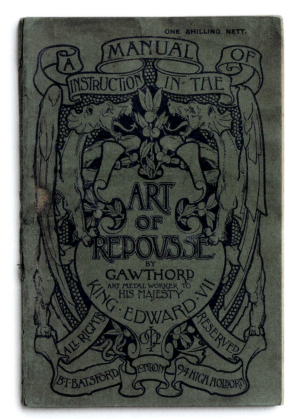

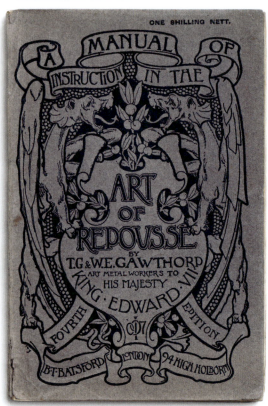

Manual of Instruction in the Art of Repoussé (third and fourth editions)
T G and W E Gawthorp, 1902

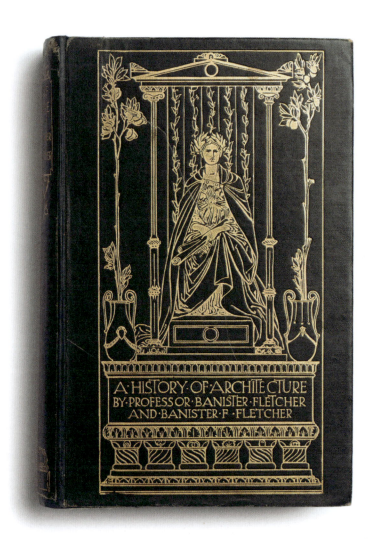

A History of Architecture (fifth edition)
Professor Banister Fletcher and Sir Banister F Fletcher, 1905

—

Sir Banister F Fletcher co-authored with his father the legendary *History of Architecture* in 1896, updating it frequently up to the 16th edition just before he died in 1953. Fletcher's own architectural work included the Gillette Factory on the Great West Road in Brentford, which is Grade II listed. The fifth edition shown here included his famous tree of architecture.

A Manual of Historic Ornament
Richard Glazier, 1906
—
This was a re-issue and revision of Glazier's original book of 1899, with expansion of his coverage of architecture. Glazier had taught art at Rochdale and Manchester and became Head of the Manchester Municipal School of Art. Harry Batsford referred to Glazier's 'careful drawings'. The book has a rare Batsford plain glassine jacket, designed to protect it from dust and fingerprints.

Historic Textile Fabrics
Richard Glazier, 1923
—
This was the author's second Batsford book, published posthumously. The publisher introduces the work as a survey of the evolution and changes of textile design, both woven and printed. Harry Batsford regretted in 1943 that this work had sold slowly, despite England's greatness as a textile manufacturing country.

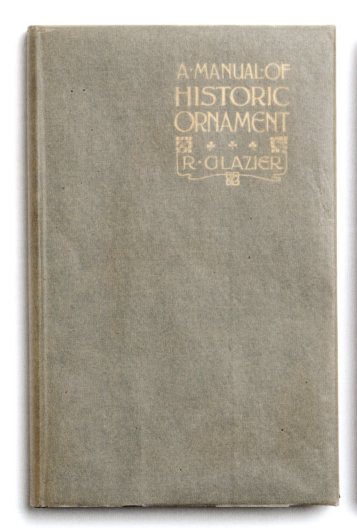
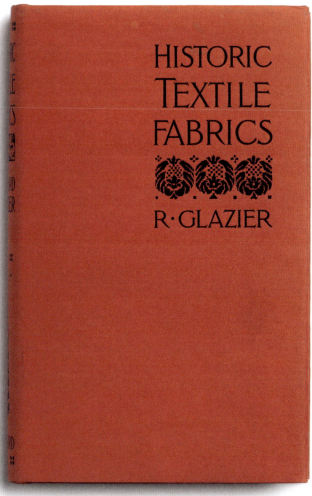

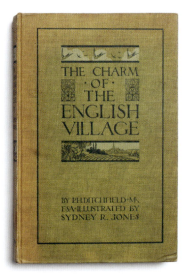
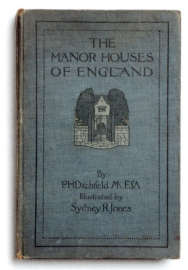

The Charm of the English Village
Rev Peter Hampson Ditchfield, 1908

—

Ditchfield was an Anglican Priest, Rector of Barkham 1886–1930, historian and prolific author. This book was generously illustrated by Sydney Robert Jones.

The Manor Houses of England
Rev Peter Hampson Ditchfield, 1910

—

The companion volume, in which the author describes the old country manor houses 'fast falling into decay'. Also illustrated by Sydney Jones.

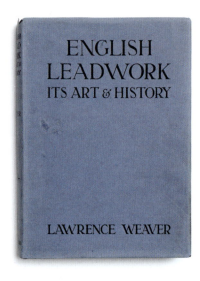
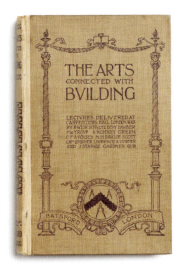

English Leadwork: Its Art and History
Sir Lawrence Weaver, 1909

—

The author trained as an architect, then wrote on leadwork and architecture generally before serving as a civil servant in WWI. This book was his first, a scholarly work with chapter headings from 'Vases and Flower Pots' and 'Rain-Water Pipe-Heads', to 'Cisterns', 'Leaded Steeples' and 'Lead Portraits'. The initial letters of each chapter were decorated. The price of 25/- was boldly shown on the jacket.

The Arts Connected with Building
1909

—

This was a republication of thirteen lectures on craftsmanship and design at the Carpenters' Hall. The cover shows the Carpenters' 1466 coat of arms, depicting three compasses and the chevron representing roof support.

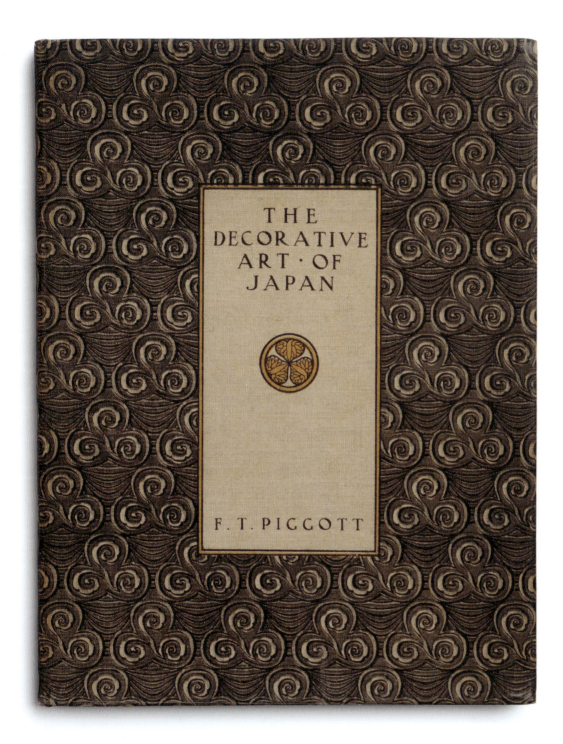

The Decorative Art of Japan
Sir Francis Piggott, 1910
—

Piggott was a British jurist who became constitutional adviser to Prime Minister Itō Hirobumi of Japan in the 1880s. On his return to London, he had much to do with the founding of the Japan Society in 1891. This book, which included colour plates, was printed and published for Batsford in Yokohama. Batsford had been among the earlier protagonists of Japonisme in publishing *A Grammar of Japanese Ornament and Design* by Thomas William Cutler in 1880 and Piggott's *The Music and Musical Instruments of Japan* in 1893.

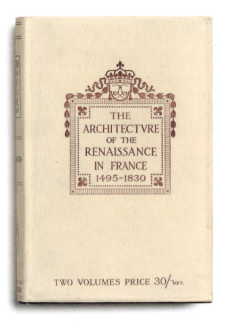

The Architecture of the Renaissance in France 1495–1830
William Henry Ward, 1911

—

Harry Batsford described this book as 'perhaps the purest piece of English literature Batsfords have ever published'. He added that Ward was a brilliant scholar–architect 'of a type not found nowadays', with wide historical knowledge, perfect French and fluent Italian, and a 'dry and penetrating sense of humour'.

Modern Cottage Architecture (second edition)
Maurice Bingham Adams, 1912

—

In the last decades of the 19th century, Batsford worked with several architects in publishing their sketches and drawings. Adams was among them, not least in his *Old English Houses and Furniture* in 1888. In his preface to that he refers to the exhibition of some of the drawings in the book at the Royal Academy and the Royal Albert Hall and suggests that the general public 'may be glad to have this collection of plates'. In *Modern Cottage Architecture*, Adams describes and illustrates the work of many of his contemporaries. The book includes a debossed Batsford colophon on the rear.

The Art of Colour Decoration
John Dibblee Crace, 1912

—

The author was an interior designer who worked on many public buildings. His preface describes his object as to examine how far the art of decoration was controlled by natural laws and how far colour affects architecture. The book has 20 plates of mainly Italian examples. The price of 30/- is on the jacket.

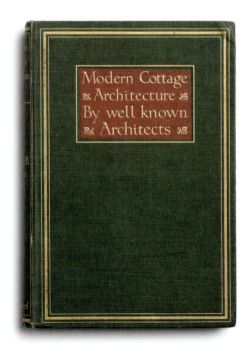

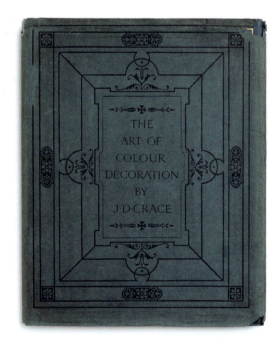

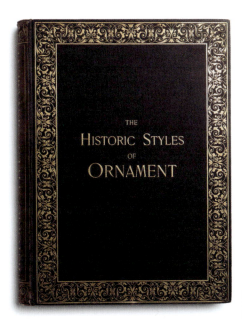

The Historic Styles of Ornament (revised second English edition)
Heinrich Dolmetsch, 1912
—

Dolmetsch was an architect and restorer of churches in southwest Germany. The book was originally published in German in 1898. It has 100 plates, most in vivid colour.

Series of 18 Fellowship Books
various authors, edited by Mary Stratton, 1911–14
—

Batsford introduced this 2/- series, of which these are two examples, with the aim of recalling 'those simple and essential ideas by which we live and move and have our intellectual well-being'. But Harry Batsford reflected 20 years later in *A Batsford Century* that the experiment was unsuccessful, the subjects vaguely abstract, though carefully written and produced with great taste (laid paper with gilt top edges) and charming to hold and read. Early reviewers were positive, *The Graphic* noting that 'beautiful ideals demand beautiful clothing, and here Mr Batsford is at home, for the format of the volumes is very charming'. *Childhood* was by Alice Meynell, *Fairies* by Gertrude Faulding.

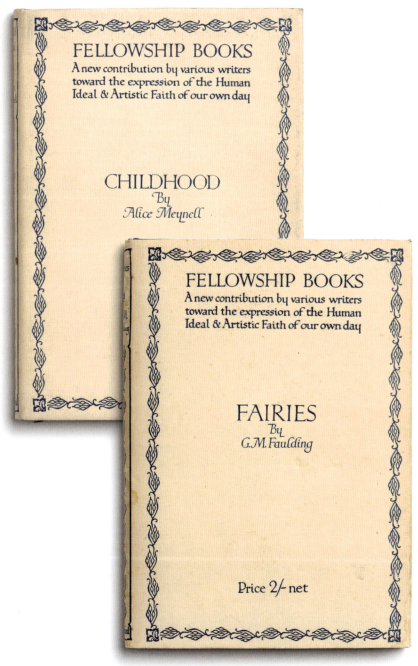

The Cheap Cottage and Small House
Gordon Allen, 1919

—

Gordon Allen wrote several books on low-cost housing and belonged to the Garden Cities and Town Planning Association. He won the *Daily Mail* prize for the best £1,500 house. In his preface to this new edition (the previous one having been before WWI), the author writes that the national need for additional cottages and houses was never before so urgent and that by cheapness he meant simple fitness, restraint and perhaps efficiency, as contrasted with elaboration or unnecessary ornamentation which was expensive in upkeep.

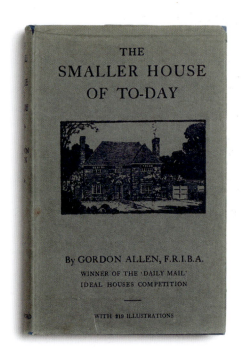

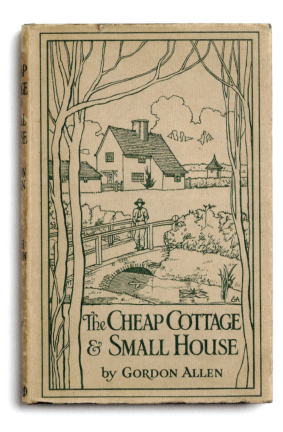

The Smaller House of To-day
Gordon Allen, 1926

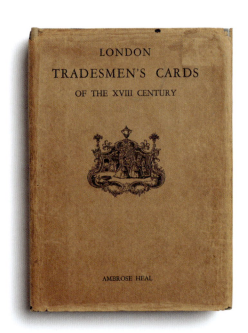

London Tradesmen's Cards of the XVIII Century
Sir Ambrose Heal, 1923

—

The author was a furniture designer but became Chairman of Heal & Son 1913–1953. His preface describes this as the first book on the subject. This edition was of 700 copies for Great Britain and 250 for the US. It has 101 plates of cards.

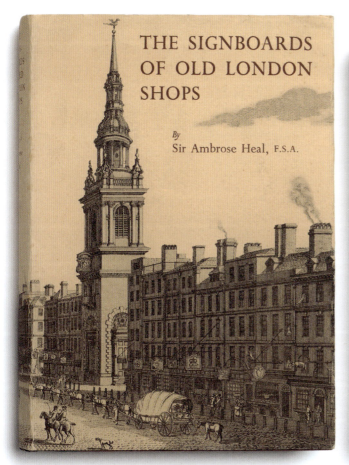 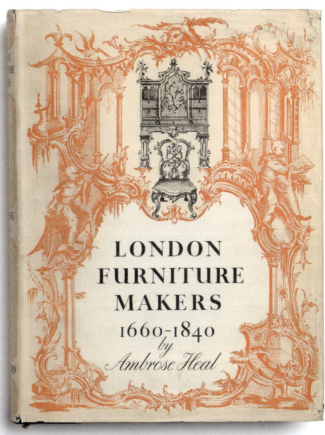

The Signboards of Old London Shops
Sir Ambrose Heal, 1947

—

A companion to the author's earlier work, published 24 years before. This edition was limited to 1,000 copies, of which 250 were printed on large paper and bound in half-morocco. It was printed under the direction of B T Batsford Ltd, Bookseller, at the Sign of the Bible and Crown, Mayfair. The jacket shows Cheapside around 1750 with shops with distinctive signboards. As a furniture designer, Sir Ambrose Heal was elected a Royal Designer for Industry in 1939.

London Furniture Makers 1660–1840
Sir Ambrose Heal, 1952

—

This book is a record of 2,500 makers, with details and 165 trade-cards. There is also a chapter on identification by architect R W Symonds.

Round the World in Folk Tales
Rachel Fleming, 1924
—
Described as folk stories for the geography, history and reading lesson, this book was an early precursor to Batsford's series on folk tales up to the 1970s. The company still publishes in this area today.

The Smaller English House of the Later Renaissance 1660–1830
Sir Albert Richardson, with historian Harold Donaldson Eberlein, 1925
—
Richardson, Professor of Architecture at University College, designed the Regency shop fittings and shopfront at the Batsford house at 15 North Audley Street to which they moved in 1930. Harry Batsford also recorded that his uncle Herbert 'could be crotchety with his authors' but Richardson's 'devotion to his work was greater than any petty pride and he stuck it out'. He added that Richardson combined whimsical humour with an unrivalled knowledge and intense appreciation of 18th century architecture and craftsmanship.

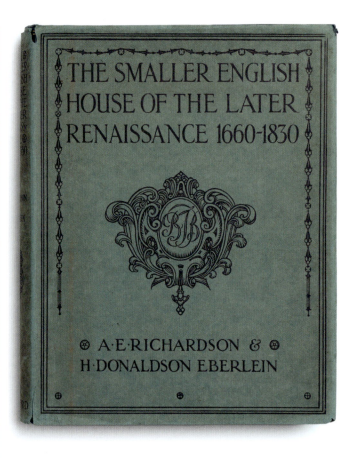

A History of English Wallpaper
Alan Victor Sugden and John Ludlam
Edmondson, 1925
—
Sugden was a significant figure in wallpaper manufacturing. The book was supplied in a custom-designed box.

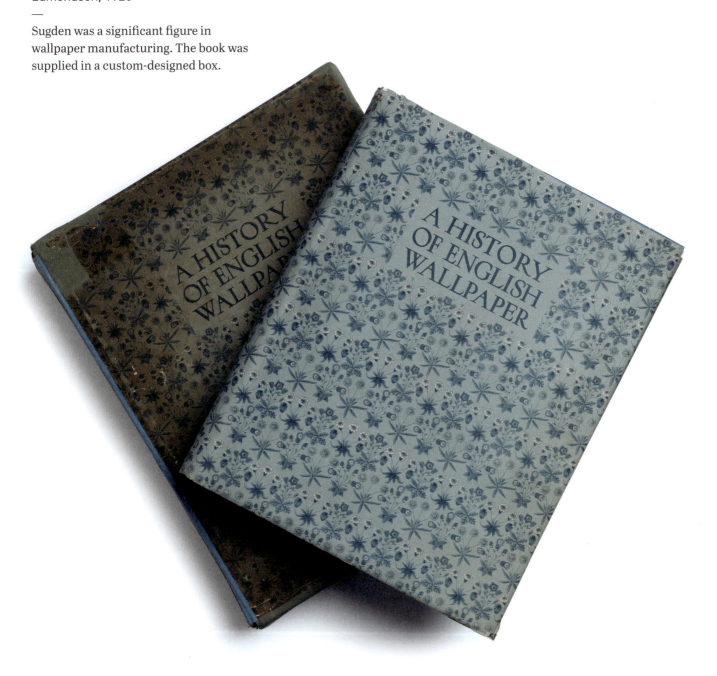

Historic Costume
Francis Kelly and Randolph Schwabe, 1925

—

Kelly was a costume historian and Schwabe a painter and illustrator who taught at the Camberwell and Westminster Schools of Art before his appointment as Slade Professor of Fine Art at UCL 1930–1948. In their introduction, the authors defined the principle governing the work as 'the superior lucidity of *graphic* evidence over *written*', and as such the book was extensively illustrated in plates and sketches. The jacket is an early example of the inclusion of illustration on a paper cover to attract interest.

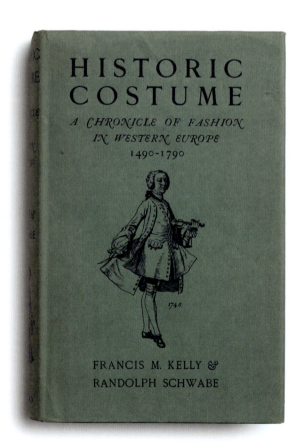

Life and Work of the People of England
Dorothy Hartley and Margaret Elliot, 1925–31

—

Originally published in six individual volumes, this massive work, richly illustrated with black and white plates, was also issued in 1931 in two parts, Volumes One and Two. These two volumes are shown here, each with a jacket by Brian Cook (before his English Life series). Dorothy Hartley was a former Art Teacher at the Polytechnic Institute, Margaret Elliot a teacher at St Aloysius' Secondary School, both in London. The authors prefaced the work as a view of the social life of each century through the eyes of the people who lived in it.

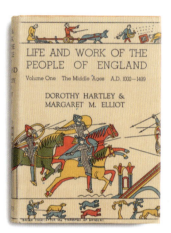 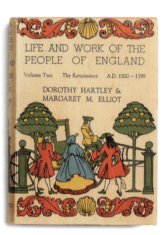

Composition
Cyril Pearce, 1927

—

Pearce was lecturer on design and composition at the University of Reading and became Vice-President of the Reading Guild of Artists.

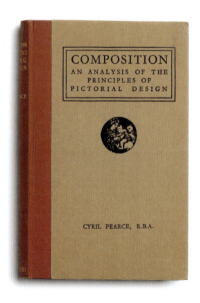

The Art and Craft of Garden Making (fifth edition)
Thomas Hayton Mawson and E Prentice Mawson, 1926
—

In a lecture at the RSA in 1983* (where Sir Brian Batsford was Vice President), Mawson's grandson David recalled that his grandfather's childhood had been in a home that encouraged reading and learning about horticulture. After an initial partnership in London, in 1884 Thomas Mawson set up a nursery in Windermere, where his brothers ran the nursery and he looked after the contracting. He went on to design a park in Newport and moved into landscaping and town planning with a partner, Dan Gibson. David Mawson recorded that his grandfather made use of long rail journeys to prepare a book on landscape architecture, using his own work for illustration. This was to be the first edition of *The Art and Craft of Garden Making* in 1900, which proved successful in bringing him commissions and led to a tour of the US and Canada. Later commissions included work for King Constantine of Greece, and he won a competition for the garden of the Peace Palace at The Hague.

The book's first edition was followed by a second after six months, a third in 1907, fourth in 1912 and this expanded fifth in 1926. In his introduction to the first, Mawson referred to garden-making as the 'only art in which realisation surpasses the original conception'. In the fifth edition, he referred to a garden as the place where 'all things differ yet they all agree'.

Supplementing *The Art and Craft of Garden Making,* in 1911 Batsford published Mawson's influential *Civic Art*. Mawson described this work in his autobiography in 1927** as, partly on the advice of Herbert Batsford, going beyond his original intention to focus on landscape architecture to address the aesthetics of town planning as the new social science 'just beginning to be recognised as the greatest factor in the development of our towns and cities'.

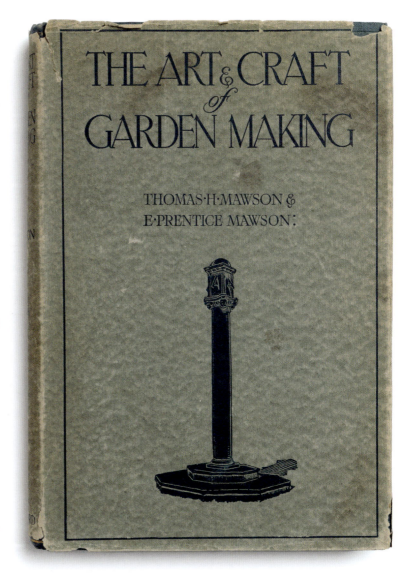

*Reflection Riding Lecture, *RSA Journal*, February 1984.

**The Life and Work of an English Landscape Architect*, The Richards Press Ltd, 1927.

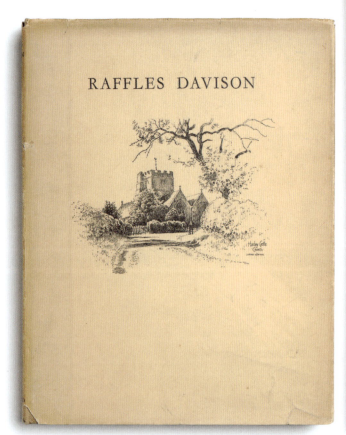

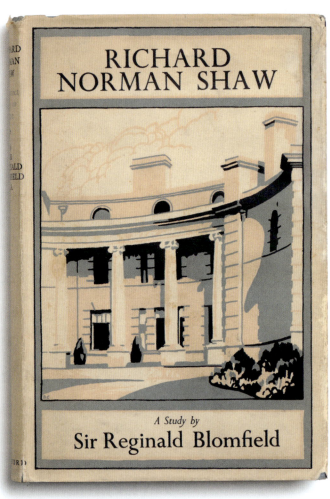

Raffles Davison
Sir Reginald Blomfield, 1927
—

Prolific Edwardian architect Sir Reginald Blomfield had already written deeply on Renaissance English architecture and on French architecture. Architectural illustrator Thomas Raffles Davison had himself written a record of Sir William Hesketh Lever's *Port Sunlight* for Batsford in 1916 and later drew a sketch of the Batsford shopfront at 94 High Holborn that featured in *A Batsford Century* (which also described some professional tiffs between Blomfield and Harry's uncles).

Richard Norman Shaw
Sir Reginald Blomfield, 1940
—

In this work, Blomfield reflected his admiration for Shaw. The jacket was by Brian Cook.

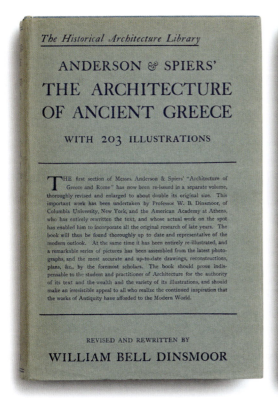
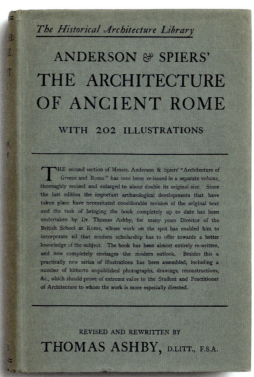

The Architecture of Ancient Greece
William Anderson and Phené Spiers, revised and rewritten by William Bell Dinsmoor, 1927

The Architecture of Ancient Rome
William Anderson and Phené Spiers, revised and rewritten by Thomas Ashby, 1927

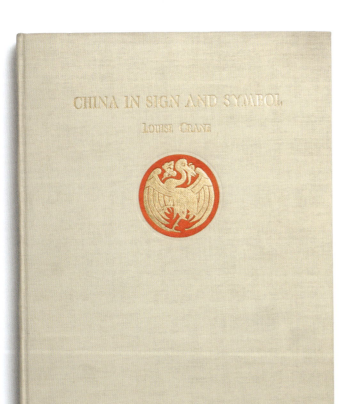

China in Sign and Symbol
Louise Crane, 1927

—

This first UK edition was published jointly with Kelly & Walsh and printed by them in Shanghai. Decorations are by Kent Crane, and the introduction by Evan Morgan describes the author as 'a faithful observer of the social life of the Chinese, and a diligent investigator of their customs and manners'.

Dinner Building
W Teignmouth Shore, 1929
—
Subtitled 'also Luncheons and Suppers', this 3s 6p book was described by the author, a journalist and writer on Edwardian fiction, as one of 'entertaining and practical instruction in the Noble Arts of cooking and eating', adding in his *au revoir* at the end that it was a 'very vagabondish' book. The cover makes a bold attempt to advertise to their intended audience.

Touring London
W Teignmouth Shore, 1930
—
This book has unusually wide margins, described by the author as useful and pleasant in a guidebook. As with *Dinner Building*, the book's cover calls out its intended reader.

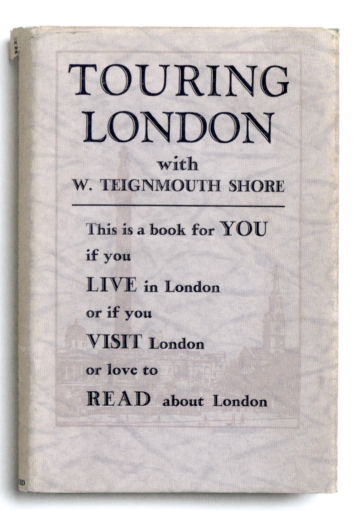

The Lady Lever Art Gallery Collections
various editors, 1928

—

In three illustrated catalogues, Batsford published the works at the Lady Lever Art Gallery at Port Sunlight, carrying out the wishes of Lord Leverhulme, inviting leading art experts of the time to introduce the books. The second Viscount Leverhulme noted in Volume I that his father's belief was that when it came to the decoration of a home, British art stood supreme. This edition of the triptych was limited to 200 copies for Great Britain and 150 for the US.

Volume I: English Painting of the XVIIIth–XXth Centuries was edited by Robert Rattray Tatlock, art critic and editor of *The Burlington Magazine* 1920–1933. Tatlock had also done for Batsford *A Short History of Art* (with André Blum) in 1926 and *Spanish Art* in 1927.

Volume II: Chinese Porcelain and Wedgwood Pottery was edited by Robert Lockhart Hobson, Keeper of the Department of Ceramics and Ethnography at the British Museum 1921–1934, then of Oriental Antiquities and Ethnography 1934–1938.

Volume III: English Furniture, Tapestry and Needlework was edited by Percy MacQuoid, theatrical designer and writer on English furniture.

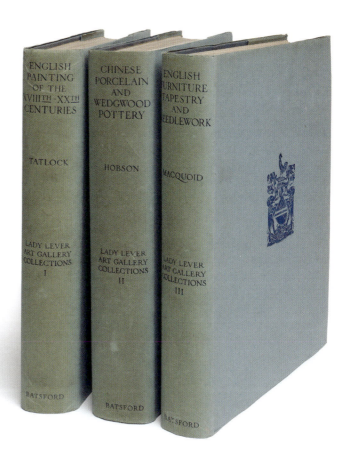

The Growth of the English House (second edition)
John Alfred Gotch, 1928
—

Even among Batsford's family of loyal authors, the relationship of over 56 years with Alfred Gotch was extraordinary, starting with *The Buildings of Sir Thomas Tresham* in 1883. Gotch's magnificent two-volume monograph *Architecture of the Renaissance in England* (1894) stood out in its era. As Gotch reminded his readers in his preface, nothing had been done before to illustrate the subject since the development of photography made possible new methods of illustration. The many plates included were photoprinted by Sinsel, Dorn & Co of Leipzig, with photolithographic illustrations by James Akerman of Queen Square. Born, and with his early architectural practice, in Kettering, Gotch entered an architectural partnership in 1887 with Charles Saunders that lasted until their retirement in 1937. Gotch designed and supervised the construction of many buildings in Kettering and after WWI worked on branches of the Midland Bank, leading to Gotch and Saunders supervising the construction of their Poultry Headquarters designed by Sir Edwin 'Ned' Lutyens (which became The NED hotel in 2017). Gotch was the first provincial President of RIBA 1923–25 and edited their centenary history in 1934.

In *The Growth of the English House*, Gotch revised the illustrations from the originals in 1909. The jacket had the book blurb on the front and advertisements for other architectural Batsford books on the rear. Batsford also published Gotch's *Early Renaissance Architecture in England* in 1901, *The English Home from Charles I to George IV* in 1918, *The Old Halls and Manor-Houses of Northamptonshire* in 1936 and *Squires' Homes and Other Old Buildings of Northamptonshire* in 1939.

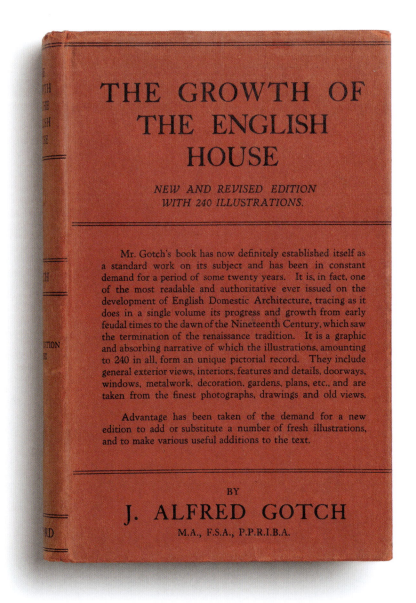

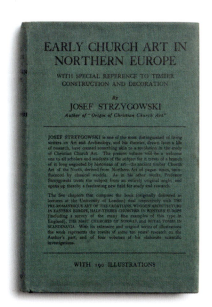

Early Church Art in Northern Europe
Josef Strzygowski, 1928

—

The author was Professor of Art History at the University of Vienna. This book is based on lectures delivered at the University of London, University College.

The Channel Tunnel Project
Reginald Arthur Ryves, 1929

—

The 1920s had been a decade of lively political debate about a tunnel. But this book was not Batsford's first engagement with the subject, having published in 1859 Frederick Walter Simms' *Practical Tunnelling*, revised by W Davis Haskoll, a work that focused on the Blechingley and Saltwood Tunnels of the southeastern railway between London and Dover.

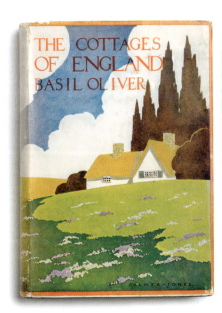
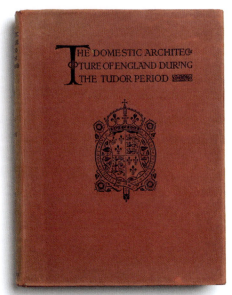
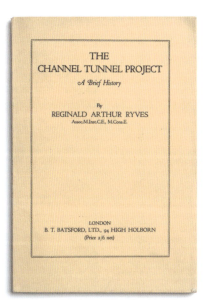

The Cottages of England
Basil Oliver, 1929

—

The author was an architect who became Fellow of the Society of Antiquaries and Master of the Art Workers Guild and writer on vernacular architecture. In a foreword by the Rt Hon Stanley Baldwin, the Prime Minister wrote that Oliver had written the book after encouragement by the Executive Committee of a movement for the preservation of old cottages organised by the RSA. The simple colour copy jacket was by architect and illustrator William Palmer-Jones. The book had a later companion in A K Wickham's 1932 *The Villages of England* with its Brian Cook jacket.

The Domestic Architecture of England During the Tudor Period (revised second edition)
Thomas Garner and Arthur Stratton, 1929

—

Stratton trained as an architect and became an architectural historian. He and Garner co-authored this monumental two-volume work first published in 1910, Stratton doing most of the text, Garner having died in 1906. Garner had trained under Sir Gilbert Scott, and formed a partnership with George Bodley, who had also worked under Scott on church and then secular designs, leading to his work on the choir woodwork at Downside Abbey. Stratton was seen by Harry Batsford as one of the company's oldest friends, in an association of 45 years.

Margaret Jourdain

Harry Batsford wrote in 1943 that his uncles 'had great faith in the scholarship of women, believing in their rare patience and concentration in the gathering and collecting of details from the welter of history'. He then recorded that the longest connection with a female writer – 35 years – had been with Margaret Jourdain. Jourdain was described by the biographer of her companion, novelist Dame Ivy Compton-Burnett, as 'belonging to the genre of New Women', making her way in the freelance world in 'journalism, catalogues, handbooks and articles on the great country houses … which she was often the first professional to penetrate'.*

*Ivy When Young, Hilary Spurling, Victor Gollantz, 1974.

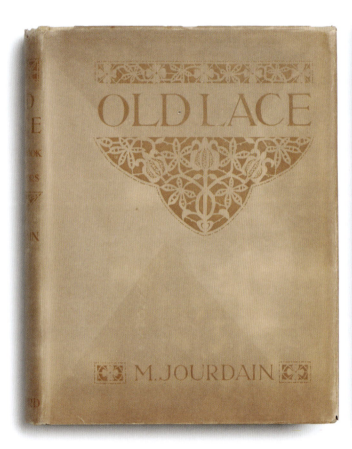

Old Lace: A Handbook for Collectors
Margaret Jourdain, 1908

—

Jourdain's first Batsford book was Old Lace, which included 95 plates from photographs.

English Decoration and Furniture of the Early Renaissance, 1500–1650
Margaret Jourdain, 1924

—

This was Volume I of Jourdain's contributions in the 1920s: a four-volume series entitled The Library of Decorative Art.

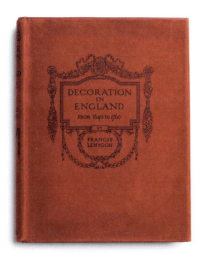

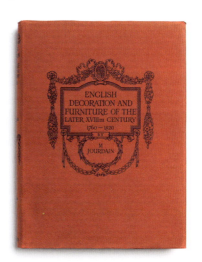

Decoration in England from 1640–1760
Francis Lenygon, 1927

—

Confusingly, Volumes II and III of *The Library of Decorative Art* were authored under the pseudonym of Francis Lenygon. These volumes reflected the joint work of photographic plate collector Colonel H H Mulliner and Margaret Jourdain, who wrote the text. This was Volume II.

English Decoration and Furniture of the Later XVIIIth Century, 1760–1820
Margaret Jourdain, 1922

—

This came out as Volume IV.

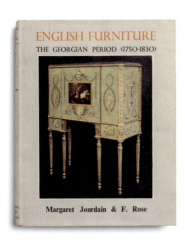

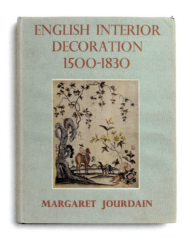

English Furniture: The Georgian Period (1750–1830)
Margaret Jourdain and posthumously completed by F Rose of Sotheby's, 1953

—

Here, Margaret Jourdain aimed to bring her furniture accounts in the two later volumes of *The Library of Decorative Art* into a single volume, updating the text. Rose completed the work after Jourdain's death, adding fresh illustrations. The jacket shows a Robert Adam cabinet designed in 1771–74.

English Interior Decoration 1500–1830
Margaret Jourdain, 1950

—

The author was recognised as a foremost authority on English decoration and furniture. This book combines in a single volume the subject of interior decoration she had covered in *The Library of Decorative Art*. The jacket, showing English-made wallpaper with a Chinese influence from about 1770, was from an engraved block and hand-painted in colour.

Travel

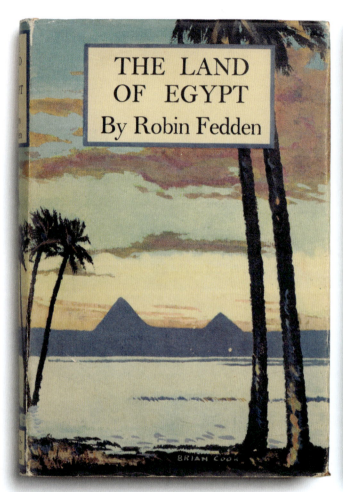

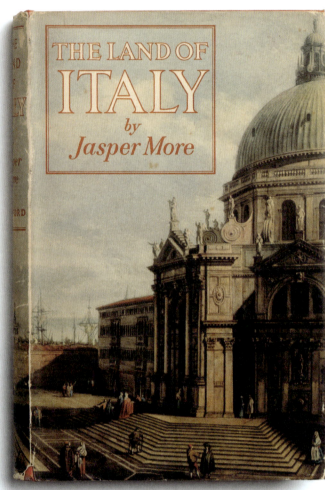

The Land of Egypt
Robin Fedden, 1939

—

Fedden wrote this in Cairo, where he taught English literature at the University. The jacket was by Brian Cook.

The Land of Italy
Jasper More, 1949

—

The jacket of Santa Maria della Salute in Venice is reproduced from the Canaletto in the Wallace Collection.

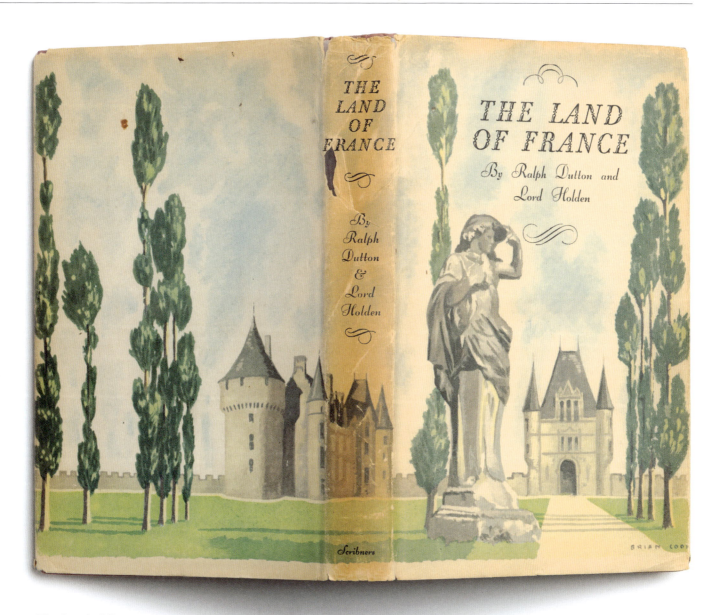

The Land of France
Ralph Dutton and Lord Holden, 1939
—
This was co-authored with Lord Holden, the politician who later served in the Attlee administration; three revised editions emerged post-War, recording war damage in France. The jacket was by Brian Cook. This was a Scribner's edition, who were close American associates of Batsford for over 50 years.

Travel

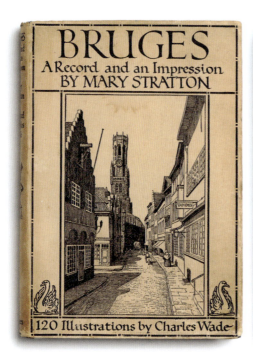 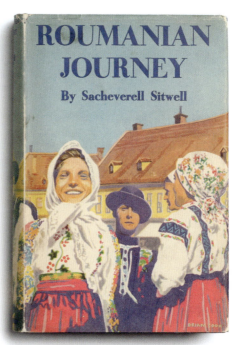

Bruges: A Record and an Impression
Mary Stratton, 1914
—
Written just before the outbreak of WWI, Mary Stratton's book was illustrated by Charles Wade. The Bruges drawing on the jacket was an early example of such jacket illustration.

Roumanian Journey
Sacheverell Sitwell, 1938
—
The jacket was designed by Brian Cook, with photographs by A Costa and Richard Wyndham, who had accompanied the author on his journey. Sitwell wrote several books for Batsford (see page 60).

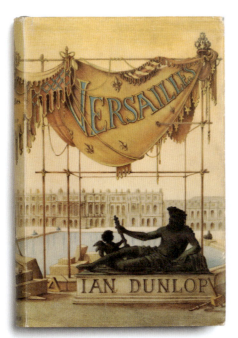

Versailles
Ian Dunlop, 1956
—
In his foreword, Sir Arthur Bryant noted that the author had based this architectural study on history, likely to appeal to lovers of history and the general reader. The jacket is by Loudon Sainthill, an Australian artist and costume and set designer.

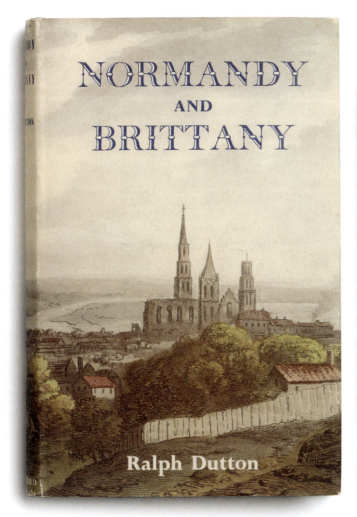 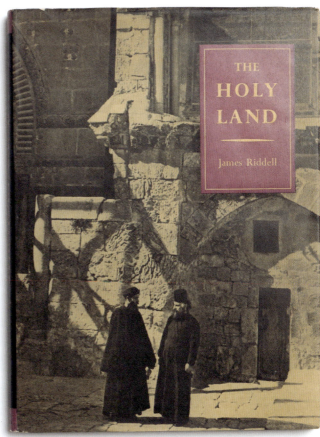

Normandy and Brittany
Ralph Dutton, 1953

—

The jacket was reproduced from Colonel Thornton's *A Sporting Tour through France* of 1806. Other Batsford books written by the prolific Dutton were *The English Interior*, *The English Country House*, *The Victorian Home*, *Wessex*, *The Age of Wren*, *The Chateaux of France* and *English Court Life*.

The Holy Land
James Riddell, 1954

—

The author was a British national champion skier. During WWII, he spent six years in the Middle East; he was Political Officer at Beirut, Liaison Officer in Damascus with the Free French Forces and Chief Instructor at the School of Mountain Warfare in Lebanon. These assignments allowed him opportunities to take the photographs that appear in this book.

A History of Everyday Things in England
Charles Henry Bourne (CHB) Quennell and Marjorie Quennell, 1918–1934
—

CHB was an architect of many buildings in the London suburbs over three decades, and Marjorie Quennell was an artist. Together they wrote much on social history. *Everyday Things* was originally for their children, and was profusely illustrated. In their own words, their picture was of the construction of everyday things at a time when destruction was 'to the fore'. History, they felt, was not just about dates but a 'long tale of man's life, labour and achievement'. Harry Batsford wrote that just before the Armistice 'we began one of the most romantic projects in our story…the volumes of Marjorie and C H B Quennell, mother and father of Peter Quennell'. Volumes I and II covered 1066–1499 and 1500–1799 respectively. The second editions were revised and expanded. Volumes III and IV covered 1733–1851 and 1852–1934. The four volumes were also put into pairs (as shown below). Harry Batsford reflected that 'I think these books have been a real and helpful influence on the young British mind'. They found a market of young people over a quarter of the century.

The Quennells went on to write *The Good New Days* in 1935 and several books in the Everyday Life series: Anglo-Saxon, Viking, Roman, Norman, Prehistoric, Greek, as well as *Victorian Panorama.* After CHB's death, Marjorie became Curator of the Geffrye Museum in London, now the Museum of the Home.

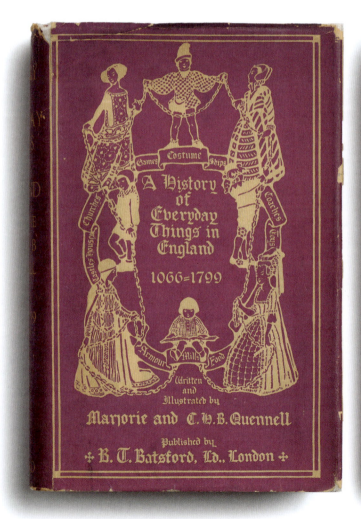
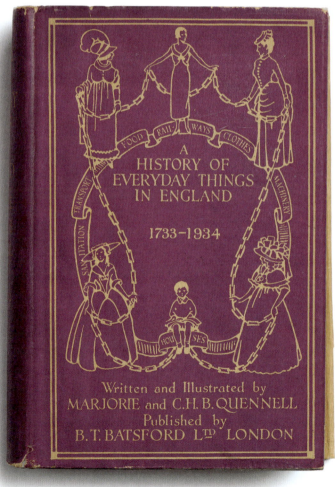

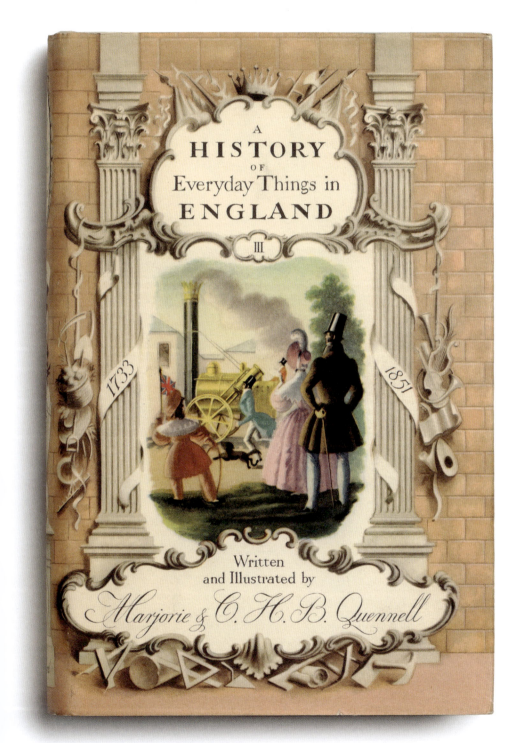

A History of Everyday Things in England 1733–1851
Charles Henry Bourne (CHB) Quennell and Marjorie Quennell
—
The jacket of this later version of Volume III was by Philip Gough.

**The Orders of Architecture
I, II and III**
Arthur Stratton, 1931

—

Soon after his magnum opus on Tudor domestic architecture (see page 37), Stratton contributed this trilogy of diagrams on basic architecture, each in the same jacket.

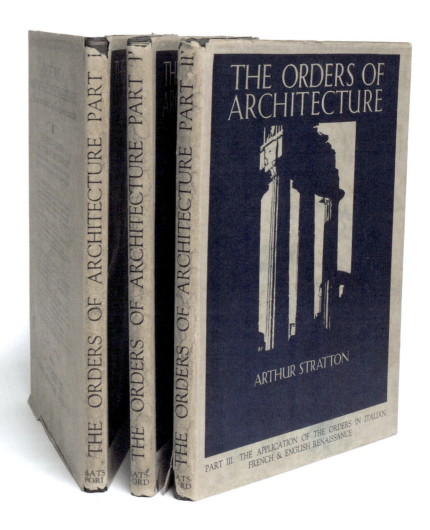

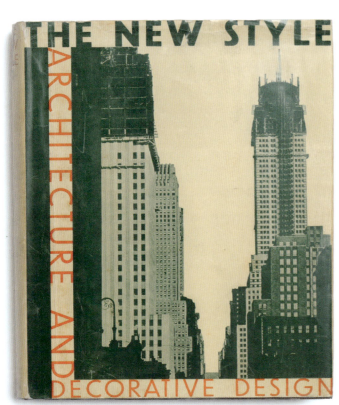

The New Style Architecture and Decorative Design
Maurice Casteels, 1931

—

Casteels adapted this from the French original *L'Art Moderne Primitif*. The book has 144 plates illustrating the new direction of art in buildings.

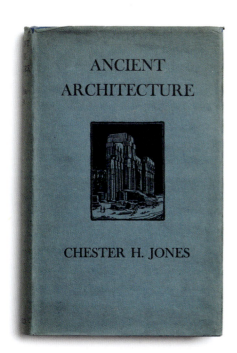

Ancient Architecture
Chester Henry Jones, 1933

—

The author was born in 1906 but died in 1933. He did not live to read the proofs of this work, which was a commentary in verse on architecture from the prehistoric to Egyptian, Western Asian and Greek and Roman periods, illustrated throughout by the author. Sir Edward Lutyens wrote in his foreword that the book was a memorial to the author's genius as a born architect in love with his profession. Jones's drawing of the Temple to Amon at Luxor is on the cover.

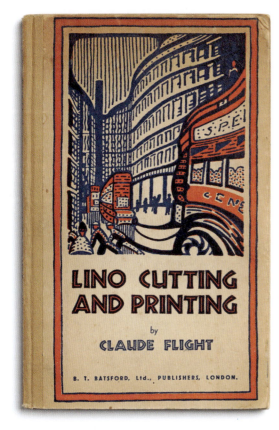

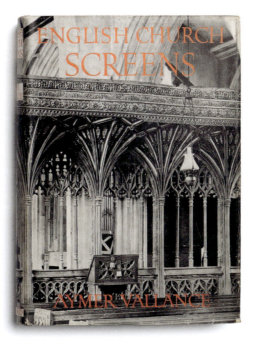

Lino Cutting and Printing
Claude Flight, 1934

—

Flight was a dynamic pioneer and promoter of lino cutting. The front cover of this book was his print *Speed* from 1922.

English Church Screens
Aymer Vallance, 1936

—

The author wrote the first biography of William Morris in 1897, and for Batsford in 1912, the definitive *Old Colleges of Oxford*. Vallance was a leading authority on ecclesiastical art and architecture. Batsford published his *Old Crosses and Lychgates* in 1920. They saw *English Church Screens* as the standard work on the subject; it is profusely illustrated with plates and drawings, with the index compiled by Brian Cook. In 1920, Vallance took on the restoration of Stoneacre near Maidstone, now a National Trust property.

Aviation

The Book of Speed
Charles Fry and Brian Cook (editors), 1934
—

In the mid-1930s, Charles Fry and Brian Cook worked together on some new directions for Batsford book themes. Fry had joined the company in 1934 as Harry Batsford's personal assistant, and later became a director. Batsford wrote of him in *A Batsford Century* 'to watch him planning a book, choosing illustrations and placing them, is a revelation'. Cook, Harry's nephew, had joined the business in 1928. He had been educated at Repton under the guidance of the art master Arthur Norris. Harry wrote of him 'his brightly coloured jackets […] accomplished a great deal in giving a distinctive note to the appearance of Batsford books'.

In their note introducing *The Book of Speed*, Fry and Cook recognised that this work took them into 'an unexplored country', in comparison with the scope of Batsford's other books. *The Book of Speed* comprises material provided by many friends and advisors, including authors Captain G E T Eyston and Colonel P T Etherton, Sir Malcolm Campbell and others. Brian Cook designed the jacket and also provided a watercolour for the frontispiece. The editors set out to present, through the contemporary art of photography, the 'mechanical speed of the twentieth century'.

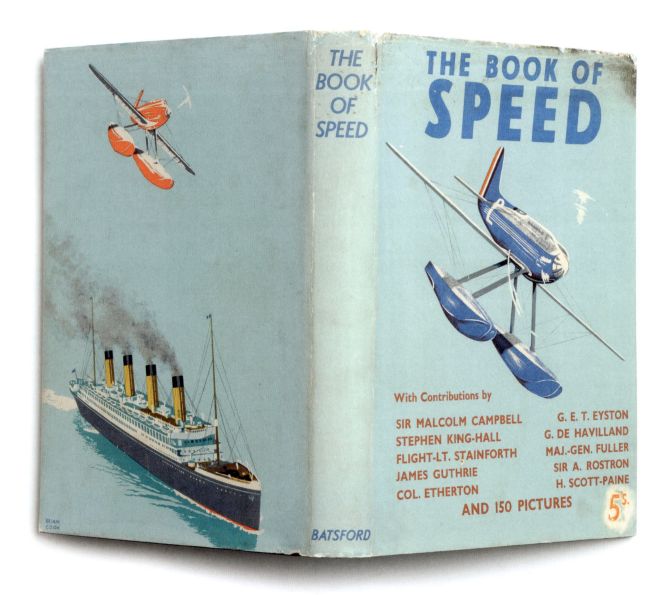

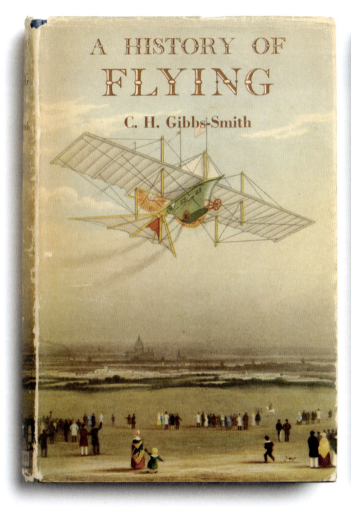 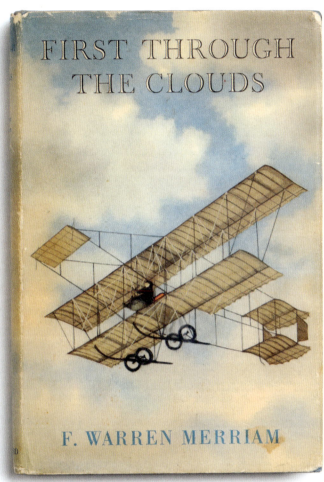

A History of Flying
Charles Harvard Gibbs-Smith, 1953

—

The author's dedication page quotes the poet Cecil Day-Lewis: 'High spirits they had: gravity they flouted'. The jacket image of Henson's 'Aerial Steam Carriage' is reproduced from an engraving at the Royal Aero Club.

First Through the Clouds
Frederick Warren Merriam, 1954

—

This was the autobiography of the box-kite aviator, the first in Britain to fly through the clouds in 1912. He was a flying instructor at Brooklands aerodrome in Surrey.

Railways

The Railways of Britain: Past and Present
Oswald Stevens Nock, 1947
—
The author worked for Westinghouse Brake and Signal Company and wrote widely on railways.

The Railway Engineers
Oswald Stevens Nock, 1955
—
The jacket illustration was a drawing by J C Bourne from 1846, showing *Acheron* emerging from Bristol No 1 Tunnel.

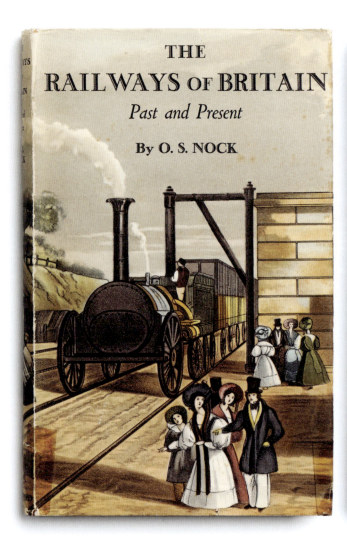

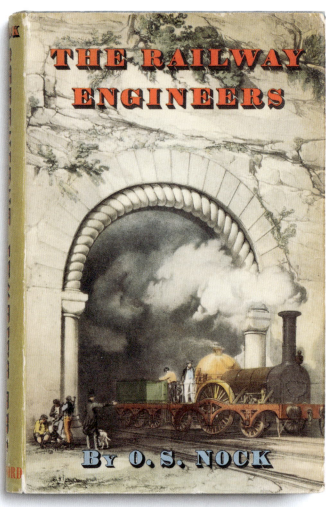

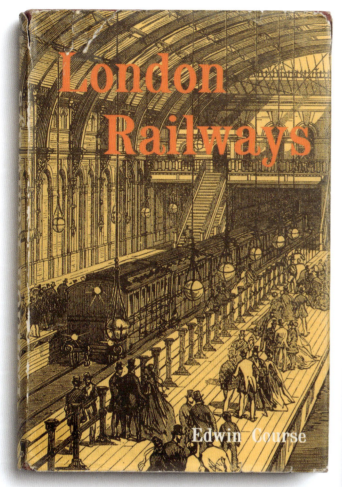

London Railways
Edwin Course, 1962

—

Dr Course was a lecturer, author, industrial archaeologist and railway enthusiast, and was on the staff of the University of Southampton. This book was based on his doctoral thesis. His collection of *c.* 9,900 railway maps is conserved at Historic England.

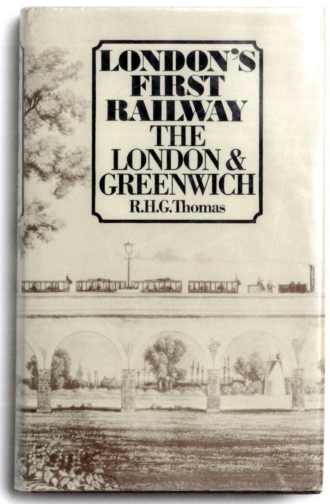

London's First Railway: The London & Greenwich
R H G Thomas, 1972

—

Originally an accountant and after WWII a schoolteacher, the author became London Secretary of the Railway and Canal Historical Society and lectured on railway history for the University of London Extramural Department. The jacket of this definitive work was designed by Jim Bamber, a cartoonist specialising in motorsports illustration, based on an aquatint by A C Clayton in 1834 and reproduced courtesy of the Science Museum.

Cars

Motor Racing and Record Breaking
George Eyston and Barré Lyndon, 1935
—
This was Batsford's entry into a new field. The book was dedicated to industrialist and philanthropist Viscount Wakefield of Hythe, whose company Wakefield Motor Oil is now known as Castrol. Racing driver Captain Eyston went on to break land speed records and was made an OBE and Chevalier of the Légion d'Honneur. The jacket was designed by Brian Cook.

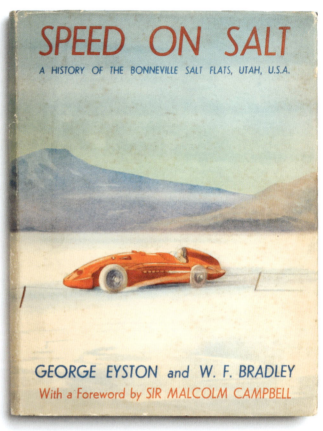

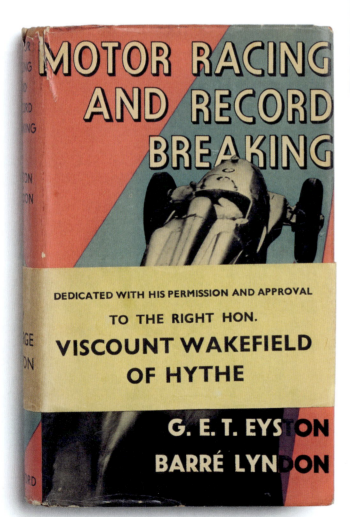

Speed on Salt
George Eyston and W F Bradley, 1936
—
Next came this, a history of the Bonneville Salt Flats of Utah, with a foreword by Sir Malcolm Campbell and again the jacket and frontispiece by Brian Cook. In his foreword, Campbell suggests that the book 'should be something of a milestone in the literature of motor-racing' and that 'every statesman, every big business man and even every banker appreciates the fact that the future peace and stability of the world depends very largely on speed and mobility of transport'. The themes of flying and particularly motor-racing would return to the Batsford repertoire in the 1950s and 1960s.

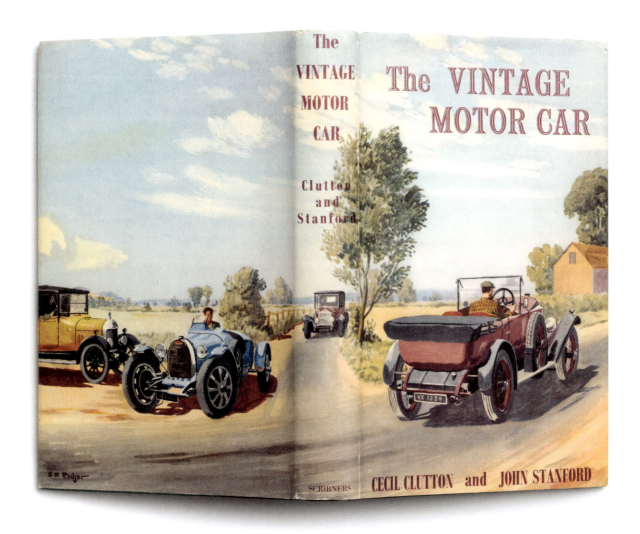

The Vintage Motor Car
Cecil Clutton and John Stanford, 1954

—

The 1950s saw the development of popular British marques of motor cars like the Morris Minor, Austin A30, MG and Triumph sports cars, and of widening interest in motor car nostalgia and in motor racing.

This book (which is a Scribner's version) was the first of a trilogy. Cecil Clutton had been bulletin editor of the Vintage Sports-Car Club and President 1954–56, and was also an organist and horologist. John Stanford had an engineering background. The jacket was by Sidney Robertson-Rodger, who had been a war artist. In 1957, Stanford wrote Batsford's *The Sports Car*.

Cars

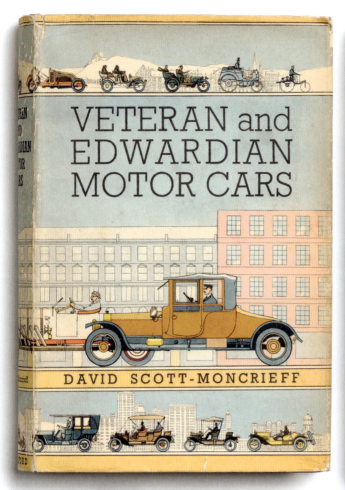 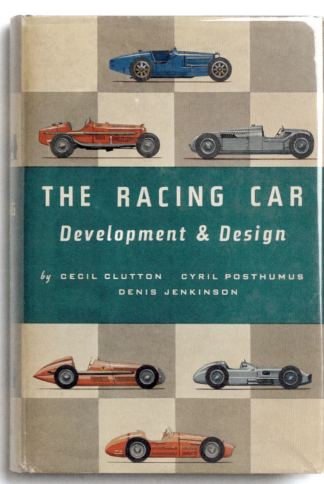

Veteran and Edwardian Motor Cars
David Scott-Moncrieff, 1955

—

Scott-Moncrieff, also known as 'Bunty', studied engineering at Cambridge University and later wrote Batsford's *The Thoroughbred Motor Car 1930–40* in 1963.

The Racing Car
Cecil Clutton, Cyril Posthumus and Denis Jenkinson, 1956

—

Third in the trilogy, with a jacket by Roy Nockolds.

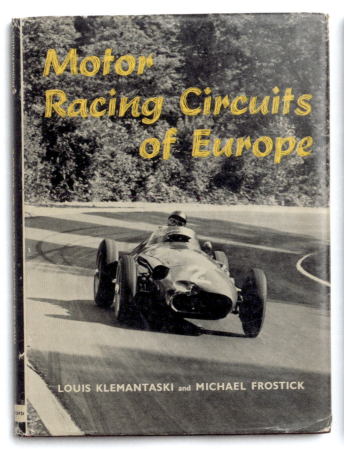

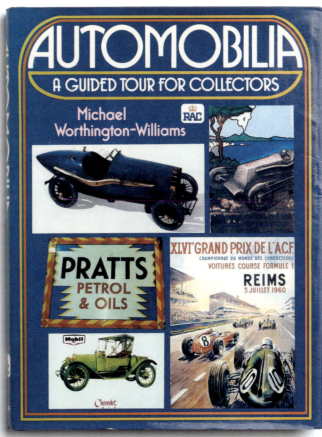

Motor Racing Circuits of Europe
Louis Klemantaski and Michael Frostick, 1958

Automobilia
Michael Worthington-Williams, 1979

—

Batsford went on to publish a series of popular books on motoring, including this by the motoring journalist and historian Michael Worthington-Williams, in collaboration with the Royal Automobile Club.

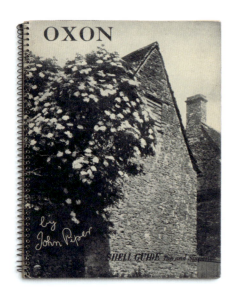
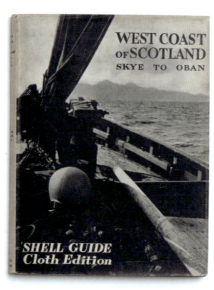

Shell Guides to Oxon, West Coast of Scotland, Hampshire, Northumberland & Durham and Bucks
Various editors, 1930s

—

Batsford shared with others the series of 13 pre-war Shell Guides under the general editorship of John Betjeman CBE, as aspiration grew of motor car ownership and motoring. Among Batsford's editors were John Nash and John Piper. Pencil drawings in the Northumberland and Durham guides were by A E Newcombe.

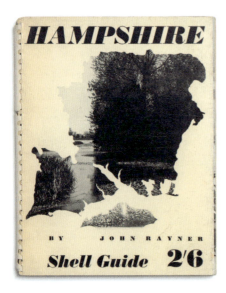
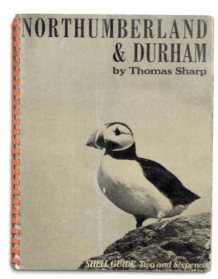
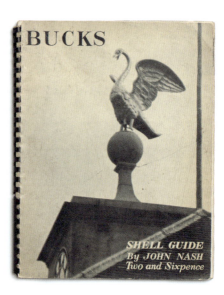

Chinese Art
Roger Fry and others, 1935

—

This work followed the first exhibition of Chinese Art at Burlington House in 1935–36. Individual contributors, experts in their fields, reviewed the chief divisions of the arts of China. The book has colour illustrations and the jacket is by Brian Cook.

RMS Queen Mary
George Blake and Stewart Bale, 1936

—

Two versions of this book of photographs recording the construction and launch of the Cunard–White Star Line's *Queen Mary*. Each had pages for autographs, for passengers on the inaugural voyage to New York and subsequent voyages in both directions.

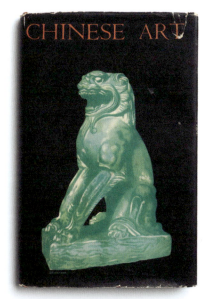

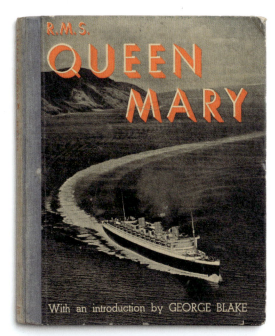

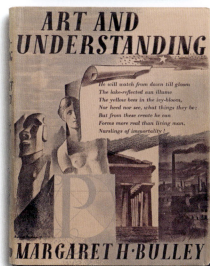

Art and Understanding
Margaret Hattersley Bulley, 1937

—

This book, with 276 illustrations, addresses questions such as what gives rise to fine form and design in art, and whether there is a difference in kind between the design of a fine car and a fine chair. The jacket is by Barnett Freedman CBE RDI.

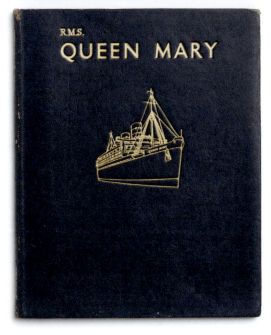

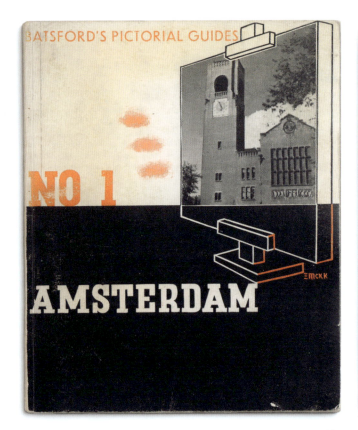
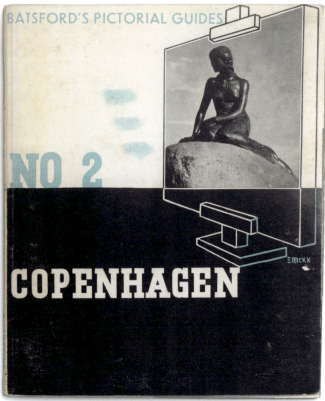
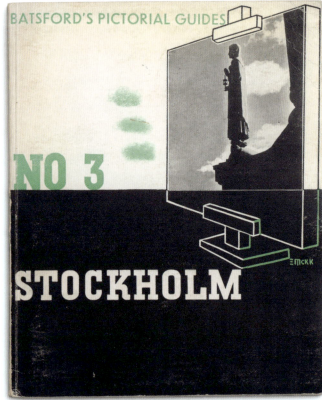
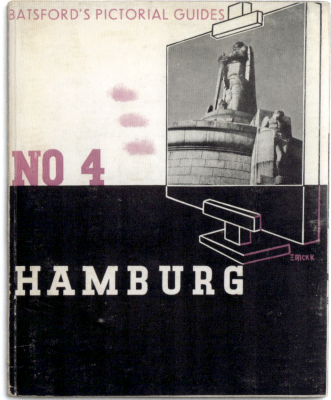

Batsford's Pictorial Guides 1–4
Photographed by Geoffrey Gilbert, cover designs by graphic designer
Edward McKnight Kauffer, 1936

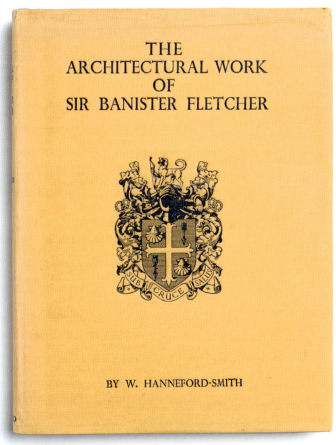

The Architectural Work of Sir Banister Fletcher
William Hanneford-Smith, 1934

—

William Hanneford-Smith was a central figure at Batsford. He joined the company in 1893 and worked with founder Bradley Thomas Batsford, then with his sons Bradley and Herbert (working for 24 years with the latter). After Herbert's death in 1917, Harry Batsford was head of the company and Hanneford-Smith was manager of the retail department. He completed a half-century in the Batsford centenary year of 1943. Together with Harry, he became an Honorary Associate of RIBA, and was also Fellow of the Royal Society of Edinburgh and Associate of the Institute of Civil Engineers. In his foreword to this biography of Sir Banister Fletcher, he thanks Sir Banister for his patience and courtesy in the process. The edition shown had a print run of 500 copies, of which 400 were for sale. Hanneford-Smith had already worked on the production of 10 editions of Sir Banister's magnum opus *History of Architecture on the Comparative Method.* In his deckle-edged *Recollections of a Half-Century's Association with the House of Batsford* (1943), Hanneford-Smith records his appreciation of Banister Fletcher, referring to the presentation clock he received from Sir Banister to mark their 45 years of collaboration. He also chronicles 68 individuals with whom he had close contact since 1893, including many other authors featured in this book and such notable figures as the politician John Burns (who was a constant visitor to the Batsford shop), Sir W H Lever (later Viscount Leverhulme), Sir Edwin Lutyens and Guglielmo Marconi.

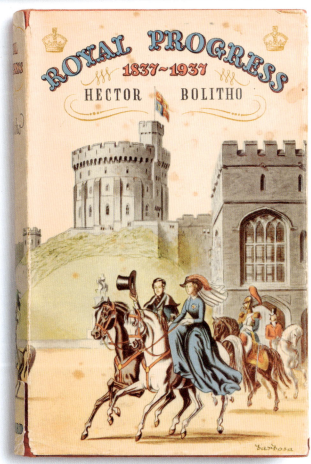

Royal Progress 1837–1937
Hector Bolitho, 1937

—

Born and educated in New Zealand, Hector Bolitho arrived in Britain in the 1920s, becoming a freelance journalist. This informal British Royal history was his first writing for Batsford, with a jacket designed by illustrator Artur Barbosa. At the outbreak of WWII, Bolitho joined the RAF Voluntary Reserve, working in intelligence and editing public RAF material.

Sacheverell Sitwell

Conversation Pieces and **Narrative Pictures**
Sacheverell Sitwell, 1936 and 1937
—

Charles Fry wrote in *A Batsford Century* that 'In the summer months, Sachy Sitwell sometimes had a house around the corner, and when he was doing a book for us, we would often be his first port of call of a morning. I always enjoyed his visits, his interest in all we were doing and in the fireworks of his brilliant, discursive conversation'. In his preface to both these books, Sitwell records his obligations to his fellow artist Michael Sevier and to Charles Fry, 'who has been the inspirer and the force of energy behind this most pleasant of tasks'. The jackets of both were designed by Rex Whistler.

Conversation Pieces had in its theme been preceded just five years before by *English Conversation Pieces* (1931), by G C Williamson. In his foreword to that, Sir Philip Sassoon wrote that our real sense of intimacy with the 18th century was due not only to the profusion of literary records but also in large measure 'to our familiarity with the intriguing little pictures of men, women and events by … a succession of brilliant painters'.

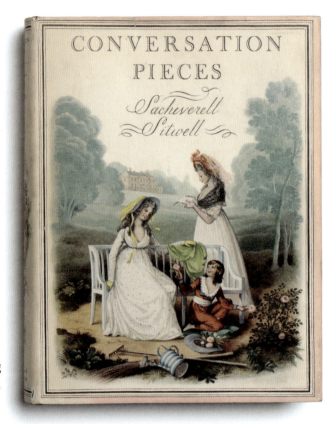

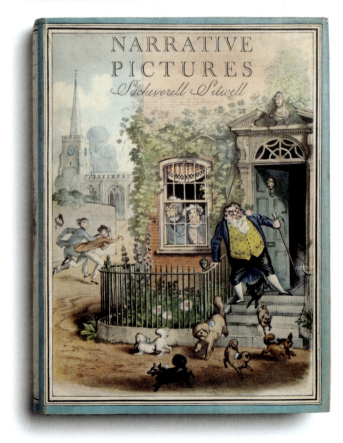

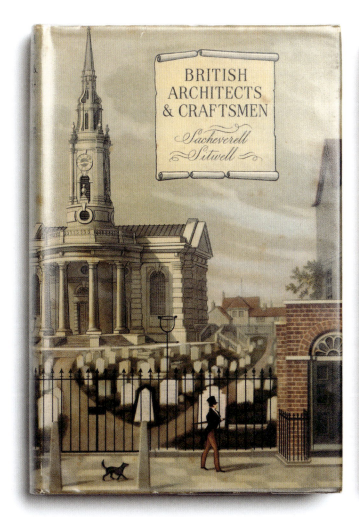 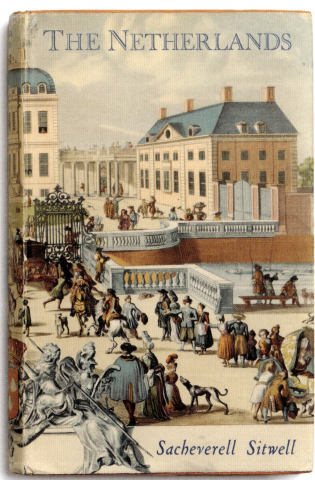

British Architects and Craftsmen
Sacheverell Sitwell, 1945

—

In this book, prepared in the sixth year of WWII, Sitwell makes a significant addition to Batsford's tradition of focus on architecture. The jacket is reproduced from a coloured aquatint of the Baroque St Paul's church in Deptford, built by Thomas Archer in 1730. At the end of an extensive introduction, Sitwell reflects that architecture 'can console, and inspire, as can no other art but music. Under that stimulus, whether it soothes or fires, we see what the man-made world has been, and what it could still be'.

The Netherlands
Sacheverell Sitwell, 1948

—

The jacket of this work shows the de Voorst castle, seat of the Keppel family, ancestors of the Earl of Albemarle, *c.* 1700. The endpapers show gardens at Enghien in Flanders. The jacket blurb notes that the author looked at the Netherlands through his own eyes rather than those of his predecessors, and suggests that the book will awaken and satisfy the reader's curiosity. It is profusely illustrated with photographs and some colour plates. Among Sitwell's many other contributions to Batsford were others in the European series: *Spain* in 1950, *Portugal* in 1954, *Denmark* in 1956 and *Malta* in 1958.

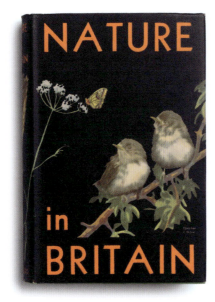
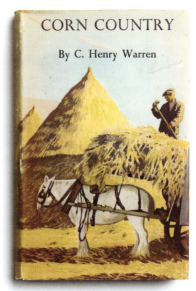

Nature in Britain
introduced by Henry Williamson, 1936
—

This work included contributions by Frances Pitt, Seton Gordon, Edward George Boulenger and Robert Gathorne-Hardy. The jacket was by Brian Cook and the introduction was by Henry Williamson, the author of *Tarka the Otter*.

Corn Country
C Henry Warren, 1940
—

This book ends with the author's contention that 'her countryside is still the true source of Britain's greatness'.

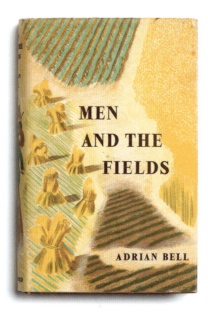
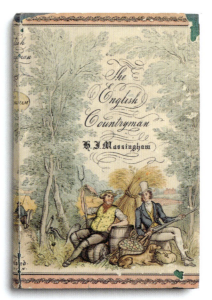

Men and the Fields
Adrian Bell, 1939
—

The author was a country man himself and the book and jacket were illustrated by his friend and neighbour John Nash.

The English Countryman
Harold John Massingham, 1942
—

This was described by the author as a 'workshop of character'. The jacket was by Rex Whistler. This reprinted edition was identical to the first but on thinner paper, reflecting wartime savings.

World Natural History
Edward George Boulenger, 1937

—

Described as a cheap edition (5s), this book by zoologist Boulenger was associated with the Batsford British Nature Library, which included three books on wildflowers, birds and animals of Britain. In his introduction, the novelist H G Wells welcomed the focus on evolution and on the rules of nature: 'I think this is a rather important thing for a young mind to grasp and so I welcome in this *World Natural History* a more brightly illustrated revival of that classic of my childhood [the Rev John George Wood's *Natural History* in various editions from the 1850s]'. The *New Statesman and Nation* echoed Wells' view that this was a book to own, to give as a present and to give as a prize. Brian Cook also designed this jacket.

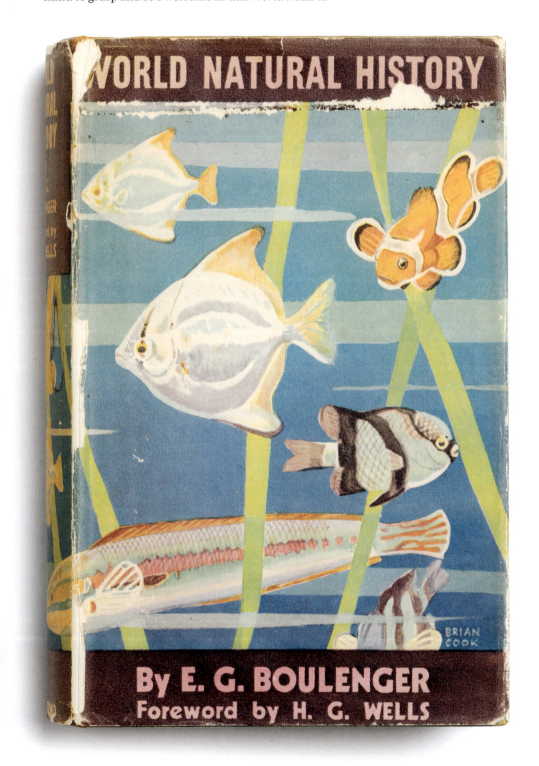

Circus Parade
John Smith Clarke, 1936
—
The author was a lion tamer and lifelong circus man, and an Independent Labour MP from 1929 to 1931. The jacket was designed by Brian Cook.

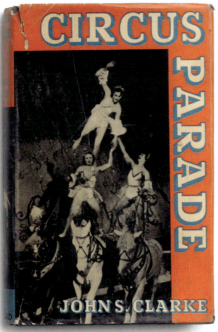

Romeo and Juliet
Oliver Messel, 1936
—
This edition of the script has 32 plates in collotype and eight colour reproductions tipped in of Messel's designs for the contemporary MGM film by Irving Thalberg, starring Norma Shearer and Leslie Howard. The text being Shakespeare's, Messel states that had it been his he would have dedicated the book to Norma Shearer.

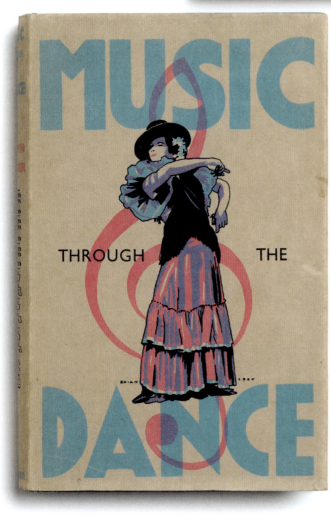

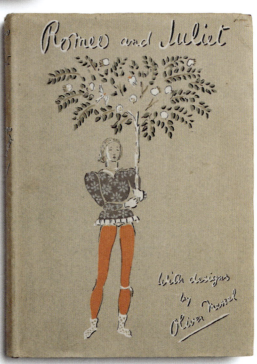

Music Through the Dance
Evelyn Porter, 1937
—
This volume for music teachers and students was based on an experiment with the girls of the Music Club at Wembley Grammar School. Musical appreciation is presented in a new form, with descriptions of leading forms of dance and its musical development, each chapter of dance examples is accompanied by notes on the music of the period. The jacket is by Brian Cook.

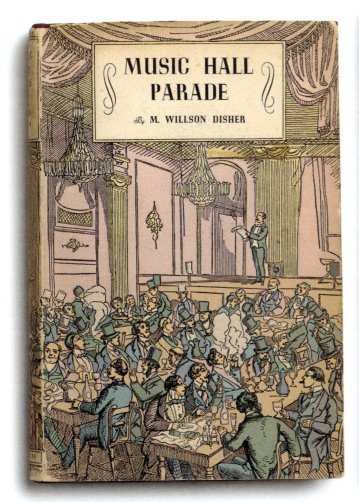
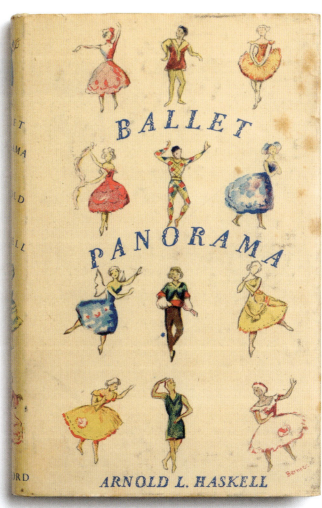

Music Hall Parade
Maurice Willson Disher, 1938

—

Disher was a music hall critic. This joint Scribner's and Batsford book was also published separately by Batsford in London under the different title of *Winkles and Champagne: Comedies and Tragedies of the Music Hall.*

Ballet Panorama (revised third edition)
Arnold L Haskell, 1947–48

—

The revised edition was dedicated to Robert Helpmann, the Australian ballet dancer and actor. The jacket was by composer and writer Lord Berners.

How to Study an Old Church
A Needham, 1957
—
This is a guidebook that reverses the usual order of text and images, giving priority to the pen drawings, with supporting notes.

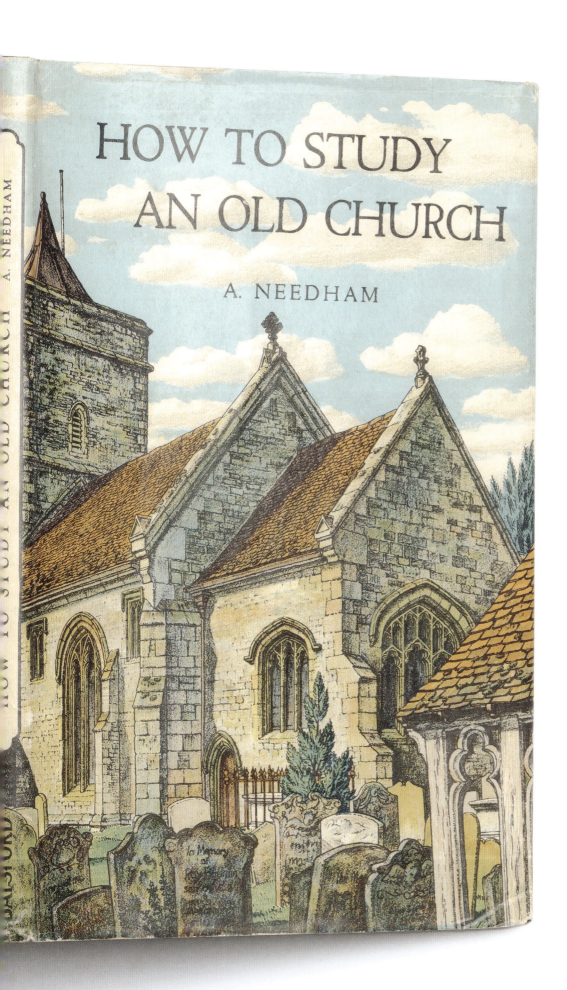

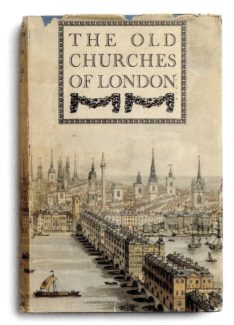
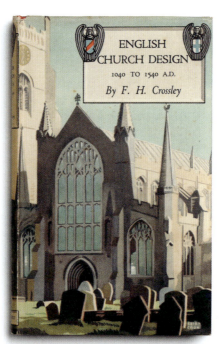

English Church Design 1040 to 1540 AD
Fred H Crossley, 1945

—

Other works by the author for Batsford were *English Church Woodwork*, *English Church Monuments*, *The English Abbey*, *English Church Craftsmanship* and *Timber Building in England*. The jacket is by Brian Cook.

The Old Churches of London
Gerald Cobb, 1941

—

The author was an ecclesiastical historian and heraldic artist (Queen Elizabeth II's artist at the College of Arms). He included in this book photographs from Herbert Batsford's collection. His nephew Harry noted that his uncle had a particular affection for the furniture and fittings of Wren churches. Randolf Schabe (Slade Professor of Fine Art at UCL 1930–48) provided this jacket and had previously co-authored with Francis Kelly *Historic Costume 1490–1790* in 1925 and *A Short History of Costume* in 1931.

Practical Craftwork Design
Winifred M Clarke, 1937

—

This book included colour plates designed by the author, a teacher of needlework in Loughborough. She also wrote *Illustrated Stitchery Decoration* in 1930.

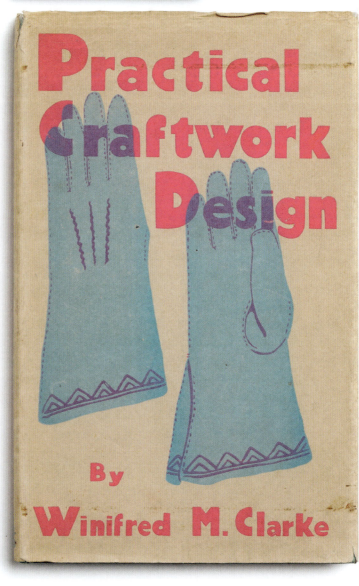

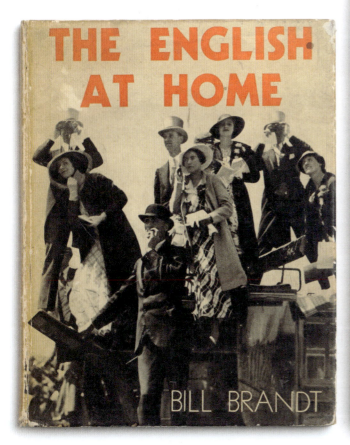 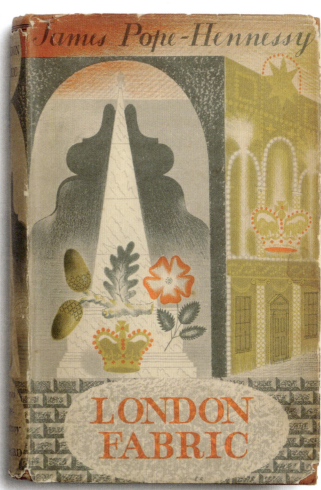

The English at Home
Bill Brandt, 1936
—
While so many Batsford books are supported by photographs, a handful were almost fully photographic, with this prominent among them. In his introduction, Raymond Mortimer noted that as Brandt had spent most of his life abroad, he could pick up what made Britain different and showed himself to be an anthropologist as well as an artist, with the detached curiosity 'of a man investigating the customs of some remote and unfamiliar tribe'. In 1978, Brandt was appointed Royal Designer for Industry, for photography.

London Fabric (second edition)
James Pope-Hennessy, 1941
—
The younger brother of art historian Sir John Pope-Hennessy, the author wrote in his preface to the first edition that the book was an attempt to recall associations dormant in some London buildings. The book was a personal narrative of eight essays. This jacket was by designer and painter Eric Ravilious, created before he was lost in action with the RAF in September 1942. The endpapers had contemporary illustrations of Kensington and Hampton Court Palaces.

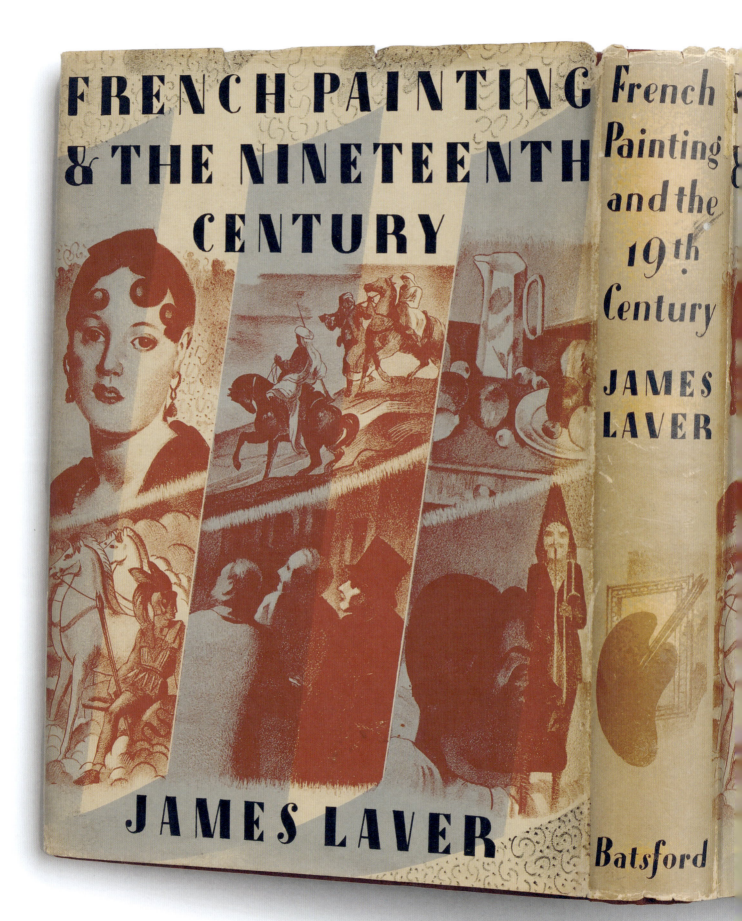

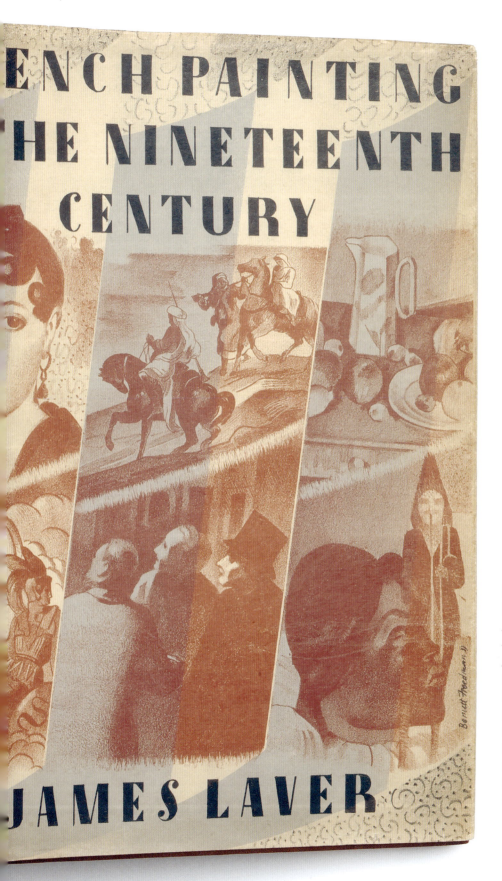

French Painting and the Nineteenth Century
James Laver, 1937
—
An art and fashion historian, the author was Keeper of Prints, Drawings and Paintings at the V&A 1938–1959. He saw painting 'not as in an aesthetic vacuum but as subject to all the political, economic, social, scientific and other influences of its age'. This jacket was by Barnett Freedman CBE RDI.

Cecil Beaton

Charles Fry wrote that Sir Cecil Beaton had been associated with Batsford for nearly all of his books, noting that the 'reproduction and layout of his splendidly varied work would set a nice problem for any publisher, but the results speak for themselves', adding 'he draws brilliantly, with wit and invention. And he takes photographs as well as, and perhaps better than, any other craftsman today'.

Cecil Beaton's Scrapbook
Cecil Beaton, 1937

—

In a manuscript preface written at Ashcombe House, Beaton introduces his scrapbook as distilling his work of the previous five years. The content includes 34 articles and 350 photographs.

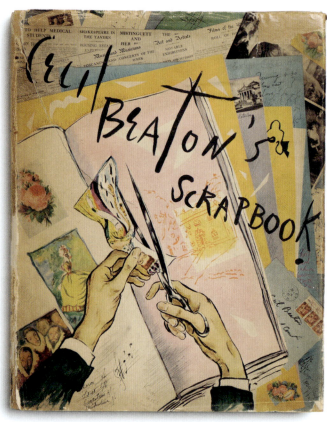

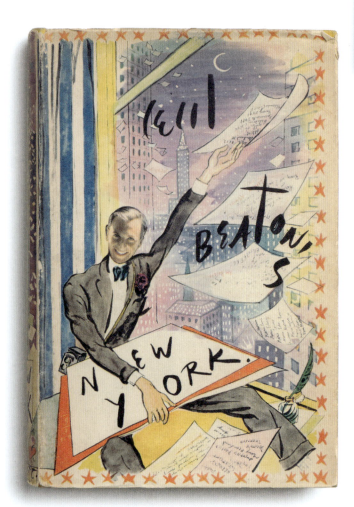

Cecil Beaton's New York
Cecil Beaton, 1938

—

This is J B Lippincott's version, published simultaneously with Batsford's in October 1938, with the Beaton jacket. Beaton's preface describes it as 'a catalogue of impressions, mostly visual, of a place I know little about'.

Near East
Cecil Beaton, 1943

—

Beaton was sent to the Near East in March 1942 to collect material for the Air Ministry and Ministry of Information.

Far East
Cecil Beaton, 1945–46

—

Beaton was sent to India and China by the Ministry of Information, this book being the sequel to *Near East*. The narrative begins with three poignant pages on the plane crashing on taking off for India.

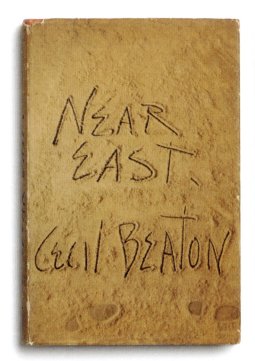

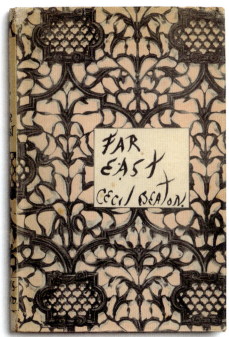

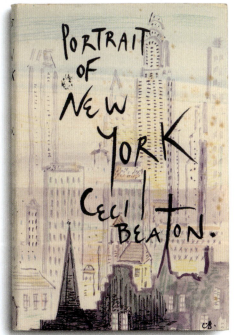

Portrait of New York
Cecil Beaton, 1948

—

This re-written and re-illustrated version of the 1938 original is virtually a new book, with a new jacket.

Cecil Beaton

An Indian Album
Cecil Beaton, 1945–46

—

The first of two follow-up books of about 100 photographs each, for which there had been no space in *Far East*. Beaton concludes his preface by asking how photography in India could be 'anything other than a joy, for no country affords greater opportunities'.

Chinese Album
Cecil Beaton, 1945–46

—

The author concludes in his preface to his snapshots that 'perhaps, in some of them, we can see the spirit of the essential, unchanging China'.

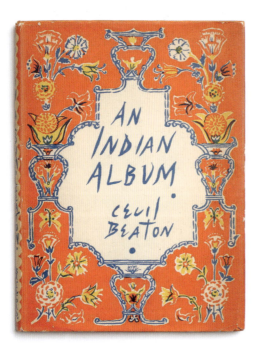

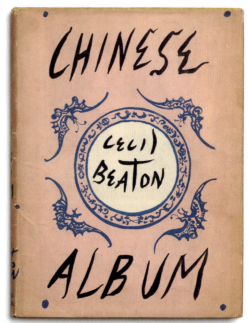

Time Exposure (second edition)
Cecil Beaton and Peter Quennell, 1946

—

This was a re-issue of the original from 1941, with over 50 new photographs. Reviewing the first edition, Edward Sackville-West wrote in the *New Statesman and Nation* that 'This curiously important book [...] contains more entertainment to the square inch than a year's issue of any illustrated paper, more beauty than the average picture show, and more cleverness than a whole club-full of barristers...'. Commentary and captions were by Peter Quennell.

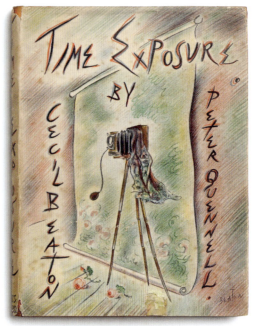

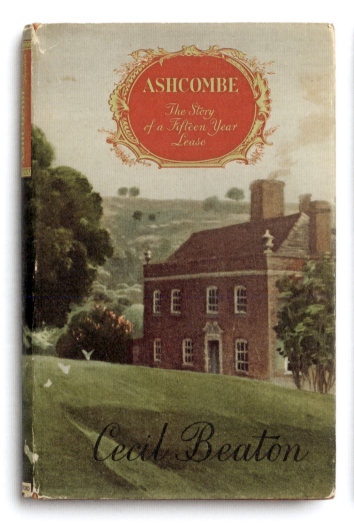
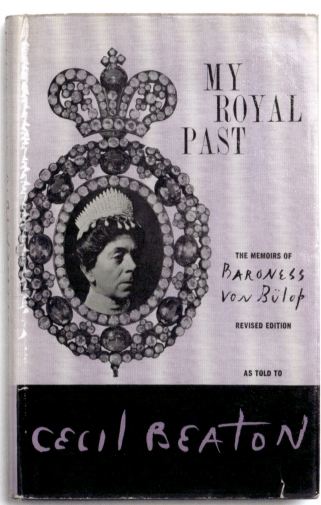

Ashcombe: The Story of a Fifteen Year Lease
Cecil Beaton, 1949

—

The subject was Beaton's country home from 1930 to 1945. The blurb extols his recreation of the atmosphere of the period, when the house and garden were made over from their unkempt and derelict state into the idyllic home. Beaton dedicates the book to the memory of Edith Olivier, 'who brought me to Wiltshire'. The jacket is by Rex Whistler.

My Royal Past (revised edition)
Cecil Beaton, 1960

—

An extravagant spoof on European aristocracy, in the form of a memoir of Baroness von Bülop.

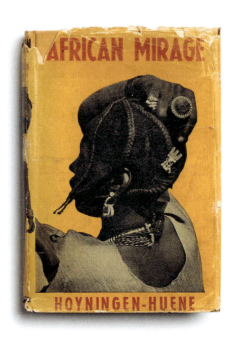

African Mirage
George Hoyningen-Huene, 1938

—

The author was a pioneer of fashion photography. This was his first book, prepared from a diary of his travels.

Remembrance
Harold John Massingham, 1941

—

The autobiography of a prolific writer on rural life that he describes as a topographical record of the country 'of my own mind'. He contributed a series of topographical books – *The English Downland*, *Cotswold Country*, *Chiltern Country*, *The English Countryside*, *The English Countryman* – all written, in his own words, 'for my wise and considerate friend, Harry Batsford'.

Curiosities of Town and Countryside
Edmund Vale, 1940

—

Vale wrote extensively for Batsford with Brian Cook jackets: *The Seas and Shores of England* (1936), *North Country* (1937), *Northern England and the Lakes* (1937), *How to Look at Old Buildings* (1940) (fourth of the Home Front Handbook series), *Ancient England* (a 1939 manuscript but published in 1941). The blurb to this book suggests that it would interest all lovers of the unusual and unique, and of Britain herself. Unusually, in the preface the author describes a difference of opinion with his publisher over the book's theme and especially the treatment of follies, for which he had a profound and contemptuous dislike.

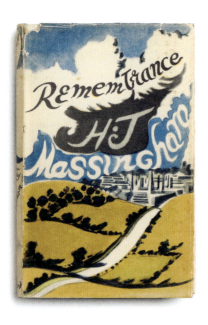
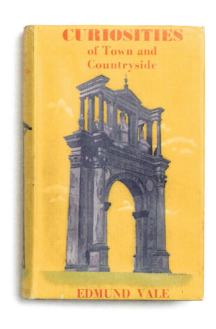

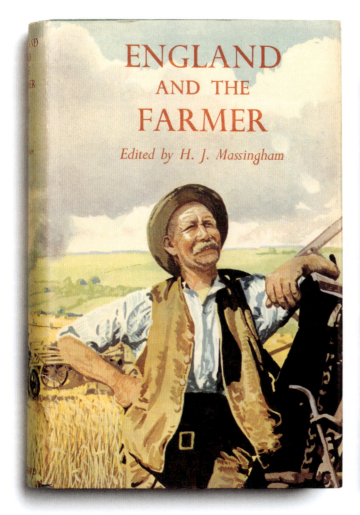
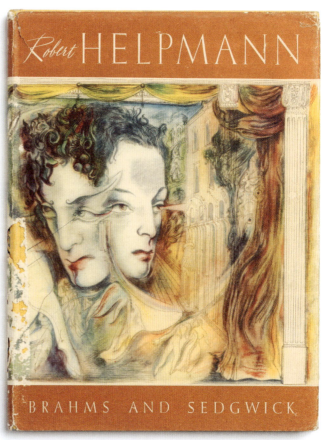

England and the Farmer
edited by Harold John Massingham, 1941

—

A wartime collection of essays by advocates of farming, introduced by the editor, urging an act of faith in our own land. The jacket is by Brian Cook.

Robert Helpmann
Caryl Brahms, 1943

—

The author was the pseudonym of Doris Caroline Abrahams, a journalist, critic and writer on theatre and ballet. The jacket was by artist and set designer Leslie Hurry, and the book's photographs were by Russell Sedgwick.

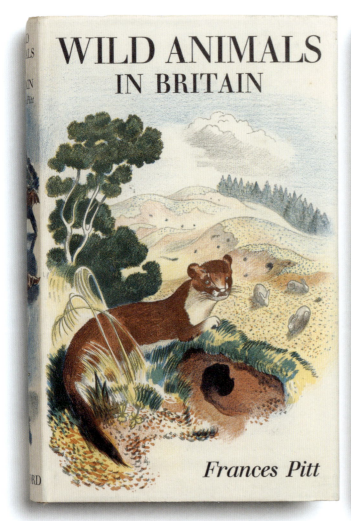 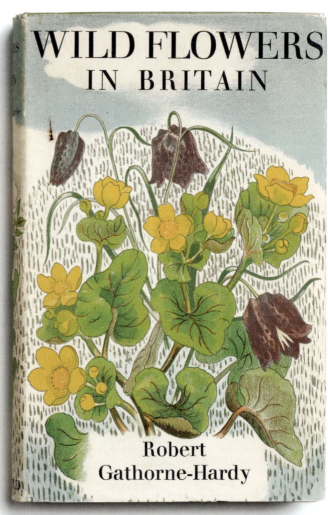

Wild Animals in Britain
Frances Pitt, 1938

—

The author was a naturalist, illustrator and photographer.

Wild Flowers in Britain
Robert Gathorne-Hardy, 1938

—

The jackets of all three 'wild' books were designed by John Nash.

Wild Birds in Britain
Seton Gordon, 1938
—
The author was a Scottish naturalist, photographer and folklorist.

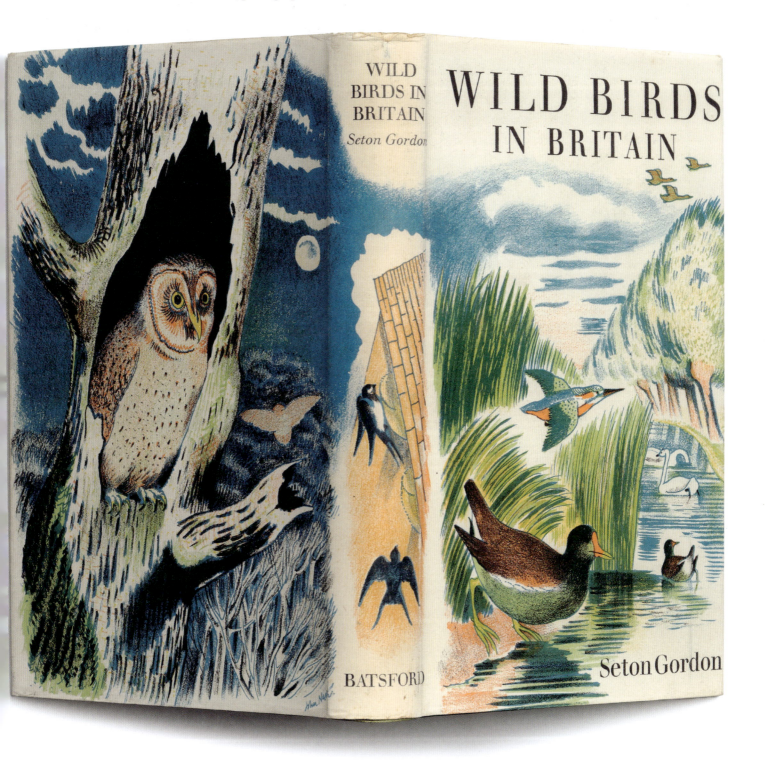

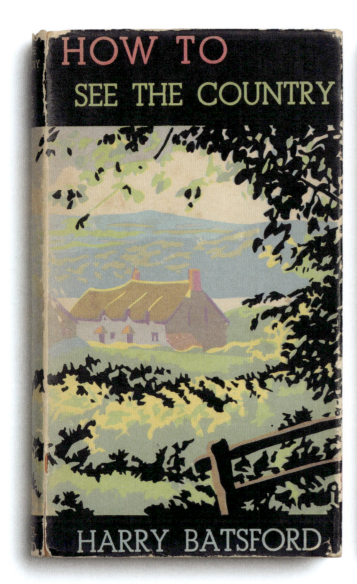
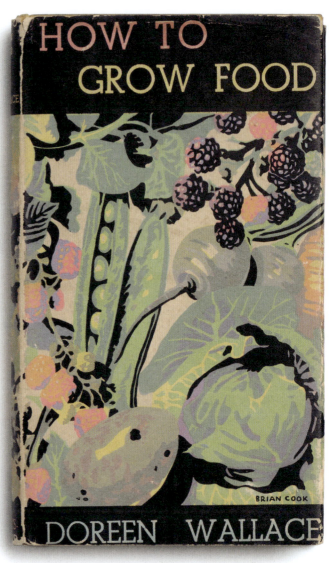

How to See the Country
Harry Batsford, 1940

—

This was one of the Home Front 'How to' handbooks, described as 'a series to meet the needs of those who, through war-time circumstances, must seek their own entertainment instead of finding it ready-made and to hand'. This was Harry Batsford's own contribution to the series. The blurb refers to the large number of individuals and families of widely different classes forced into full-time acquaintance with the country. He comments that guidebooks 'like the motor-car, are legion, and can be excellent servants if kept under subjection; otherwise they are tyrannical masters'. The series jackets were by Brian Cook.

How to Grow Food
Doreen Wallace, 1940

—

Harry Batsford recalled a printer's error in the proof of this book when it came in as 'How to Grow Good', prompting him to remark that the author was 'no mild creature with her pen, and stirs up many a skirmish with her vigorous views'. But he regarded Doreen Wallace as 'a distinguished addition to our list'. After a degree at Somerville College, Oxford, she taught English at Diss Grammar School before a long career writing fiction, belonging to the Somerville School of Novelists. The author also wrote *East Anglia* and *English Lakeland* for Batsford.

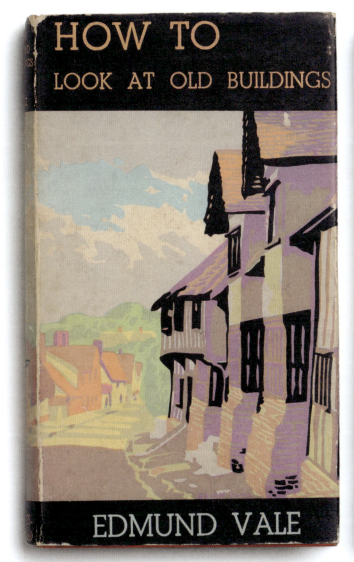
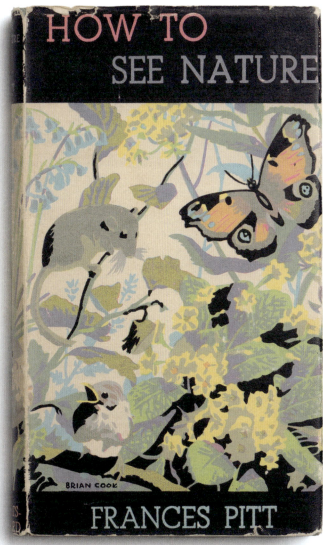

How to Look at Old Buildings
Edmund Vale, 1940

—

This was intended for 'those who are attracted by old buildings but who only know a little about them'.

How to See Nature
Frances Pitt, 1940

—

The author was a naturalist and writer on animals, including a book on her raising two young badgers brought by a rabbit catcher. *A Batsford Century* includes a photograph of her with Harry Batsford, Charles Fry and Brian Cook at her home 'The Albynes', in Bridgnorth.

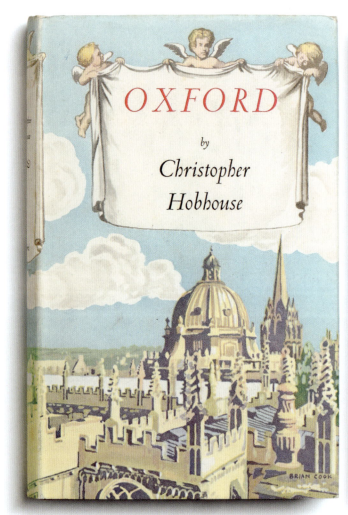 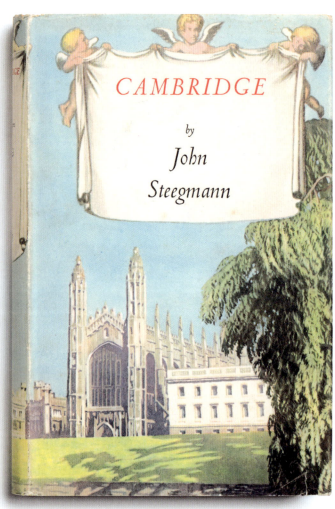

Oxford
Christopher Hobhouse, 1939
—
The jacket was by Brian Cook.

Cambridge
John Steegmann, 1940
—
Another Brian Cook jacket.

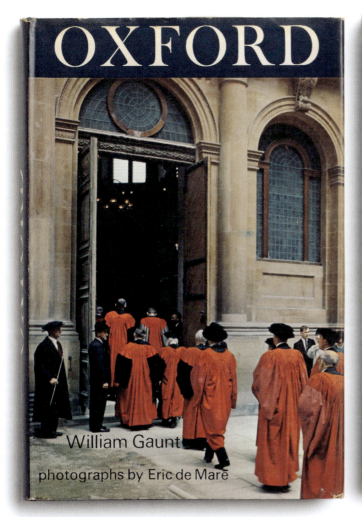 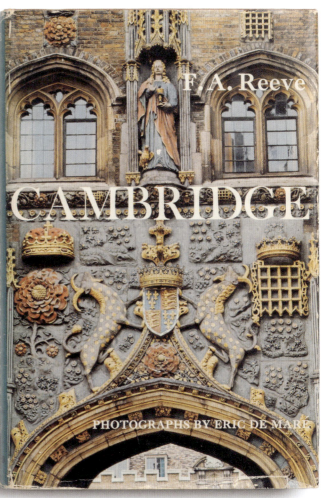

Oxford
William Gaunt, 1965

—

A 1960s take on Oxford. The jacket shows the Encaenia procession entering the Sheldonian Theatre, from a transparency by Eric de Maré, the book's photographer.

Cambridge
F A Reeve, 1964

—

A 1960s take on Cambridge. The jacket shows the gatehouse of St John's College, from a transparency by the book's photographer Eric de Maré.

The Streets of London
Thomas Burke, 1940

—

In his preface, written as the proofs were being passed for press, the author, who had a reputation as one of the staunchest and best-informed Londoners, notes that the streets were under bombardment but that 'what London is and was cannot be obliterated in a year's bombardment'.

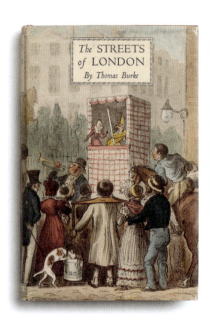

English Night Life (second edition)
Thomas Burke, 1943

—

Ending the preface for the first edition in 1941, Burke wrote that 'civilisation and intelligence will again brighten our days and nights…'.

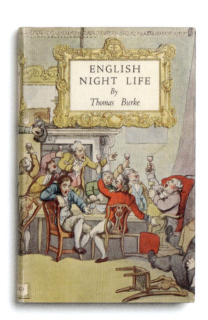

The Story of the English House
Hugh Braun, 1940

—

The jacket was by Brian Cook. The author had previously written *The English Castle* in 1936, that too with a Brian Cook jacket.

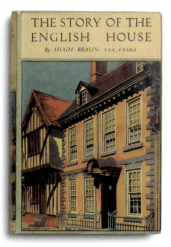

Homes, Towns and Countryside
Gilbert and Elizabeth McAllister, 1945

—

Gilbert McAllister was Treasurer of the Town and Country Planning Association (he became an MP after the July 1945 election). The book was published immediately after the end of the war in Europe and would have had a significant influence on post-war thinking on planning. The postscript by the Archbishop of York, Cyril Garbett, is entitled 'Planning for Human Needs'. The book comprises a series of essays by eminent experts in the planning field, led by Sir Patrick Abercrombie and Sir Daniel Hall, a team described by the Association's reviewer as an 'all star side'.

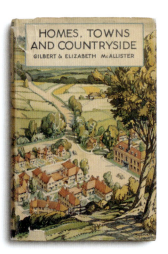

**Old English Household Life
(second edition)**
Gertrude Jekyll and Sydney Jones,
1944–45
—

As a garden designer, Gertrude Jekyll worked with Sir Edwin Lutyens and wrote widely about gardens, including a 1904 book *Old West Surrey* (published by Longmans, Green), surveying vanished country life. The latter prompted Harry Batsford to do a book on old households across England. In 1925, this emerged as *Old English Household Life*, co-authored with Sydney Jones, who provided drawings. Jones's drawings were prolific and legendary – he specialised in pencil drawings and etchings. Batsford asked Jones to enlarge and re-illustrate *Old English Household Life* in 1939, after Gertude Jekyll had died. This later, revised wartime edition was issued in the British Heritage series, with a jacket by Philip Gough. Gough had also illustrated Jane Austen's *Emma* and Lewis Carroll's *Alice in Wonderland*.

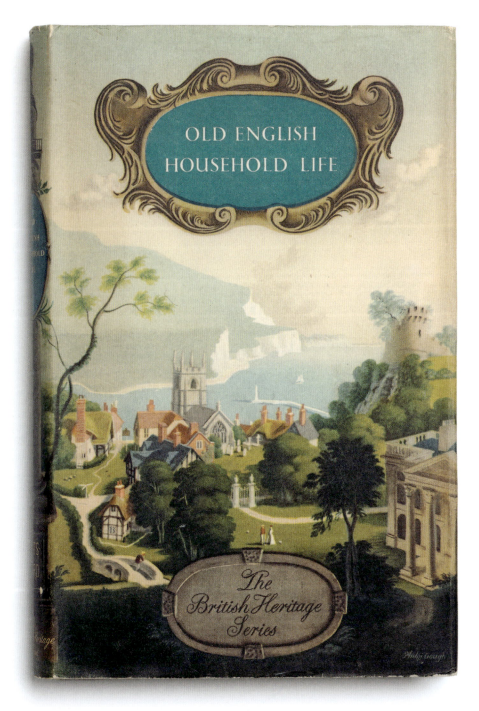

Gertrude Stein

Picasso
Gertrude Stein, 1939
—
American writer and art collector Gertrude Stein lived in France for most of her adult life, famously hosting a Paris salon. *Picasso* was first published in French, with an English version in 1938 and this reprint in 1939. This monograph includes Picasso's portrait of the author in 1906.

The World is Round
Gertrude Stein, 1939
—
The jacket was designed by Sir Francis Rose, a painter supported by Stein. In 1913, Stein had included in her poem *Sacred Emily* her well-known phrase 'A rose is a rose is a rose is a rose'. In *The Years Between*, Cecil Beaton wrote of Rose that 'for six hours on end he can paint, hunched in a thin overcoat in icy gales on the Downs, not minding that his face and hands are literally frozen blue'.

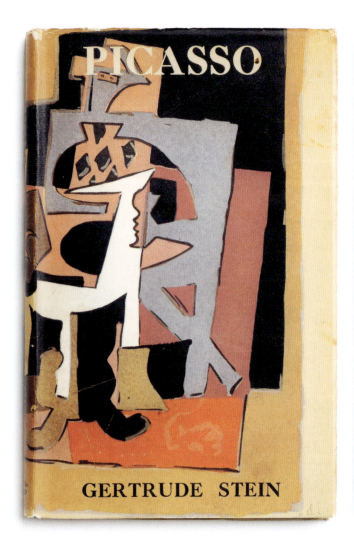

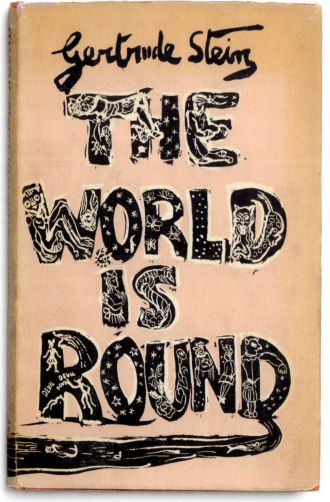

Paris, France
Gertrude Stein, 1940

—

This book was written around the outbreak of WWII, as the author's personal tribute to Paris and to France. This jacket is also by Sir Francis Rose. The blurb highlights the sense of unity between France and England in their common effort to 'civilise the Europe of the twentieth century'. Scribner's published an American edition.

Wars I Have Seen
Gertrude Stein, 1945

—

The blurb describes this as one of the most remarkable books of the War and as a reflective commentary on all wars, noting that it was written 'in long-hand under the noses of the Nazis who were often quartered in her house'. The jacket was the work of Cecil Beaton.

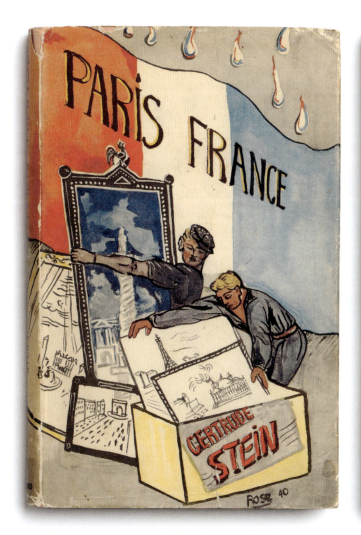
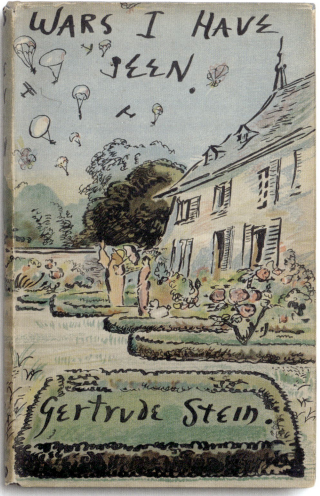

Country Moods and Tenses
Edith Olivier, 1941

Wilton had been the Anglo-Saxon capital of Wessex. Edith Olivier was born in the Rectory there, her father being its Canon. As a child she played in Wilton House and later moved with her sister to live in the Daye House on the estate. Edith became Mayor of Wilton Town Council in 1938. Cecil Beaton records in *Ashcombe* (published by Batsford in 1949, see page 75) that he and Rex Whistler were her house guests there in the spring of 1930. Penelope Middelboe records in her biography of Olivier* the author's description of Charles Fry ('a young publisher at Batsford') offering her £70 in November 1940 to write what became *Country Moods and Tenses*. The book was subtitled *A Non-Grammarian's Chapbook*, and the chapters were quirkily headed by the grammatical moods: infinitive, imperative, indicative, subjunctive and conditional. The book's jacket is by Rex Whistler, who also provided a drawing of the rural mayor in procession. Cecil Beaton provided some photographs. In his *Diaries, 1939–44***, Beaton describes Olivier as 'a woman in whom a taste for the fantastic in life and the arts are combined somehow together with a deeply religious sense and practical goodness'. He added that Whistler 'is the person she worships most in the world'.

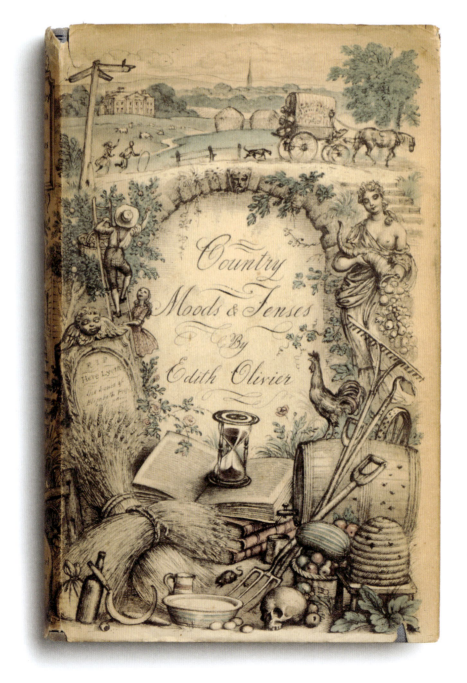

**Edith Olivier: From Her Journals, 1924–48*, Weidenfeld & Nicolson, 1989

***The Years Between: Diaries, 1939–44*, Holt, Rinehart and Winston, 1965

Night Thoughts of a Country Landlady
Edith Olivier, 1943
—

In April 1943, Edith Olivier wrote in her journal that she 'drove to Batsfords where Charles Fry lit a fire and partly dried me out before going to lunch at the Savoy. He wants to get my book out quickly and Cecil to illustrate it if Rex can't'. Whistler did take the job, and the book became Edith Olivier's wartime autobiography, published under the pseudonym Miss Emma Nightingale, reminiscing about the 'strangers within my gates' as lodgers. The reader is assured that Miss Nightingale has 'curious affinities' with the author. Batsford selected the rear jacket flap to *Night Thoughts* to review their place in the 'great apostolic succession' of English booksellers/publishers and the tradition they maintained at their new headquarters in North Audley Street, 'selling only the books they believe in and publishing only such volumes as they are proud should bear their imprint'.

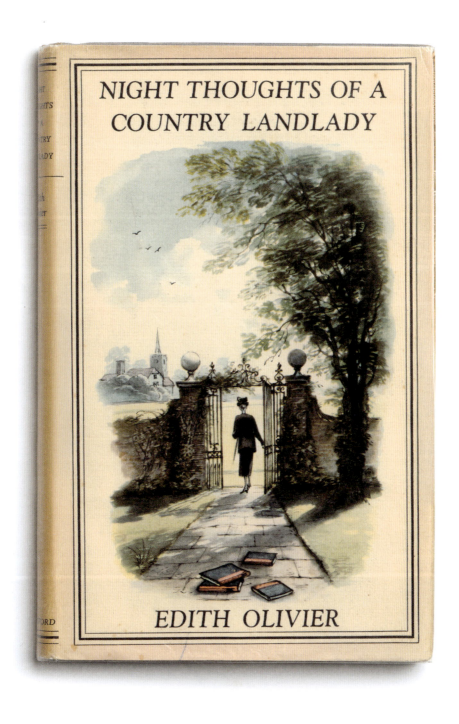

Rex Whistler: His Life and His Drawings
Laurence Whistler, 1948

—

Two Whistlers contributed to Batsford's world. The elder brother Rex drew from a young age and in his early 20s took on the murals for the Tate Gallery Restaurant, continuing with many other murals and diverse applications of his artistic talent. His first jackets for Batsford were the pair for Sacheverell Sitwell's *Conversation Pieces* and *Narrative Pictures* (see page 60) in 1936 and 1937 respectively. He joined the army in 1940 but in 1941 added the jacket for Edith Olivier's *Country Moods and Tenses* (see page 88). In 1942, he helped Batsford step into fiction with *The Last of Uptake, or The Estranged Sisters* by Simon Harcourt-Smith, an architectural fantasy set in a nobleman's mansion, illustrated by Whistler with two colour and ten monochrome illustrations. The same year, he did jackets for H J Massingham's *The English Countryman* (see page 62) and in 1943 for Bolitho's *A Batsford Century* (see page 9) and Olivier's *Night Thoughts of a Country Landlady* (see page 89). He died in action at Caen in July 1944.

His younger brother Laurence took up engraving and poetry, engraving a casket for HM The Queen Mother and a goblet for HRH Princess Elizabeth. He was honoured successively with an OBE, CBE and finally Knight Bachelor in 1988. In 1950, Cecil Beaton, James Laver and Laurence Whistler wrote appreciations of Rex in three combined volumes of *The Masque* containing colour plates and monochrome illustrations of Rex's theatrical designs, published by Batsford for the Curtain Press. Laurence completed the major monograph *The Imagination of Vanbrugh* in 1954 (below, right), which examines the art of Vanbrugh and some of his contemporaries, chiefly Hawksmoor. The jacket is by the author. Laurence also collaborated with Rex's friend Ronald Fuller on *The Work of Rex Whistler* in 1960 (below, left). The jacket is from *Gulliver's Travels*, illustrated by the artist.

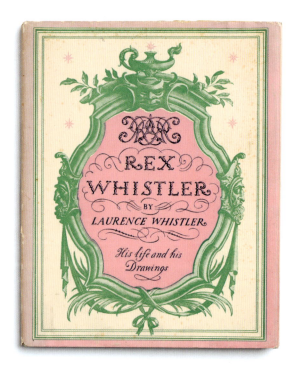

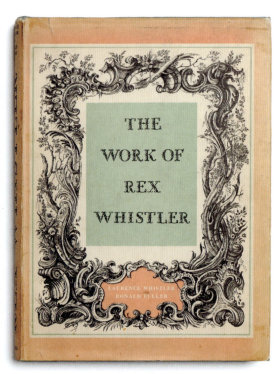

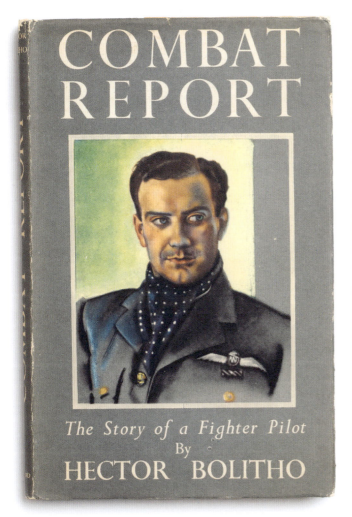

Combat Report
Hector Bolitho, 1943

Five Graves at Nijmegen
Eric Baume, 1945

—

The cover was by John Nash, the younger brother of Paul Nash. He was a painter and illustrator especially of botanical and landscape work, who was closely connected to Dora Carrington.

Christina Hole

English Folklore
Christina Hole, 1940

—

This was Christina Hole's first book for Batsford, in which she sought to put on record the wealth of traditional English folklore material that had been neglected or subordinated to that of Celtic neighbours. The jacket depicting the harvest was by Lynton Lamb, from an old print. In 1974 he was appointed a Royal Designer for Industry, for books and illustration.

English Folk Heroes
Christina Hole, 1948

—

Following her works on witchcraft, folklore and customs, in this book the author records popular legends, relating them to the facts of the heroes as known. The jacket, colour frontispiece and internal woodcuts are by Eric King.

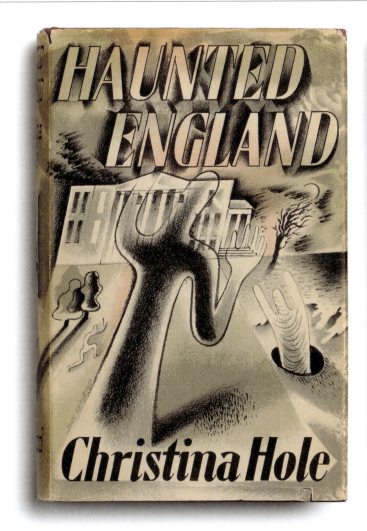

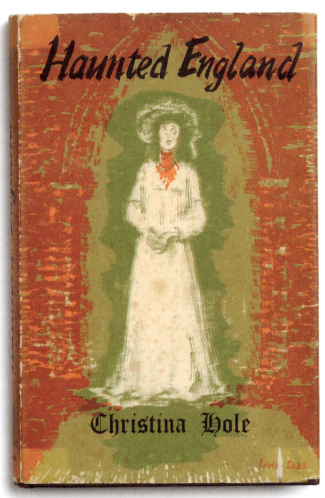

Haunted England
Christina Hole, 1940

—

In this book, the author gathers a few of the stories of the diversified ghost-lore of England. The jacket and illustrations are by John Farleigh.

Haunted England (second edition)
Christina Hole, 1951

—

An amended version for the next generation, with a different jacket by Lynton Lamb.

Christina Hole

Witchcraft in England
Christina Hole, 1945
—
This was the first concise survey of the subject, with the striking jacket and illustrations by Mervyn Peake.

Witchcraft in England
Christina Hole, 1947
—
This version of the book was for the US market, with a jacket by American graphic designer Milton Glaser.

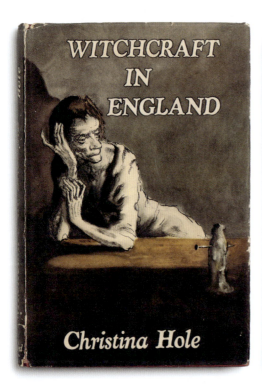

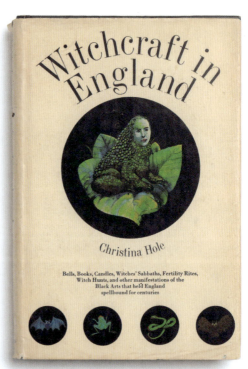

Witchcraft in England
Christina Hole, 1977
—
A further amended version, with a different jacket. The jacket and other illustrations were again by Mervyn Peake.

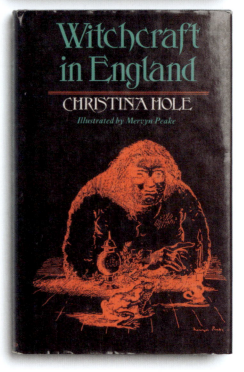

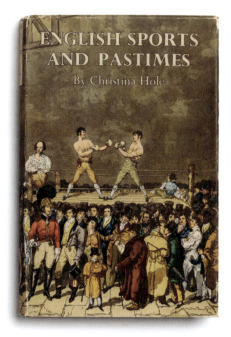
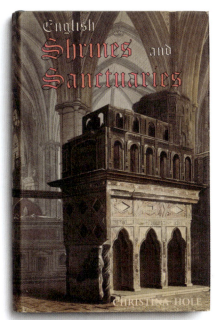

English Sports and Pastimes
Christina Hole, 1949

—

Here the author recorded English social history not about kings, soldiers and politicians but about the lives of ordinary men and women. The jacket is from an early 19th century print by Messrs Fores of New Bond Street.

English Shrines and Sanctuaries
Christina Hole, 1954

—

The jacket shows the shrine of Edward the Confessor. The illustration was reproduced from an aquatint by Pugin for Ackermann's *Westminster Abbey*. Wood engravings throughout were by Eric King.

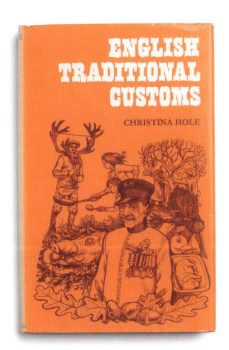

English Traditional Customs
Christina Hole, 1990

—

A re-written version of this book, first published in 1975. The jacket was by Gay John Galsworthy.

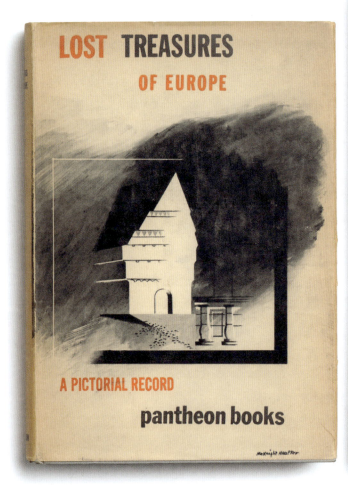
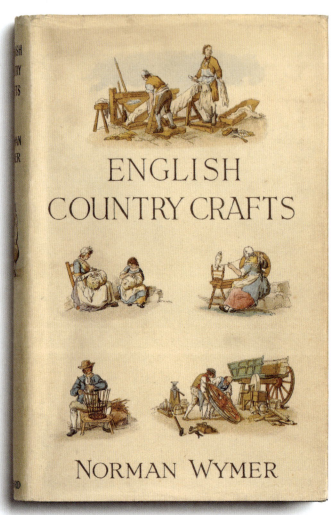

Lost Treasures of Europe: A Pictorial Record
edited by Henry La Farge, 1946

—

A comprehensive survey of the cultural monuments of Europe destroyed in WWII, with 427 photographs. The jacket is by Edward McKnight Kauffer.

English Country Crafts
Norman Wymer, 1946

—

The author collected material for this by visiting craftsmen across England to study their work and checking his draft manuscript with them for accuracy. The reader meets weavers, wheelwrights, charcoal-burners, rush-workers, boat-builders and hoop-makers, among others.

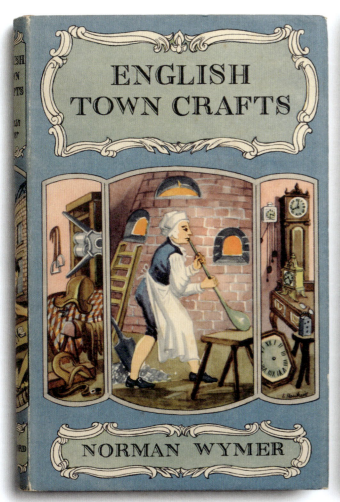
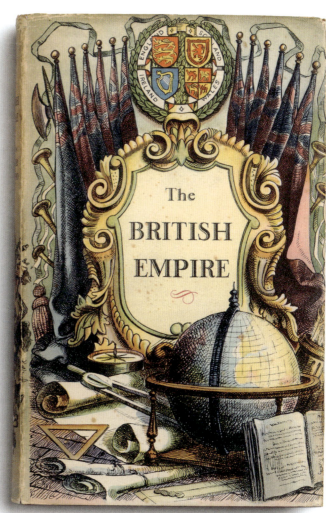

English Town Crafts
Norman Wymer, 1949

—

A later companion to the 1946 *English Country Crafts*, covering the range of craftsmen serving the church, domestic and sport sectors, and cordwainers, musical instrument makers, bookbinders, paper makers and shipwrights. The jacket is by Yorkshire artist Irene Beatrice Hawkins.

The British Empire
edited by Hector Bolitho, 1947–48

—

A collection of essays on the countries of the Commonwealth, India and the Empire. Planned towards the end of the war, the original text was revised to include developments up to the early months of 1947, though changes in the government of India took place after the book had gone to press. The jacket is by John Berry.

Henry Yevele: The Life of an English Architect (second edition)
John Hooper Harvey, 1946
—
The jacket was the author's own design, as were his other jackets (see pages 103 and 117).

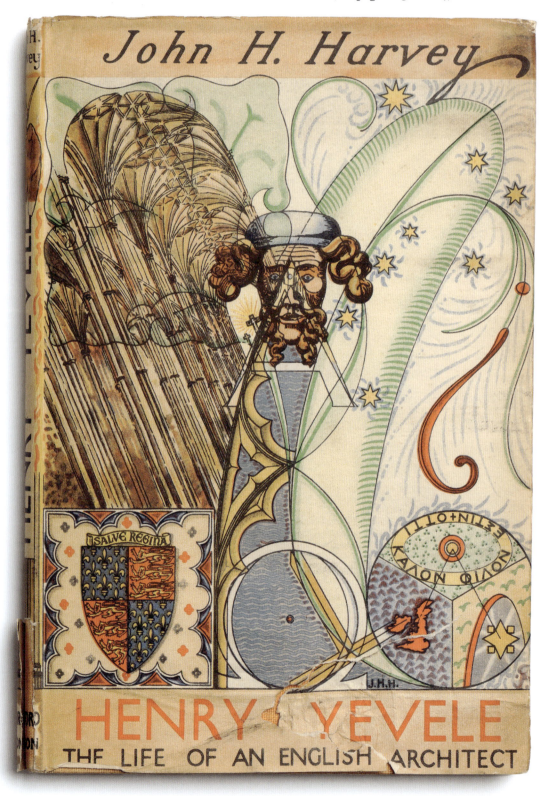

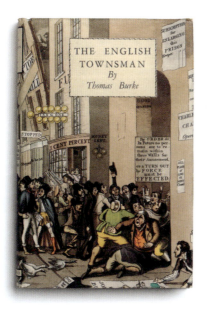

The English Townsman (second edition)
Thomas Burke, 1947

Sea-Shore Life of Britain
Leonard Robert Brightwell, 1947

—

The author was a painter and illustrator, who also did the jacket illustration.

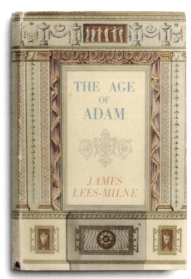

Men of Taste
Martin Briggs, 1947

—

Published with the intention of tracing the influence of 'men of taste' upon the development of art and the lives of working artists. The jacket was by graphic designer Felix Kelly.

The Age of Adam
James Lees-Milne, 1947

—

Recognising the loose usage of 'Adam Style', the author sets out to show the work of Robert Adam and his three brothers. Architectural historian Lees-Milne had already written *The National Trust* for Batsford in 1946, and would go on to do *Tudor Renaissance* (1951), *The Age of Inigo Jones* (1953), *Baroque in Italy* (1959), *Renaissance Europe* (1961), and *Baroque Europe* (1962).

Local Style in English Architecture
Thomas Dinham Atkinson, 1947
—
In tackling local variation in architecture, the author quotes Sir Christopher Wren in following the precept of planting 'crabstocks for posterity to graft on'. The jacket is by watercolourist Stanley Roy Badmin.

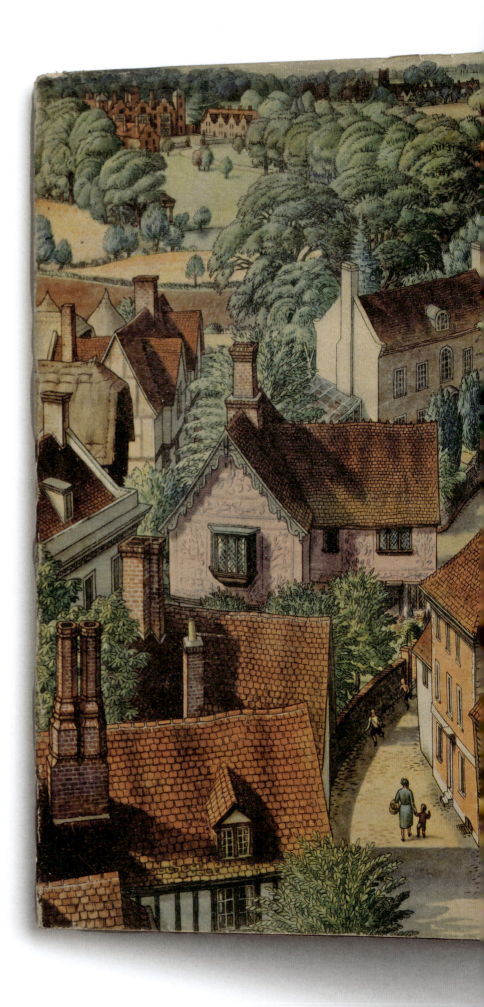

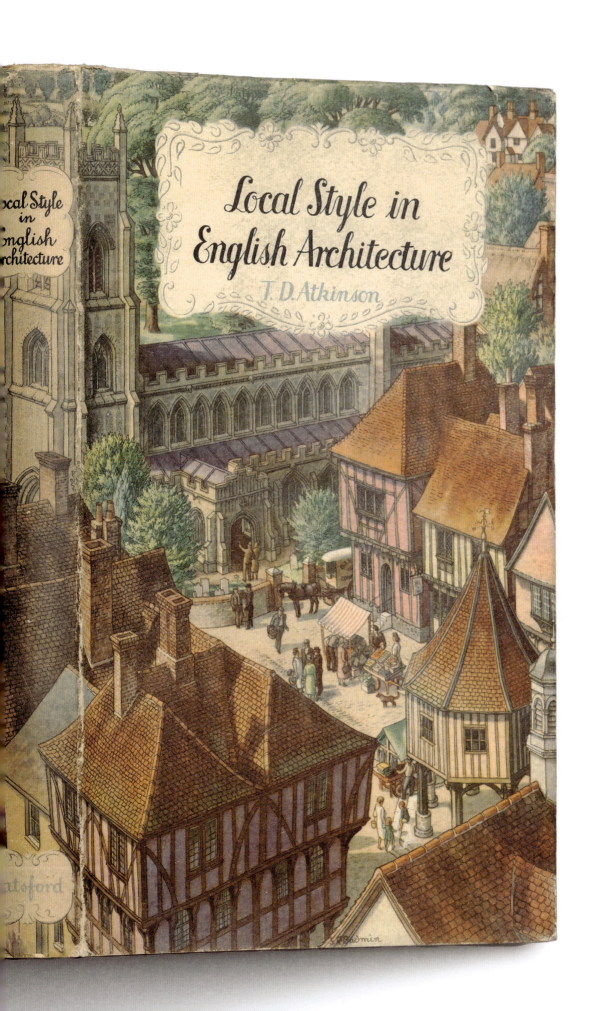

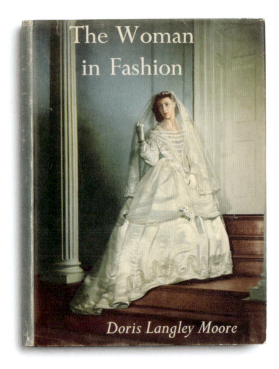
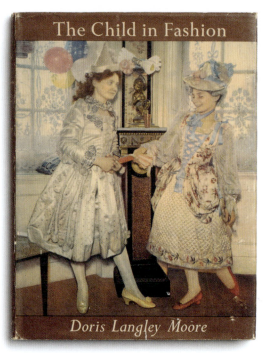

The Woman in Fashion
Doris Langley Moore, 1949

—

An authority on the history and psychology of dress, the author had a large private collection. The jacket was reproduced from a photograph by Felix Fonteyn, brother of the ballet dancer Margot Fonteyn. The photograph is from 1867 and shows American ballerina Miss Rosella Hightower wearing a wedding dress. Fonteyn's photographs are throughout the book.

The Child in Fashion
Doris Langley Moore, 1953

—

The jacket shows Miss Carole Lorimer and Miss Judy Harris in fancy dresses *Folly* and *China Shepherdess* of c.1890. The photographs in the book are by Felix Fonteyn.

Corsets and Crinolines
Norah Waugh, 1954

—

Originally studying the history of costume, the author taught costume work, joined the Ministry of Information in WWII and worked in the Press Department of the Embassy at Moscow, before returning to research at the Central School of Arts and Crafts in London. The book traces the evolution of the fashion silhouette.

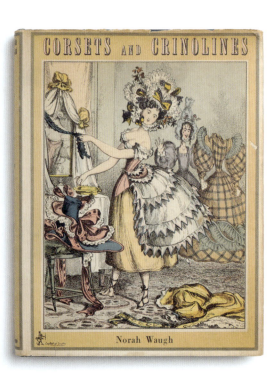

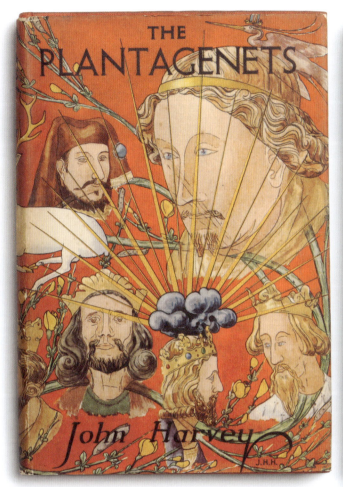 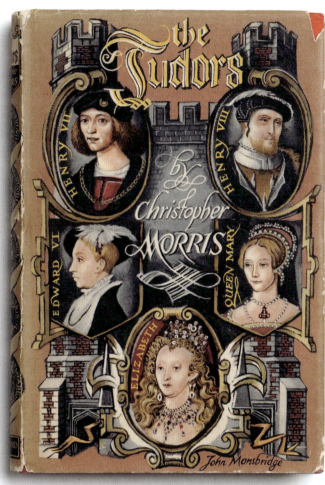

The Plantagenets
John Harvey, 1948

—

The book concentrates on the biography rather than the history of the Plantagenet rulers, illustrated with portraits. The jacket is the author's own.

The Tudors
Christopher Morris, 1955

—

Then Director of Studies in History at King's College Cambridge, the author focused in this account on the personalities of the Tudor monarchs, with contemporary portraits. The jacket is by John Mansbridge, a WWII artist who became Head of Fine Art at Goldsmiths.

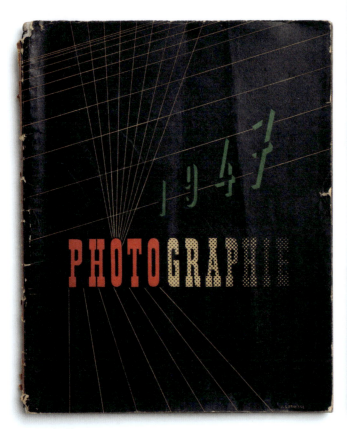
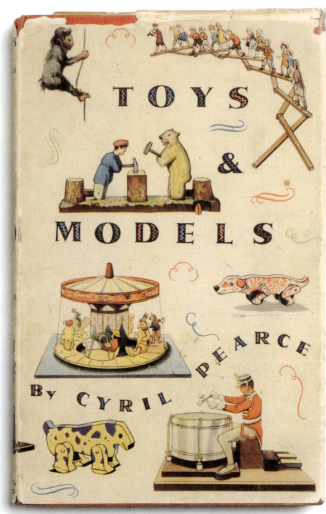

Photographie 1947
Pierre Scize (pseudonym), 1947
—
Published with French publisher Editions Arts et Métiers Graphiques. The book contains 115 black and white post-war photographs, as well as a few in colour, by leading international photographers.

Toys & Models
Cyril Pearce, 1947–48
—
The author taught art at the University of Reading. His book was intended for use at home as well as in schools and welfare centres. It followed the much earlier Batsford English version of Karl Gröber's *Children's Toys of Bygone Days* in 1928. Eight plates are in colour and the jacket is drawn from them.

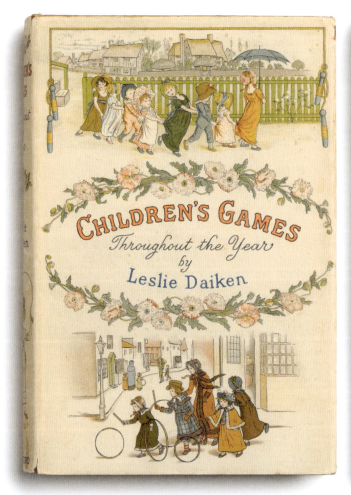 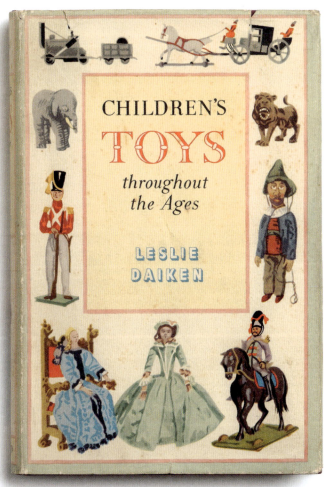

Children's Games Throughout the Year
Leslie Daiken, 1949

—

A broadcaster in the subject, the author undertakes a scholarly study of this aspect of folk history. The jacket is from illustrations by Kate Greenaway.

Children's Toys Throughout the Ages
Leslie Daiken, 1953

—

This follows *Children's Games*, completing the author's studies of children at play. The jacket was by Brian Cook.

Sport

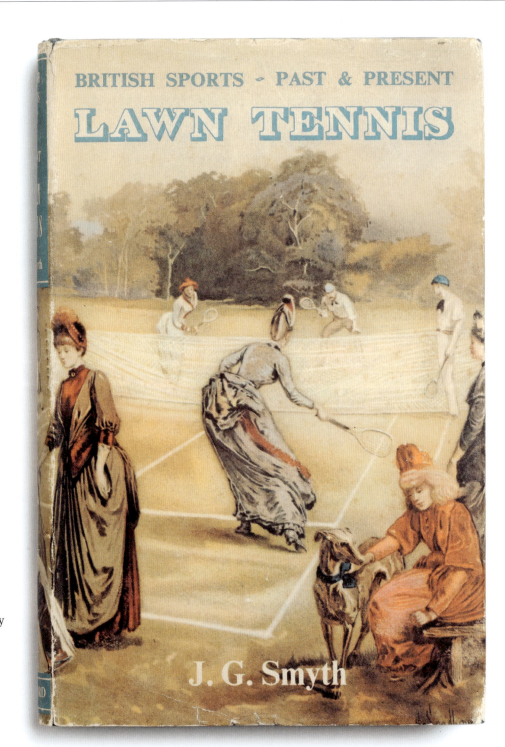

Lawn Tennis
J G Smyth, 1953
—
The jacket is from a painting by Henry Sandham.

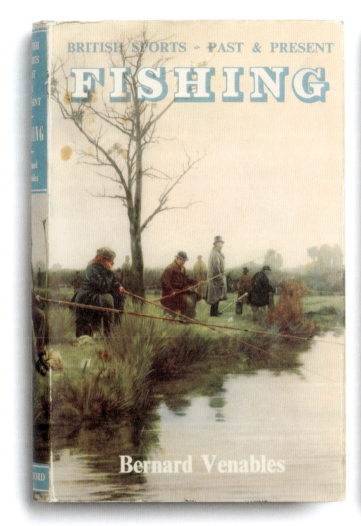

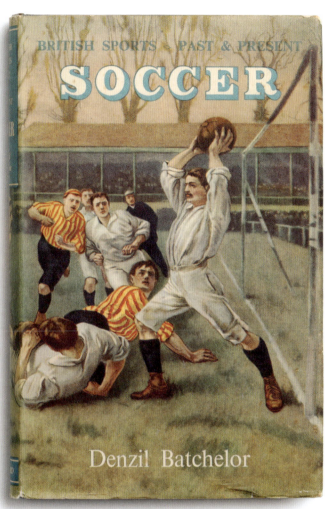

Fishing
Bernard Venables, 1953

—

The jacket *A Pegged Down Fishing Match* was by Dendy Sadler (1884).

Soccer
Denzil Batchelor, 1954

—

The jacket was reproduced from a painting by W H Overrend (1890).

Sport

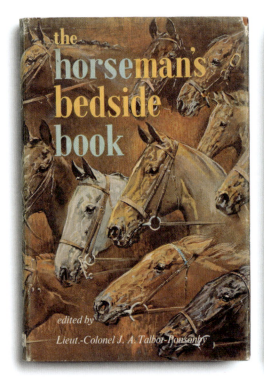

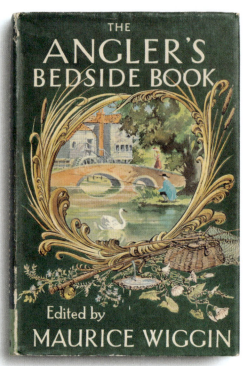

The Horseman's Bedside Book
edited by J A Talbot-Ponsonby, 1964
—
The jacket is by Joan Wanklyn.

The Angler's Bedside Book
edited by Maurice Wiggin, 1965
—
The jacket is by Will Nickless.

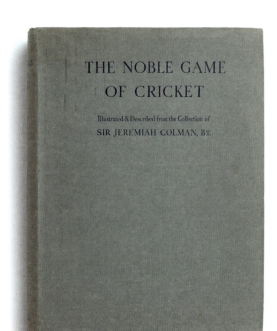

The Noble Game of Cricket
Sir Jeremiah Colman, 1941
—
The book is illustrated with pictures, drawings and prints from Sir Jeremiah's collection. The pictures were reproduced during wartime, in order that 'whatever may happen' they could be permanently available to cricket lovers. Many of the 100 plates were in colour. This edition was limited to 150 copies, of which 50 were reserved for the collector.

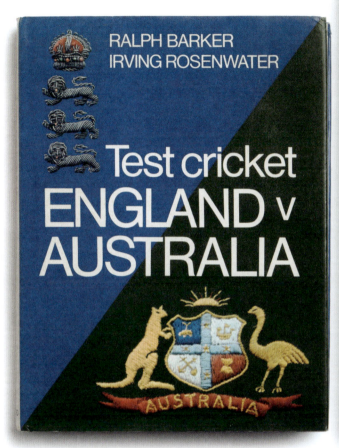
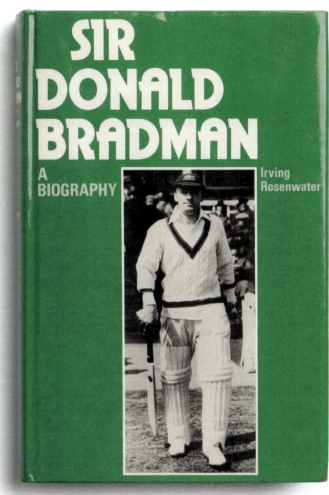

Test Cricket: England v Australia
Ralph Barker and Irving Rosenwater, 1969

—

This book celebrates the 200th Test Match between the two countries, played at Lord's in June 1968. Barker became a writer after retiring from the RAF, focusing on flying and cricket. He analysed the 203 matches played between 1877 and 1968, Rosenwater supplementing the work with statistics. The jacket design shows the English blazer badge and the Australian cap badge, and was reproduced by permission of the MCC.

Sir Donald Bradman: A Biography
Irving Rosenwater, 1978

—

The author had written for *The Cricketer* since 1955 and edited *Wisden* in the 1960s. He returned to Batsford to contribute this biography of the legendary Sir Donald Bradman. The jacket shows Bradman as Captain of the 1938 Australians at Worcester, where he scored 258.

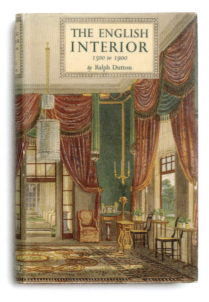
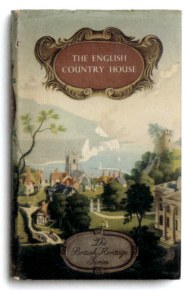

The English Interior: 1500 to 1900
Ralph Dutton, 1948

—

This completed Dutton's trilogy, alongside *The English Garden* and *The English Country House*. The jacket shows the Green Pavilion at Frogmore House, from a plate in W H Pyne's 1819 *History of Royal Residences*.

The English Country House (revised third edition)
Ralph Dutton, 1949

—

The jacket design was by Philip Gough and was used in the British Heritage series, the Brian Cook design having been used in the original edition (see page 168).

A Wiltshire Home: A Study of Little Durnford
Dorothy Devenish, 1948

—

A biographical account of the author's home and childhood, introduced by Edith Olivier. The jacket was reproduced from a watercolour by George Shepherd in the Bodleian.

A Full Life in the Country
Keith Jeremiah, 1949

—

This was the Sudbury and District Survey and Plan, prepared for their Planning Association and shown to the public in 1946 in an exhibition in the Town Hall. The jacket was by R Tilbrook.

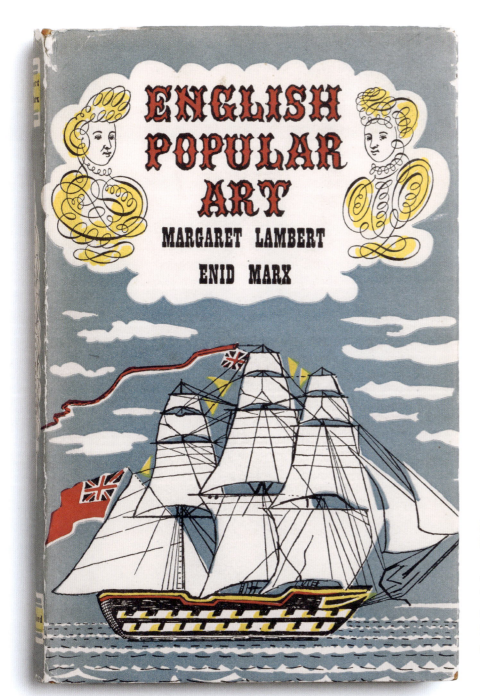

English Popular Art
Margaret Lambert and Enid Marx, 1951

—

This book studies the variety, origins and survival of popular art in England. The jacket and illustrations are by Enid Marx.

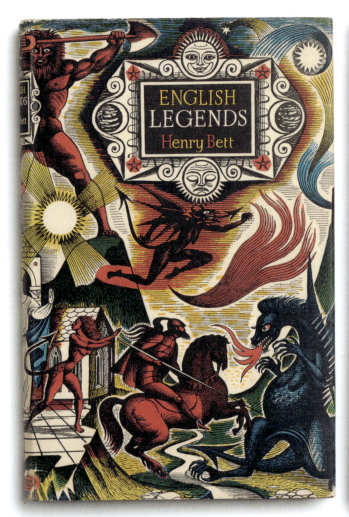 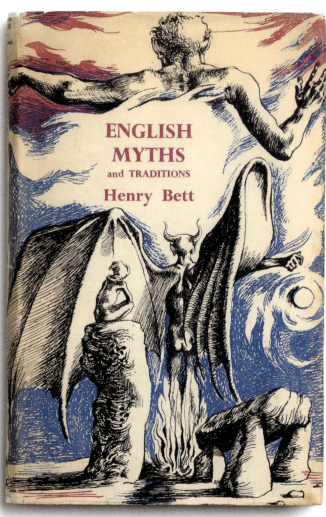

English Legends
Henry Bett, 1950

—

Illustrated by Eric Fraser.

English Myths and Traditions
Henry Bett, 1952

—

The sequel to *English Legends*. The jacket was by Michael Ayrton.

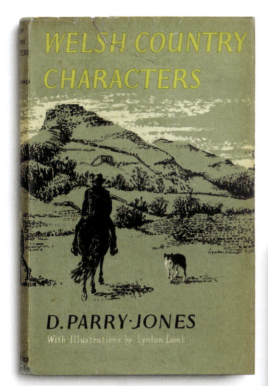

Welsh Country Characters
Rev Daniel Parry-Jones, 1952
—
This was a sequel to Parry-Jones' earlier *Welsh Country Upbringing* of 1949. The book was designed by Lynton Lamb, who also did the jacket and illustrations.

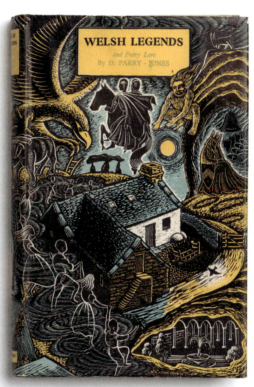

Welsh Legends
Rev Daniel Parry-Jones, 1953

Welsh Country Characters
Rev Daniel Parry-Jones, 1952
—
In the same year as the other edition, the book was sold with a different jacket replacing the original, of which supplies had been exhausted.

London: Work and Play
Harry Batsford, 1950
—
Harry Batsford introduced these two volumes of monochrome photographs, designed then as pictorial guides for visitors, with Brian Cook jackets.

London: Historic Buildings
Harry Batsford, 1950

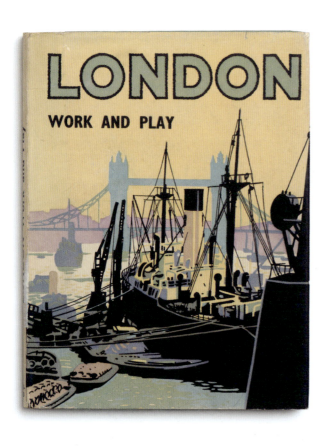

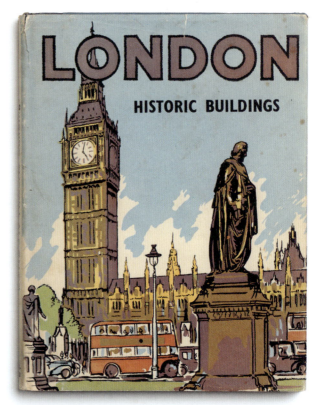

The Thames from Mouth to Source
Lionel Thomas Caswell (Tom) Rolt, 1951
—
The author was originally a locomotive apprentice, before moving into vintage sports cars and canal boating, working for Rolls-Royce on the Merlin engine, and later becoming Secretary of the Inland Waterways Association. Engaging in writing post-war, he tackled biographies on Brunel, Stephenson and Telford before this Festival of Britain-period book for Batsford, illustrated with reproductions from old watercolours and aquatints. The jacket was by Robert Havell, depicting Abingdon in 1811. Rolt returned to Batsford with rather different works in *James Watt*, part of the Makers of Britain series (1962) and *Tools for the Job: A Short History of Machine Tools* in 1965 (the latter appeared in a Japanese translation).

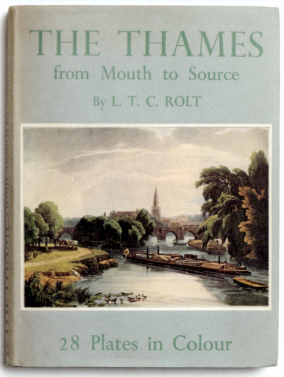

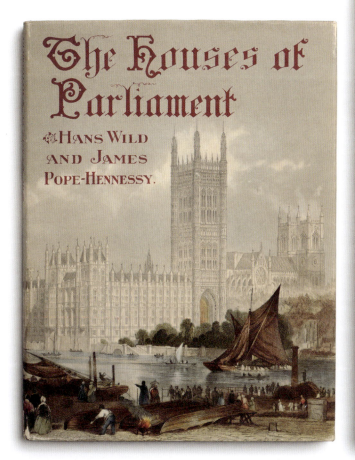 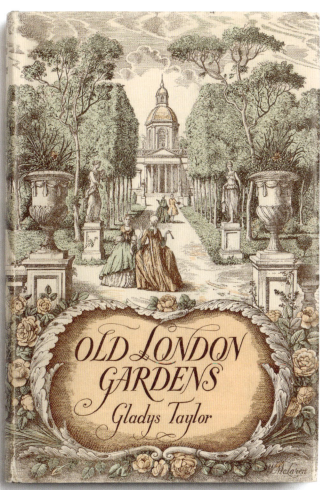

The Houses of Parliament (revised edition)
Hans Wild and James Pope-Hennessy, 1953
—

A revised edition of the original collection, originally published in 1945. This is the collection of professional photographer Hans Wild, whose work specialised in WWII, portraits and London. This edition includes an extended accompanying essay by Pope-Hennessy.

Old London Gardens
Gladys Taylor, 1953
—

The jacket was by William McLaren, based on a print of the garden at Chiswick House.

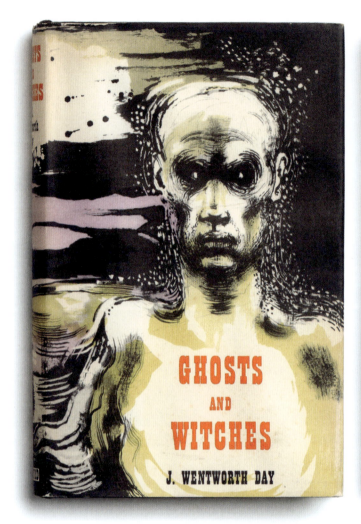 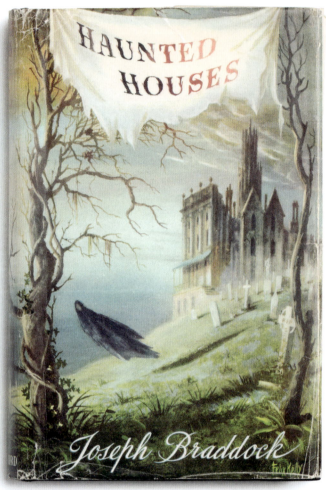

Ghosts and Witches
James Wentworth Day, 1954
—

The writer had also written *Norwich and the Broads* in 1953. The jacket and illustrations, including chapter headpieces, were by Michael Ayrton, an artist and writer.

Haunted Houses
Joseph Braddock, 1956
—

The author was a student of psychical research and a poet. The jacket and illustrations are by Felix Kelly.

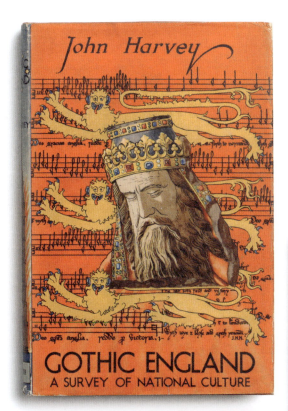

Gothic England: A Survey of National Culture
John Harvey, 1947

—

The author was the foremost authority on Perpendicular architecture. The jacket was his own.

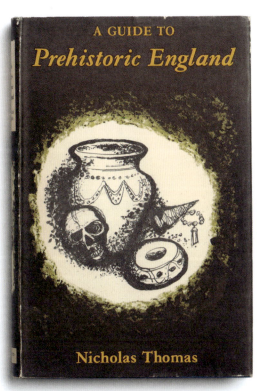

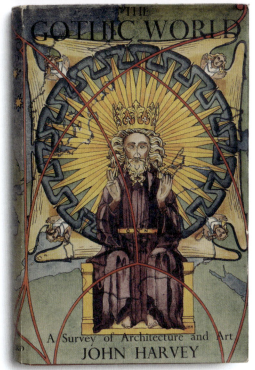

A Guide to Prehistoric England
Nicholas Thomas, 1960

—

The author was Assistant Keeper in the Department of Archaeology at the City Museum and Art Gallery, Birmingham. The jacket was by John Piper.

The Gothic World: A Survey of Architecture and Art
John Harvey, 1950

—

At the time, this was the most complete account of later Gothic art. The jacket was the author's own.

Herbert L Edlin

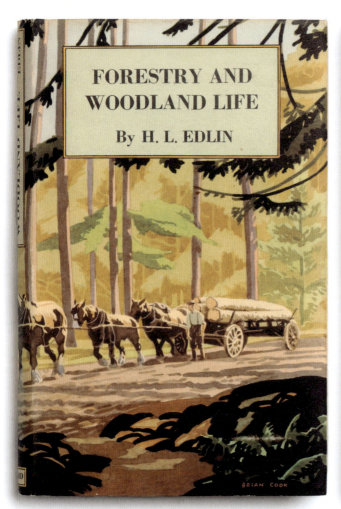

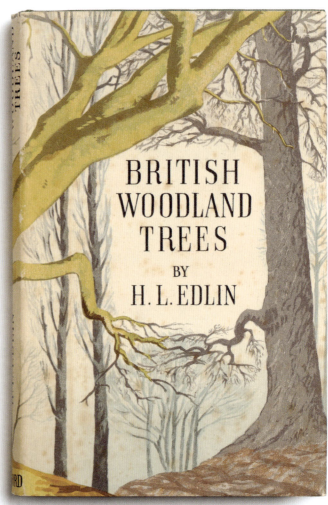

Forestry and Woodland Life
Herbert L Edlin, 1947

—

The author wrote widely on forestry. The jacket was by Brian Cook.

British Woodland Trees (third edition)
Herbert L Edlin, 1949

—

The first edition was the initial work of the author on woodland life. The jacket was by Brian Cook.

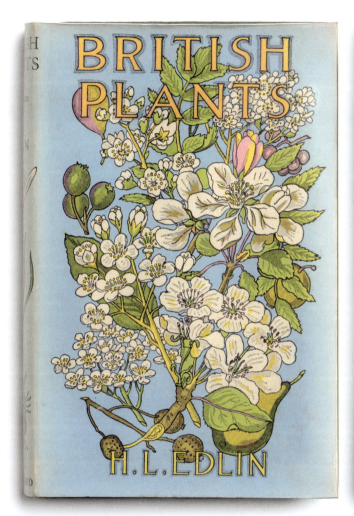

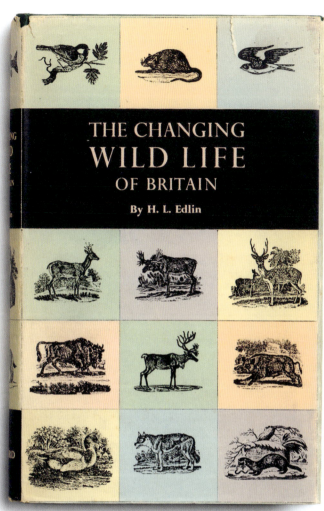

British Plants
Herbert L Edlin, 1951

—

The author breaks the convention of division between wild and cultivated plants and between native and introduced kinds, reviewing the subject from the human angle.

The Changing Wild Life of Britain
Herbert L Edlin, 1952

—

This book contains numerous illustrations, including woodcuts by Thomas Bewick, such as those shown on the jacket.

Seaside England
Ruth Manning-Sanders, 1951
—

The author was a prolific writer of children's books. This and Batsford's *The West of England* (1949) were among her few non-fiction works. The jacket here was from a print of Scarborough in 1878 by Randolph Caldecott.

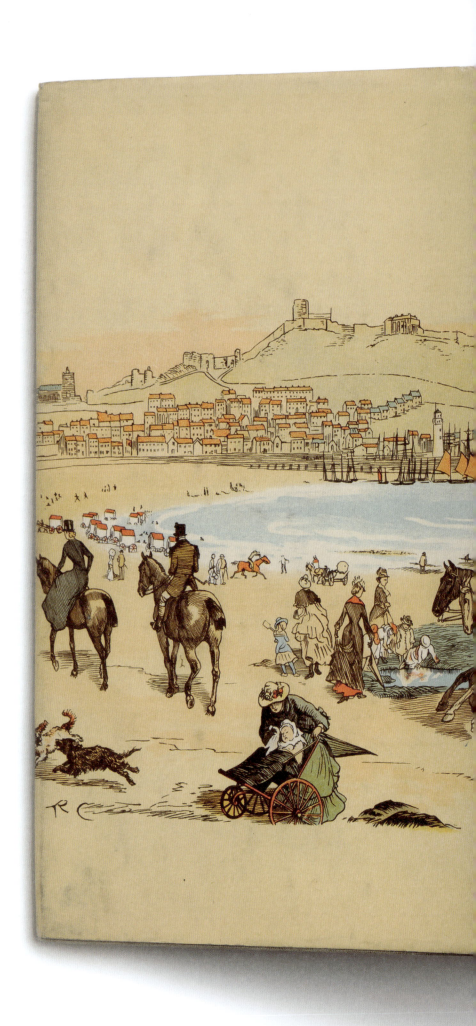

SEASIDE ENGLAND

By Ruth Manning-Sanders

Early Medieval Illumination
Hanns Swarzenski, 1951

—

This book comprises 21 fine colour plates and an introduction. This was one of the Iris Colour Books series of around a dozen such volumes in the late 1940s to early 50s, edited by Dr Hans Zbinden and printed in Switzerland.

Gothic Europe
edited by Harald Busch and Bernd Lohse, 1959

—

One of a series of Batsford books on the buildings of Europe, produced and printed in Germany.

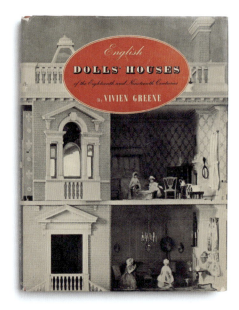

Hand Coloured Fashion Plates 1770 to 1899
Vyvyan Holland, 1955

—

Son of Oscar Wilde, Holland was mentioned in despatches in WWI and then embarked on a literary career.

English Dolls' Houses of the Eighteenth and Nineteenth Centuries
Vivien Greene, 1955

—

The author had a large collection of old English dolls' houses and was an authority on the subject and President of the Dolls' Club of Great Britain.

Masterpieces of English Furniture and Clocks
Richard Wemyss Symonds, 1940

—

This edition, which had an unusual plain paper jacket, was limited to 750 copies for Great Britain and 500 for the US.

Thomas Tompion: His Life and Work
Richard Wemyss Symonds, 1951

—

The blurb for this comprehensive monograph describes Tompion as England's greatest watch- and clock-maker. The jacket reproduces the first colour plate of Tompion's repeating clock with *grande sonnerie* striking of *c.* 1680.

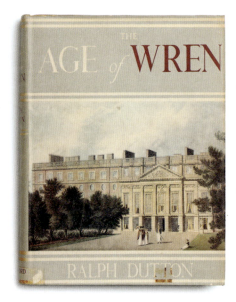

The Age of Wren
Ralph Dutton, 1951

—

The jacket illustration of Hampton Court Palace is from Pyne's *Royal Residences* (1819).

The Age of Inigo Jones
James Lees-Milne, 1953

—

The author describes this as a reference book, to collate articles published since Gotch's work on the subject in 1928. He also wrote for Batsford *Age of Adam* in 1947 and *Tudor Renaissance* in 1951.

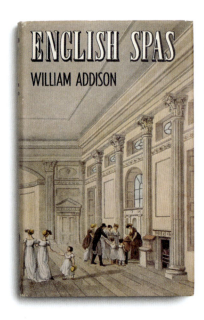
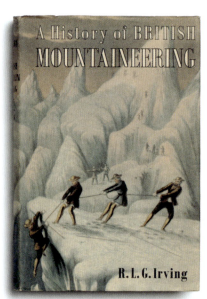

English Spas
William Addison, 1951

—

This jacket is reproduced from an aquatint of the Pump Room in Bath, by J C Nattes in 1805.

A History of British Mountaineering
R L G Irving, 1955

—

A teacher and mountaineer, the author charts the physical and spiritual course of British climbing over two centuries. The jacket *The Ascent of Mont Blanc: The Glacier du Tacconay* is from a lithograph by George Baxter (1856).

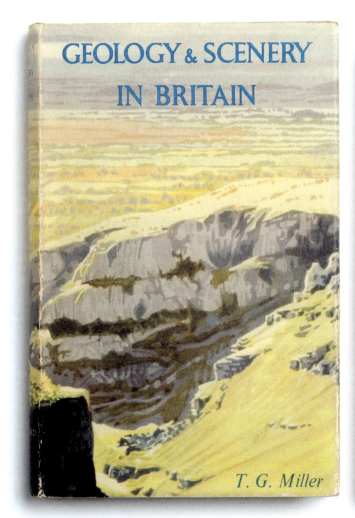
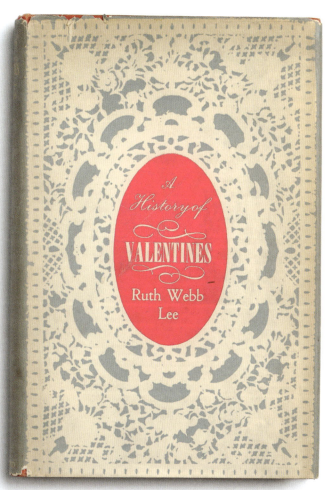

Geology and Scenery in Britain
Terence G Miller, 1953

—

The author served as a soldier in WWII, then returned to Cambridge as University Demonstrator in Geology and a Research Fellowship. The jacket was by Brian Cook.

A History of Valentines
Ruth Webb Lee, 1953

—

This was a diversion on history after the author's many years writing on American glass.

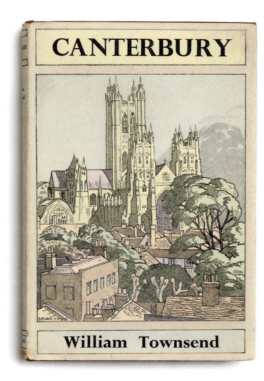
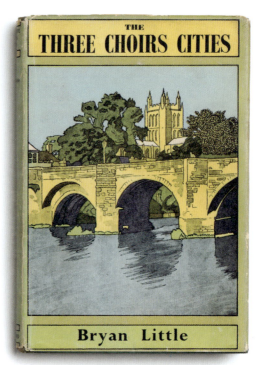

Canterbury
William Townsend, 1950

The Three Choirs Cities
Bryan Little, 1952

—

These were four of eight small format books in the British Cities series, with jackets by Brian Cook.

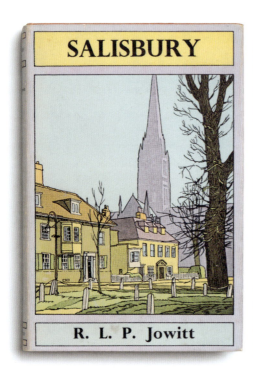
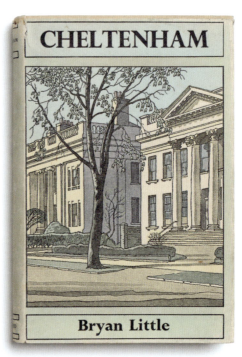

Salisbury
Robert Lionel Palgrave Jowitt, 1951

Cheltenham
Bryan Little, 1952

Dartmouth
Percy Russell, 1950
—
Aligned with the British Cities series, this book relates the home of famous sailors from Chaucer's time. The jacket is by R Tilbrook.

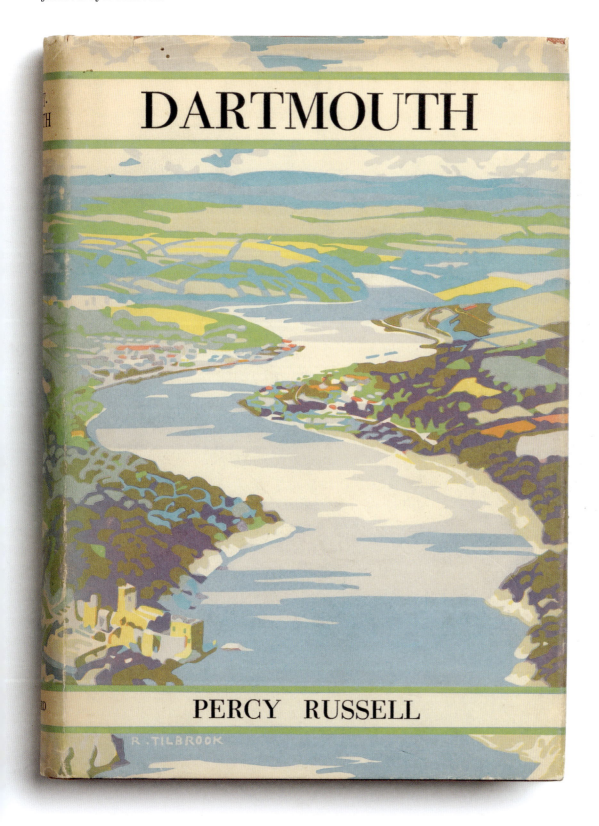

The Art of Sign Writing
Bertie Hearn, 1953

—

The author and his family were long associated with signwriting. He helped his father set up a signwriting business in 1912.

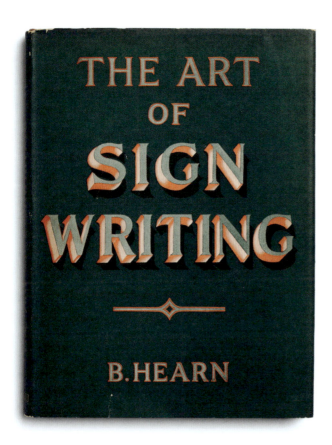

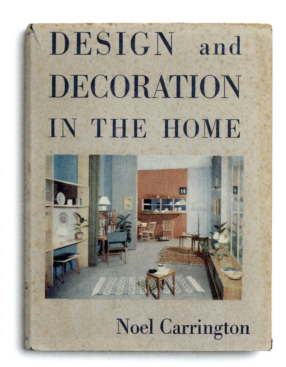

Design and Decoration in the Home
Noel Carrington, 1952

—

The first post-war survey of domestic interior design in Great Britain. The author had founded the magazine *Design for Today* in 1933.

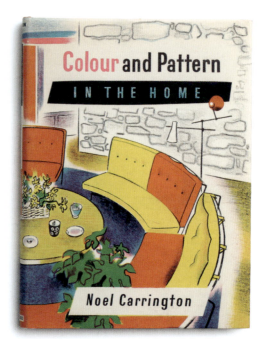

Colour and Pattern in the Home
Noel Carrington, 1954

—

A companion to *Design and Decoration in the Home*. The jacket and colour lithographs were by Roland Collins.

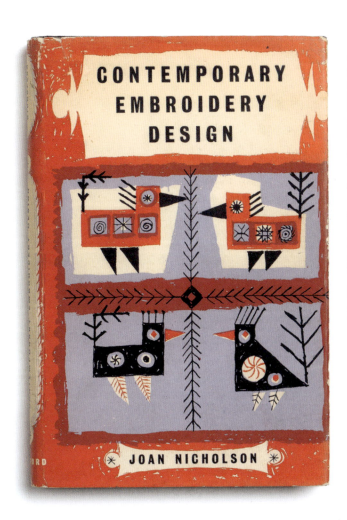 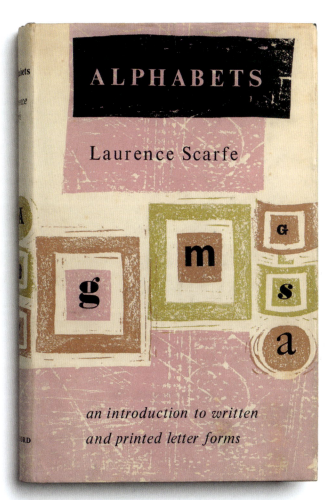

Contemporary Embroidery Design
Joan Nicholson, 1954

—

Batsford published much on embroidery in the 1950s. Maurice Wheatley, Senior Art Inspector to the London County Council, wrote in the foreword to this profusely illustrated book that this was the first book to be addressed to 'Everywoman'. Textile art remains a core Batsford subject area to this day.

Alphabets
Laurence Scarfe, 1954

—

An artist and mural decorator, the author was also a visiting teacher at the Central School of Arts and Crafts.

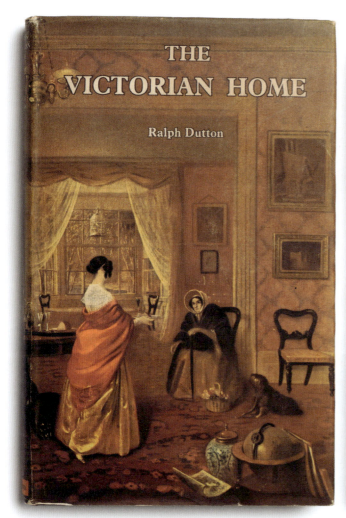
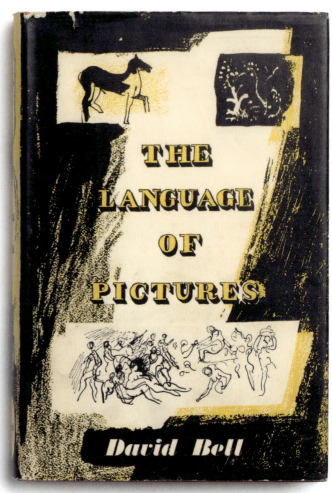

The Victorian Home
Ralph Dutton, 1954

—

The author traces the course of styles affecting homes through the reign of Queen Victoria. The jacket shows a drawing room *c.* 1840, from a painting by Dutch painter Pieter Christoffel Wonder.

The Language of Pictures
David Bell, 1953

—

The author was an artist and translator from Welsh. The jacket was by artist and stained-glass designer John Piper.

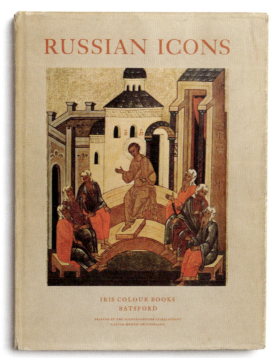

Russian Icons
Philipp Schweinfurth, 1953

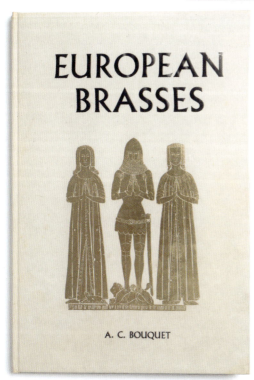

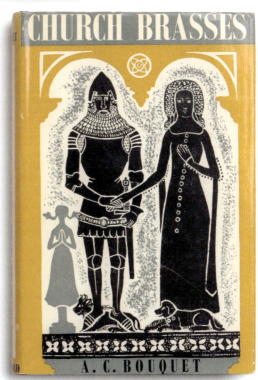

European Brasses
Alan Coates Bouquet, 1967

—

The massive size of this book (51cm × 35.5cm/21in × 14in) permitted fidelity in the monochrome photolithography of the 32 monumental brass reproductions of, in effect, facsimile quality.

Church Brasses
Alan Coates Bouquet, 1956

—

The blurb describes the author's approach as humanistic, valuing the beauty of monumental brasses and the light they throw on the costume and life of our ancestors. The jacket design by Stella Marsden shows *The Knight and his Lady* of 1380 in Chrishall, Essex.

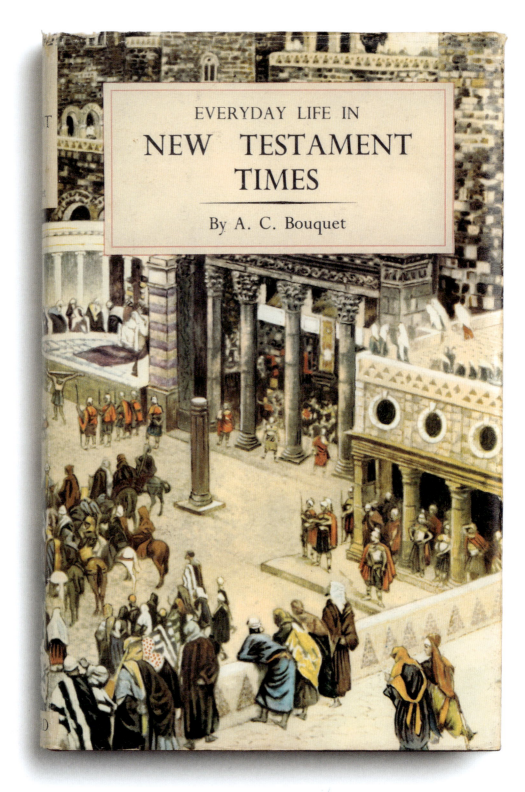

Everyday Life in New Testament Times
Alan Coates Bouquet, 1953
—
The author undertook special study of the history of religions and held lectureships at both Cambridge and Oxford. The jacket is from a reconstruction by J J Tissot of the Forum at Jerusalem. The book is illustrated by Marjorie Quennell.

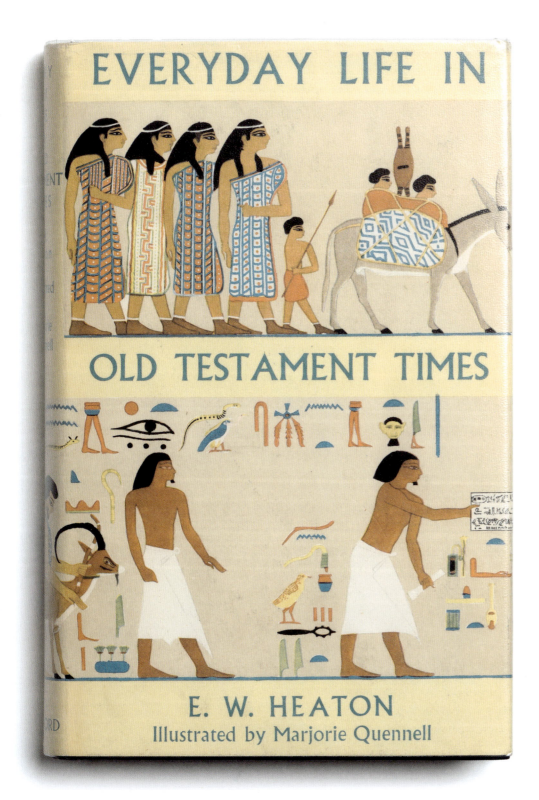

Everyday Life in Old Testament Times
E W Heaton, 1956
—

The author was Fellow Lecturer in Theology and Chaplain of St John's College Oxford. The jacket shows the appearance of the Hebrew patriarchs, from a tomb painting *c.* 1900 BC.

Wedgwood
Wolf Mankowitz, 1953
—

Widely famed later for his writing on theatre and film, the author of this fine, definitive monograph was already an authority on Wedgwood from the early 1950s. This edition of the book was limited to 1,500 copies, of which 625 were for the US.

Surrey Gardens
Eric Parker, 1954
—

The author lived at one of the houses of whose gardens he writes. Describing his aim, he wrote that 'nothing is more characteristic of the English scene than the garden that frames and beautifies the country house'. The jacket and drawings in the book are by William McLaren.

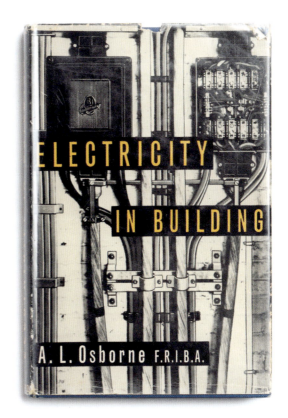

Bristol Cream
Godfrey Harrison, 1955

—

The book pays particular attention to the wine trade. The jacket is reproduced from a painting by Peter Monamy.

Electricity in Building
Arthur Leslie Osborne, 1957

—

The author, an architect, introduced this subject for readers unfamiliar with it, using minimal technical terms.

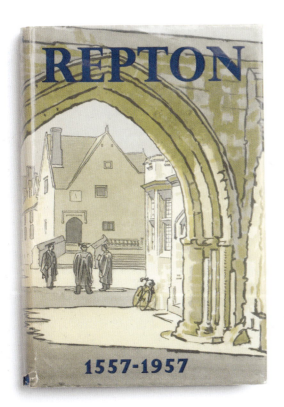

Repton 1557–1957
edited by Bernard Thomas, 1957

—

The jacket, two photographed drawings and sketches, were by old Reptonian Brian Cook. The foreword was by the Archbishop of Canterbury, Geoffrey Fisher.

English Fairs and Markets
William Addison, 1953

—

The jacket and illustrations are by Barbara Jones.

ENGLISH FAIRS and MARKETS

WILLIAM ADDISON

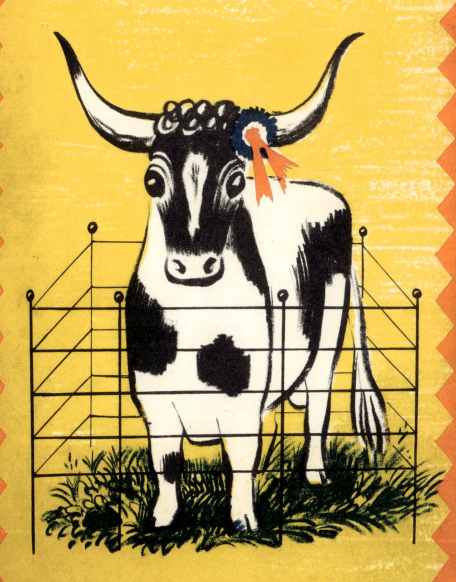

English Children's Books
Percy Muir, 1954 and 1975
—

The author was an amateur book collector turned antiquarian bookseller. He was President of the Antiquarian Booksellers' Association and later of the International League of Antiquarian Booksellers. The first edition of this book, in 1954, was dedicated as a colleague and friend to Dr Edgar S Oppenheimer of New York ('My dear Oppenheimer'), a fellow collector to whom Muir had sold most of the Bussell Collection. Muir noted that this made him the owner of by far the finest collection in existence of children's books of all nations.

Muir's book includes 107 illustrations, a few in colour, and in it he focuses on books intended for entertainment, from the 17th century to 1900. He concludes by describing the account as of the 'gradual and often reluctant realisation that children were meant to enjoy life in their own right, and to a great extent, on their own terms'.

The jackets of these two editions use the same Kate Greenaway illustration but on differing background colours and front cover decoration. The bindings are also in different colours.

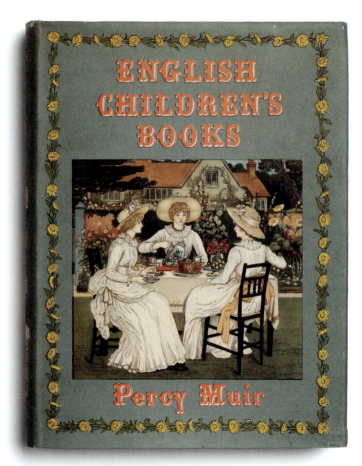

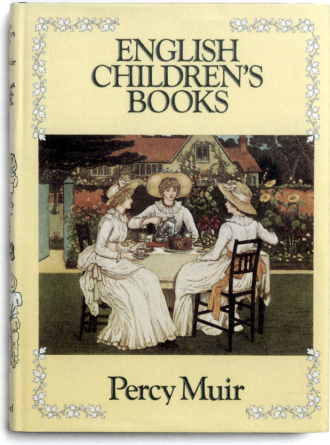

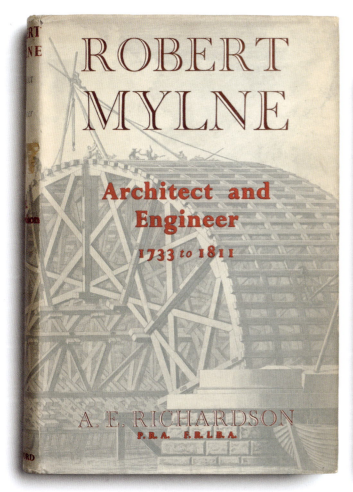 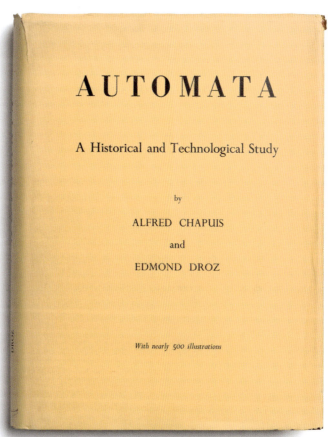

Robert Mylne: Architect and Engineer, 1733 to 1811
Sir Albert Edward Richardson, 1955

—

Professor Richardson was the fourth architect to become President of the Royal Academy. The jacket design shows Blackfriars Bridge under construction in 1764, reproduced from an engraving by Piranesi.

Automata: A Historical and Technological Study
Professors Alfred Chapuis and Edmond Droz, translated from French by Alec Reed, 1958

—

Professor Chapuis was an authority on horology and mechanical music, his collaborator was Professor at the École de Mécanique at Neuchâtel, where the book was printed together with Éditions du Griffon. Reviewing the development of thinking about automation, the authors judged that 'the most extraordinary automation will always be controlled by human thought'.

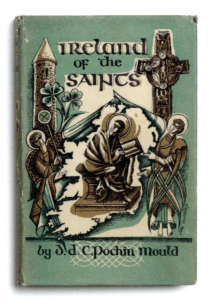
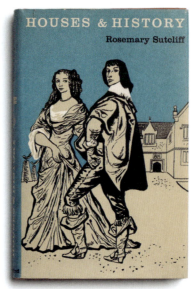

Ireland of the Saints
Daphne Desiree Charlotte Pochin Mould, 1953

—

The author was a geologist, pilot, flight instructor, mountaineer, motorist and student of the Church in Ireland. The jacket was by John Mansbridge, who was also a founding member of the Blackheath Art Society.

Houses and History
Rosemary Sutcliff, 1960

—

One of the Living History series. The author recreates events in 15 of England's great houses.

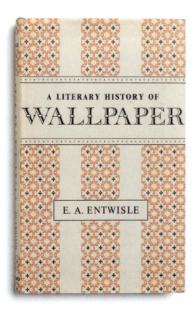

A Literary History of Wallpaper
Eric Arthur Entwisle, 1960

—

A scholar and businessman, Entwisle was director of Wallpaper Manufacturers Ltd. He read a paper on wallpaper and its history at the Royal Society of Arts on 1 February 1961.

A Literary History of Wallpaper
Eric Arthur Entwisle, 1960

—

This edition of the book had a Stephen Conway wallpaper cover.

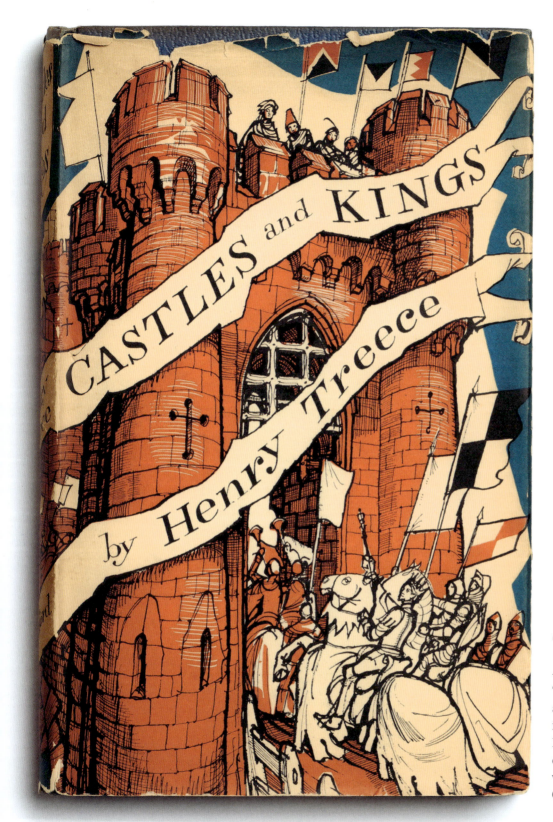

Castles and Kings
Henry Treece, 1959
—
The stories of 13 English and Welsh castles. This is illustrated by C Walter Hodges, illustrator of children's books who went on to receive the Greenaway Medal in 1964.

Autobiography

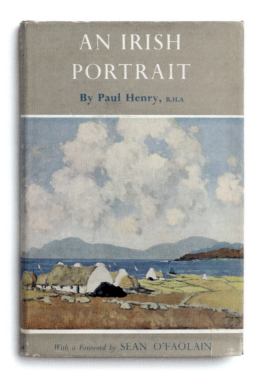

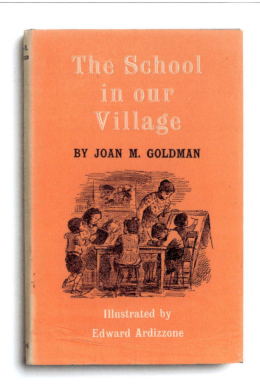

An Irish Portrait
Paul Henry, 1951

—

This autobiography of the Irish landscape painter covers his time in Paris and London but mainly in the West of Ireland, the place that dominated his art. In the foreword, writer Seán Ó Faoláin includes the author among the few painters who also wrote books, demonstrating their interest in people.

The School in our Village
Joan M Goldman, 1957

—

This is the author's record of her teaching experience in a small Cotswolds village school.

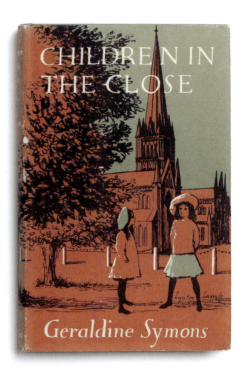

Children in the Close
Geraldine Symons, 1959

—

The author's autobiography of life in the Close of Salisbury Cathedral before and during WWI. The jacket was by Lynton Lamb.

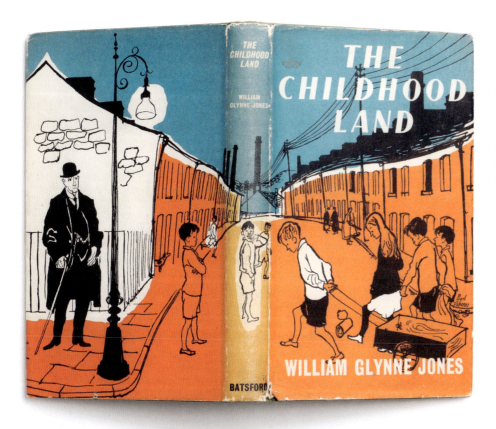

The Childhood Land
William Glynne Jones, 1960
—
The author's autobiography of his childhood in a small Welsh industrial town. The jacket was by Pearl Falconer.

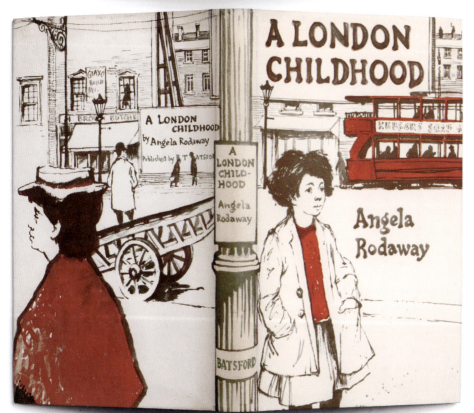

A London Childhood
Angela Rodaway, 1960
—
The author's autobiography of her childhood in London between the Wars. The jacket was by Charles Mozley.

Autobiography

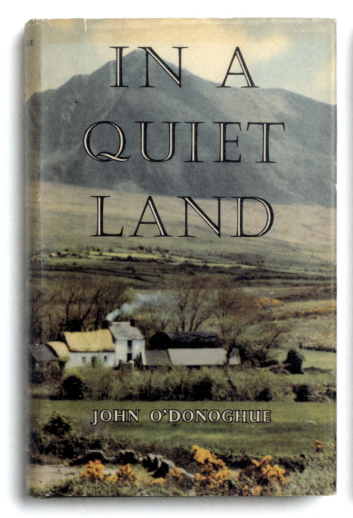

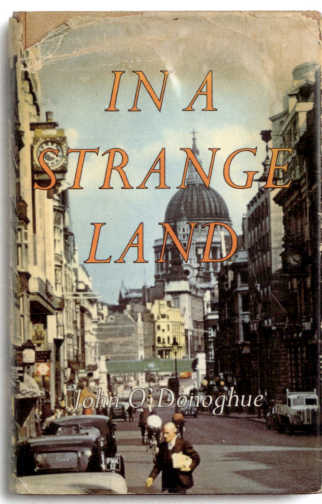

In a Quiet Land
John O'Donoghue, 1957
—
This is the author's account of life as a peasant boy in the south-west of Ireland. The jacket was from a colour photograph by J Allan Cash.

In a Strange Land
John O'Donoghue, 1958
—
The author's account of life as an immigrant, labourer and housepainter in England. The jacket was from a colour photograph of Fleet Street by James Riddell.

In Kerry Long Ago
John O'Donoghue, 1960
—
Here the author takes up the story of his youth where he left off in *In a Quiet Land*.

Military

The War of the Guns
Aubrey Wade, 1936

—

This jacket was designed by Brian Cook, using photographs from the Imperial War Museum. In his introduction, Edmund Blunden identifies the distinction of this book among the multitude of war books as being the pictures that diversify it (122 of them). The blurb refers to the need for a frank statement on war and its horrors, hoping that the book could serve to advance the cause of peace. As with many other Batsford books in that era, this book was also launched by Charles Scribner's in New York. It was a precursor to a score of Batsford books in the British Battles series of later years.

Trafalgar
Oliver Warner, 1959

—

One of the first batch of the British Battles series. The aim of the series was to show how each battle came about and its consequences. After WWII, the author joined the British Council as Deputy Director for Publications, before turning to writing some 20 books, most on maritime history. The jacket shows the scene on the deck of *Victory* in the painting by Denis Dighton at the Royal Museums, Greenwich.

Mons: The Retreat to Victory
John Terraine, 1960

—

The author, then a young military analyst, chose the subtitle to epitomise the subject of Mons, alongside Corunna and Dunkirk, as initial defeats paving the way to great feats of arms and success. The jacket is reproduced in reverse from a picture by Italian war artist Fortunino Matania.

The Battle of the Nile
Oliver Warner, 1960

—

In this book, the author follows a similar approach to that in *Trafalgar*, describing the scene and the commanders involved and the aftermath of the battle. The jacket is from a print by Robert Dodd, then held in the Parker Galleries.

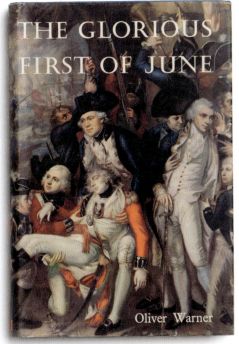

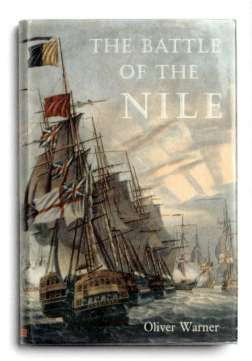

The Glorious First of June
Oliver Warner, 1961

—

In this third book for Batsford in successive years, the author focuses on this first full-scale naval battle with Revolutionary France. He includes up to then unpublished material drawn from logs at the National Maritime Museum and the British Museum. The jacket is from a painting by Mather Brown, showing the deck of *Queen Charlotte*.

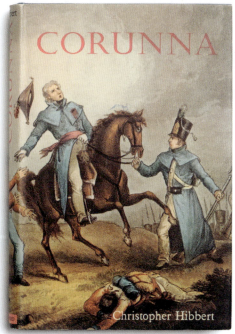

Corunna
Christopher Hibbert, 1961

—

After WWII, the author turned to a writing career with prolific output, including *The Battle of Arnhem* (1962) and *Agincourt* (1964), also for Batsford. This was the first book exclusively on Corunna. The jacket was reproduced from an aquatint by Thomas Sutherland of the death of Sir John Moore.

Military

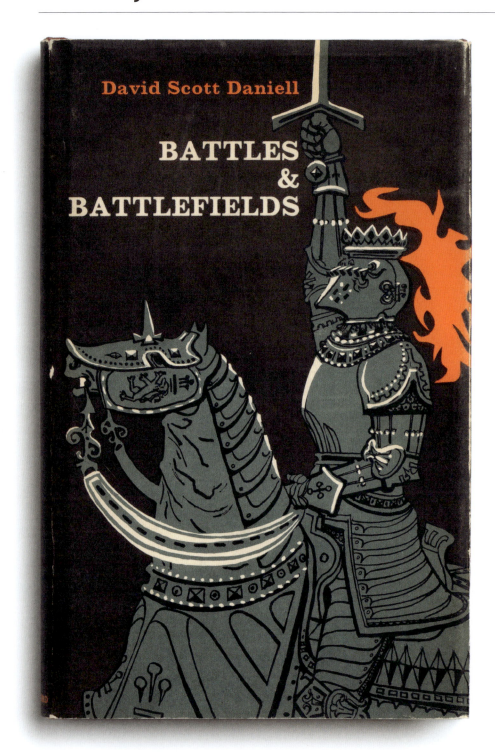

Battles and Battlefields
David Scott Daniell, 1961
—
A book in Batsford's Living History series. The author began as a novelist, but after service in WWII in the Royal Engineers he turned to non-fiction, also writing under the name Richard Bowood. The jacket was by writer and illustrator William Stobbs.

Explorers and Exploration
David Scott Daniell, 1962
—
In the same series; the jacket, drawings and maps were also by William Stobbs.

Military

The Battle of Britain
Basil Collier, 1962

—

Basil Collier MBE was a military historian who served in the RAF 1940–48 and then at the Cabinet Office. He had been appointed Air Historical Officer at Fighter Command. The jacket was from a painting by Roy Nockolds, who had also designed the jacket for *The Racing Car* in 1956 (see page 54). Nockolds was an RAF war artist, designing posters. He became Chair of the Guild of Aviation Artists in 1975. Collier dedicated the book to Lord Dowding, Sir Keith Park and Lord Beaverbrook.

Wellington's Peninsular Victories
Michael Glover, 1963

—

Preceding his work on Wellington himself, the author focuses here on the four battles at Busaco, Salamanca, Vitoria and the Nivelle in which Wellington defeated his principal opponents, basing his study on eye-witness descriptions. The jacket is from a painting by General Louis-François Lejeune at the Musée de Versailles.

 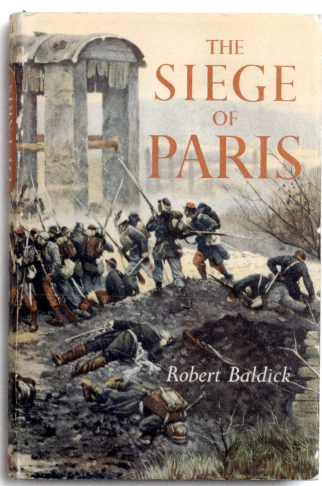

The Battle of Jutland
Geoffrey Bennett, 1964

—

The author had also written *Coronel and the Falklands* for Batsford in 1962. This account draws from previously unavailable sources, including papers left by Vice-Admiral Harper. The jacket illustration shows HMS *Lion* in action at Jutland, reproduced from a painting by maritime specialist William Lionel Wyllie.

The Siege of Paris
Robert Baldick, 1964

—

A scholar of French literature who wrote widely on his subject, the author wrote this for the Batsford series. He presents the siege through the eyes, and in the words, of diarists and participants. The jacket is reproduced from a plate in *Paris Assiégé* by Jules Claretie of *Champigny: Le four à chaux*.

Lettering
Arthur E Payne, 1921
—
The author taught for 15 years at Bath Technical School.

Lettering for Architects and Designers
Milner Gray and Ronald Armstrong, 1962
—
Both authors worked at the Design Research Unit, in the design and architectural office. Gray was a Past Master of the Faculty of Royal Designers for Industry and of the Art Workers' Guild, while Armstrong was a specialist in packaging and product design.

The Trial of Luther
James Atkinson, 1971
—
One of Batsford's series on historic trials. The author was ordained in the Church of England in 1937. He became a Luther and Reformation specialist, and was Professor of Biblical Studies at the University of Sheffield 1969–1979, then Director of the Centre for Reformation Studies there 1983–2006. The jacket was by Yvonne Dedman.

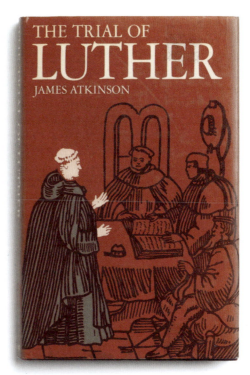

The Art of Papercraft
Hiroshi Ogawa, 1971
—
Illustrated by 110 photographs, this book demonstrates the varying forms of art made with paper, from kites and origami, to the *shōji* screens of room separation.

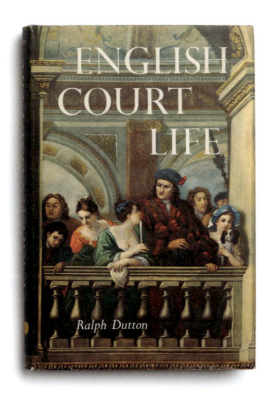

English Court Life
Ralph Dutton, 1963
—
The author's survey covers the three centuries from Henry VII to George II. The jacket is reproduced from William Kent's painting of Kensington Palace, showing members of the court of George I.

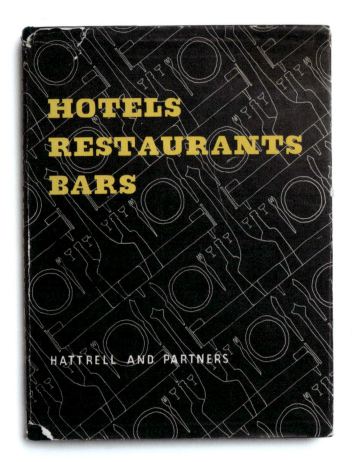
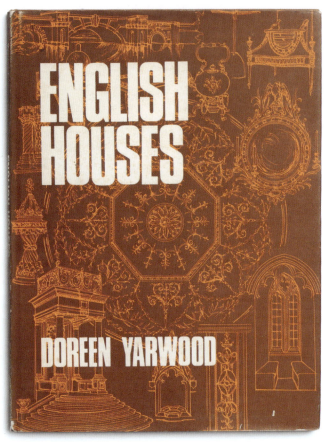

Hotels, Restaurants, Bars
W S Hattrell and Partners, 1962

—

The authors were a firm of architects; the book was designed to be a working desk book for hotel, restaurant and bar designers, including motels. The jacket was by G W Hammond.

English Houses
Doreen Yarwood, 1966

—

One of the author's many works for Batsford, this book, rich in drawings, was targeted at GCSE (or O Level) students as material for their architectural study.

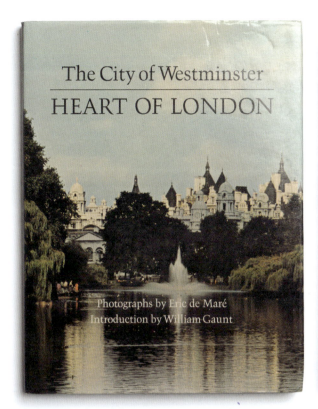

The City of Westminster: Heart of London
photographs by Eric de Maré, introduction by William Gaunt, 1968

—

The jacket shows the view across St James's Park, across the lake towards Whitehall.

The Gardens of Britain 1: Devon and Cornwall
Patrick M Synge, 1977

—

The first of six volumes covering different regions, published in association with the Royal Horticultural Society.

The Brothers Dalziel: A Record 1840–1890
foreword by Arthur Graham Reynolds, 1978

—

In a fine slipcase, this was a facsimile reprint of the original 1901 Methuen and Co anthology by George and Edward Dalziel of their engravings done in conjunction with other artists. This reprint was published in Batsford's Collectors Books series. Reynolds was Keeper of Paintings at the V&A. The jacket illustration is an engraving, *Coach and Horses* from *Good Words* by A Boyd Houghton, published by Alexander Strahan.

Biography

 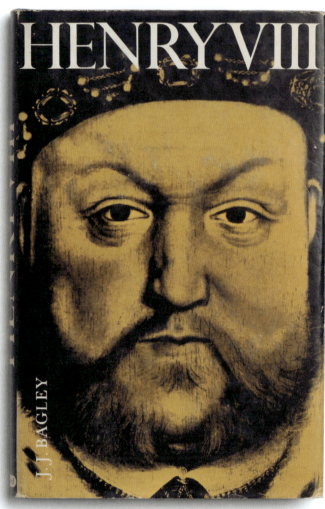

Elizabeth Fry
John Kent, 1962

—

One of Batsford's Makers of Britain series, this assesses the subject as an eminent woman in British history, alongside Florence Nightingale and Queens Elizabeth I and Victoria, and as a symbol of the triumph of good over evil.

Henry VIII
John Joseph Bagley, 1962

—

This was also in the Makers of Britain series. The author was long associated with Liverpool University, where he was Senior Lecturer and Reader, and with the Royal Historical Society, joining in 1945 and becoming President in 1964. Illustrations, many of Holbein's work, are a strong feature of the book, supporting the author's approach of illuminating Henry's influence through a portrayal of his character.

Elizabeth I
B W Beckingsale, 1963

—

Using contemporary sources, the author paints a portrait, authentic and credible, of a real woman, replacing myth with truth. The jacket is from a miniature in the V&A by Nicholas Hilliard.

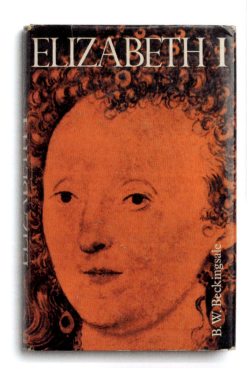

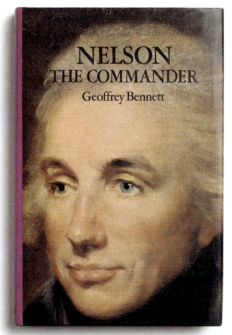

Nelson the Commander
Geoffrey Bennett, 1972

—

After long service with the Royal Navy and as Naval Attaché at Moscow, also writing novels and radio plays, the author moved to military history. This book is dedicated to the Past Overseers Society of St Margaret and St John, Westminster, whose members maintain the annual tradition of a silent toast to the Immortal Memory that began in 1805 when the news was received of Nelson's death. The jacket was designed by Jim Bamber, from a painting by Lemuel Abbott in the National Portrait Gallery.

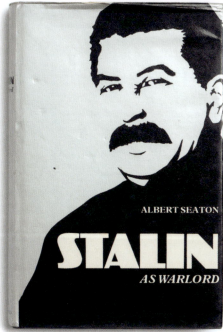

Stalin as Warlord
Albert Seaton, 1976

—

Colonel Seaton was a British Army Officer and, later, researcher on the Russian and Soviet armies. His comprehensive biography here follows Batsford's Military Commander series and other military titles (see page 146).

Biography

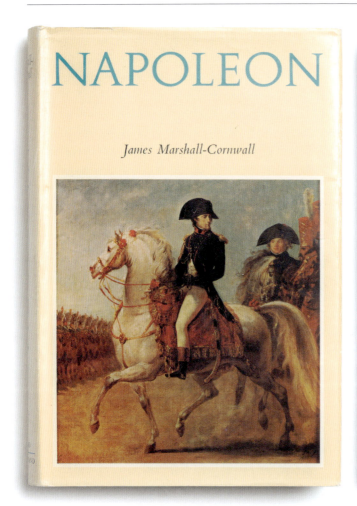

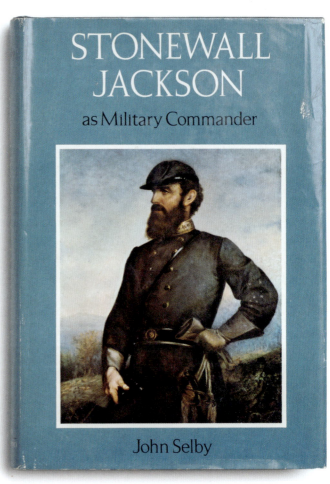

Napoleon
General Sir James Marshall-Cornwall, 1967

—

In what was to become the Military Commander series, this was published with D van Nostrand, Inc. The author was a geographer, linguist and historian, who fought in both World Wars, authored a number of scholastic works and assisted the Foreign Office in the publication of the German Foreign Ministry archives. The jacket shows Napoleon reviewing his Guard after the Battle of Marengo, from a painting by Antoine-Jean Gros in the Wallace Collection.

Stonewall Jackson as Military Commander
John Selby, 1968

—

After WWII, the author was Senior Lecturer at Sandhurst Royal Military Academy. The jacket image of General Jackson is from a portrait by John Adams Elder, held in the Corcoran Gallery in Washington.

Wellington as Military Commander
Michael Glover, 1968

—

The author served with the British Army in North Africa and Italy. He also wrote *Wellington's Peninsular Victories* (see page 150). The jacket showed Wellington at Salamanca, reproduced from an aquatint made in 1813.

Montgomery as Military Commander
Ronald Lewin, 1971

—

The author served in the Royal Artillery in WWII, then worked at the BBC 1946–1965 and as Editor at Hutchinson Publishing, taking up writing later in life. He had also written *Rommel as Military Commander* for this series in 1968.

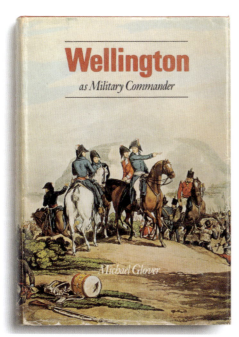

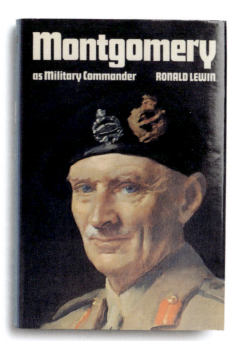

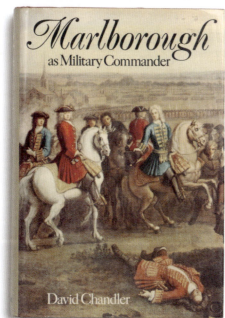

Marlborough as Military Commander
David Chandler, 1973

—

The author of this work in the Military Commander series served in the British Army, taught at Sandhurst and had Visiting Professorships at Ohio State University, the Virginia Military Institute and Marine Corps University. The jacket shows John Churchill, Duke of Marlborough, at Ramillies, from a sketch by Louis Laguerre.

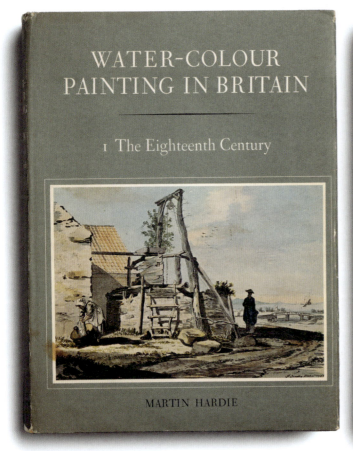
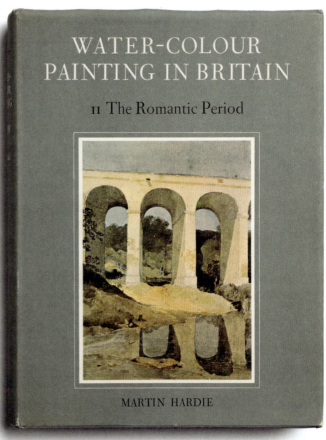

Water-Colour Painting in Britain Volume I: The Eighteenth Century
Martin Hardie, 1966

—

The author was a painter, writer and Keeper of the Department of Prints and Drawings at the V&A 1921–1935. The three volumes of his magnum opus were published posthumously. Introducing this first volume, Basil Taylor notes that Hardie completed the work just after WWII but that the 'circumstances of publishing' delayed publication of such a large work (this volume first in 1966). The volume covers the 18th century, with 242 illustrations. The jacket shows *Draw Well at Broughton near Edinburgh* by Paul Sandby (1751).

Water-Colour Painting in Britain Volume II: The Romantic Period
Martin Hardie, 1970

—

This second volume covers the Romantic Period, the author assembling all significant biographical and technical information about watercolourists of that era, with 230 illustrations. The jacket shows *Chirk Aqueduct* by John Sell Cotman (1805).

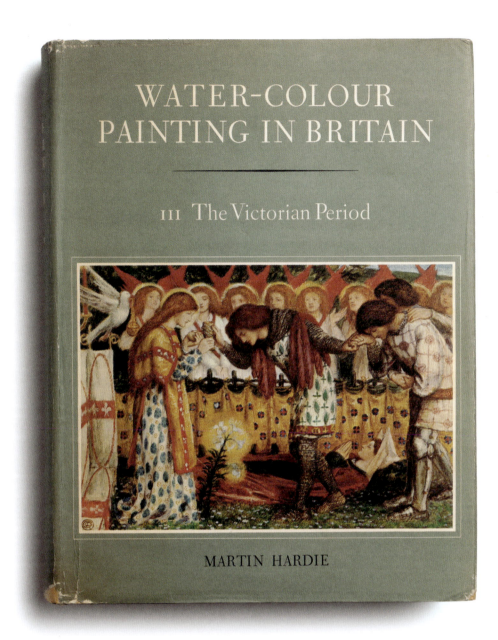

Water-Colour Painting in Britain Volume III: The Victorian Period
Martin Hardie, 1971

—

The final volume covers the Victorian Period, including both familiar names and minor or forgotten artists. There are also painters of the Scottish School, reflecting the author's ancestry. As well as 285 illustrations, the volume had lengthy appendices covering the drawing-masters, amateurs and collectors, a bibliography, biographical sources and an index of the whole work. The jacket shows *Sir Galahad* by Dante Gabriel Rossetti (1864).

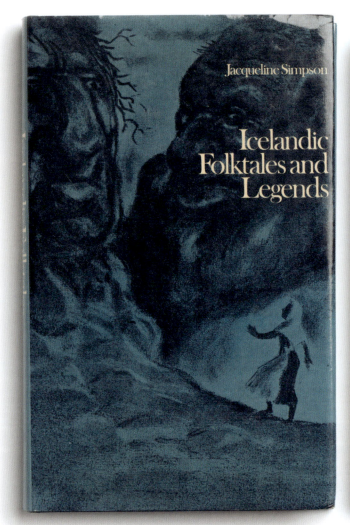

Icelandic Folktales and Legends
Jacqueline Simpson, 1972
—

The author was co-author with Professor G N Garmondsway of the Penguin English Dictionary and then wrote on medieval Icelandic literature. Preceding a long run of Batsford folklore books on the British regions later in the 70s, this work is a selection of translations from the two volumes of Icelandic tales of Jón Árnason in 1862–64. Simpson also wrote for Batsford *Everyday Life in the Viking Age*. The jacket is by Yvonne Dedman.

Movies for the Millions
Gilbert Seldes, 1937
—

The author was an artistic critic and writer of several books on movies. The preface to this is by Charlie Chaplin, who addresses the future of motion pictures 'built as they are on the shifting sands of popular entertainment'. Asking if the motion-picture industry, astride the world of success, has reached its zenith, Chaplain focuses on censorship, calling for aesthetic criticism to be considered for a 'more adequate method of judging what is morally fit for the public'. The jacket is by Brian Cook. The frontispiece was prepared at Walt Disney Studios and features also on the jacket. Among the book's many illustrations are several by Cecil Beaton.

Shadow Theatres and Shadow Films
Lotte Reiniger, 1970

—

The author's background was as a film director and silhouette animator. Her book addresses the history of shadow theatre and contains practical analysis of making shadow plays and shadow films, and includes a list of suppliers in London and New York.

The Illustrated Who's Who in British Films
Denis Gifford, 1978

—

The author, a collector, cartoonist and TV creator, had already written a series of film books. This comprehensive reference volume lists alphabetically 1,000 personalities in the history of British films to that date.

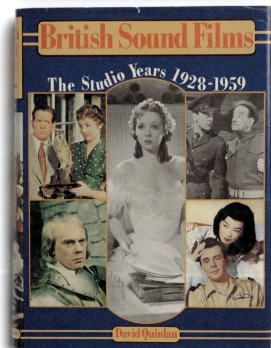

British Sound Films: The Studio Years 1928–1959
David Quinlan, 1984

—

A comprehensive guide to British films for entertainment, by the author of two other Batsford books on films (an illustrated directory of film stars and one of directors). Centre on the front of the jacket is Jessie Matthews OBE, top centre on the rear is Lord Olivier.

Brian Cook

Brian Cook described himself as a painter. He was Harry Batsford's nephew, joining the business in 1928 just before they moved to North Audley Street. In 1935, Brian became the fourth Director at the company, alongside Harry Batsford, William Hanneford-Smith and Charles Fry. Harry wrote that in addition to Brian's art contributions he also acquired a thorough knowledge of editorial and production work. In 1952, after RAF service, he took his mother's maiden name, Batsford, and succeeded Harry as Chairman. He also went into politics, and was elected Member of Parliament for Ealing South in 1958. Knighted in 1974, he served as Chairman of the RSA 1973–75.

Charles Fry wrote of Harry's willingness to listen to the young and how Batsford had talked over a new kind of book about Britain, its churches, houses and landscape. The plan was to include 100 illustrations in each book, with wrappers designed by Brian. Thus emerged the British Heritage series.

Brian Cook's jackets for the English Life, British Heritage, Face of Britain and British Cities series and miscellaneous others on topography and the country are widely recognised and extensively shown in books including *The Britain of Brian Cook* (1987) and *Brian Cook's Landscapes of Britain* (2010). Many others are shown elsewhere in this book, with just a few of his most familiar designs included in this section. Sir Brian Batsford died in 1991.

The Villages of England
A K Wickham, 1932
—
As well as the jacket, Brian Cook illustrated a pull-out geological map and a number of internal drawings. This was Cook's first jacket and the first reproduced by the Jean Berté process. This was a colour printing process that involved overlaying colour designs, printed using water-based inks and rubber stamps.

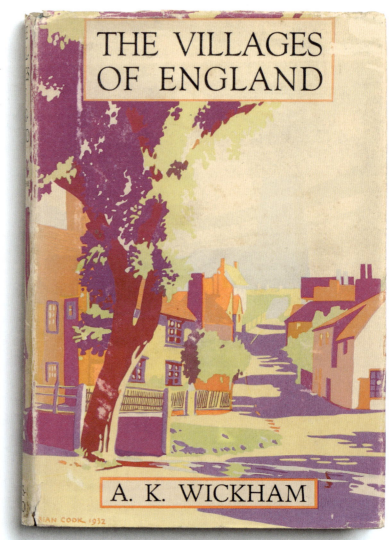

The Landscape of England
Charles Bradley Ford, 1933
—

The eighth book in the English Life series, the author divides England into five regions: the scenery, the activities of Englishmen labouring upon the land, geological elements, physical conditions and sociological and industrial movements. Within the limits of the word count, this resulted in what an early manuscript critic described as 'England from an aeroplane'. As well as the jacket, Brian Cook provided a colour frontispiece of the River Severn at Bridgnorth and many internal pen drawings.

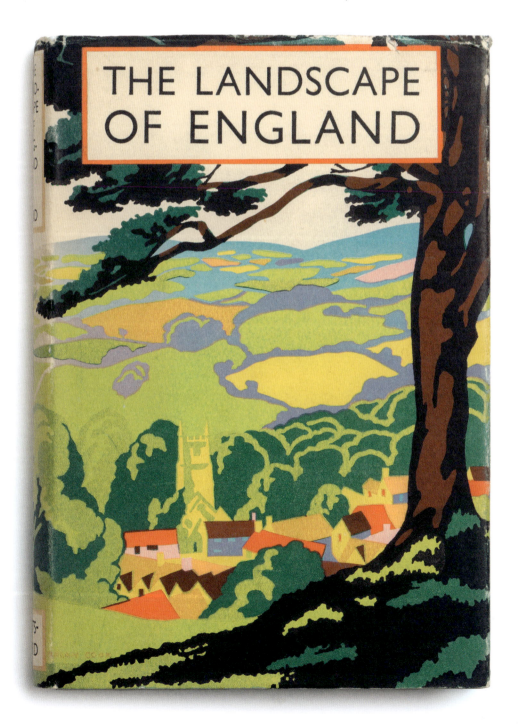

Brian Cook

Harry Batsford and Charles Fry

Both were authors as well as Directors of the company – together they wrote *The Face of Scotland*, *The English Cottage*, *The Cathedrals of England* and *The Greater English Church*. Their partnership was so well-known that contributing writer H J Massingham wrote in his autobiography *Remembrance* (see page 76) that he was tempted into song:

'Who writes the best books for Batsford and Fry?
Why, Batsford and Fry.
Then why, oh why,
Do Batsford and Fry
Employ other authors for Batsford and Fry
When Batsford and Fry
Could write 'em and print 'em for Batsford and Fry?'

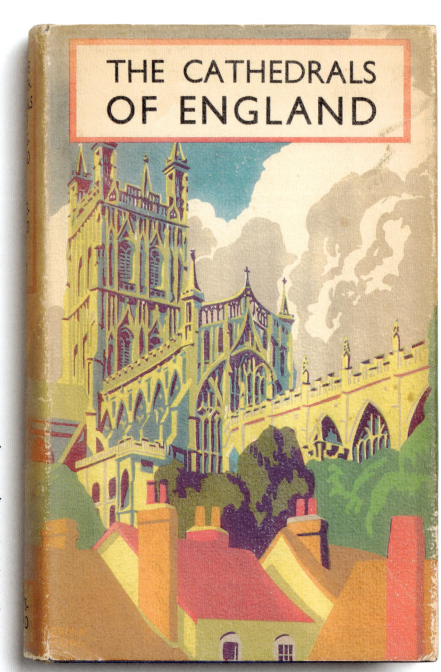

The Cathedrals of England
Harry Batsford and Charles Fry, 1934
—
Intended as a compact pictorial review of the cathedrals, with brief accounts of each, illustrated using the 'resources of modern photography, with its transformed technique of lighting and effect'. The book has 133 plates. Thirty-two sketches and the jacket are by Brian Cook, and a colour frontispiece of Lincoln is by watercolourist Frederick Mackenzie. The book remains in Batsford's backlist after nine decades.

The Greater English Church
Harry Batsford and Charles Fry, 1940
—
Our authors return here to address the cathedral, monastic and larger collegiate church of the Middle Ages, from a different angle, under the headings of how the building was used, planned, built, designed, furnished and how it survived. The book has 120 plates, several in colour, including a frontispiece by the architect of Beverley Minster, J C Buckler, and the jacket by Brian Cook.

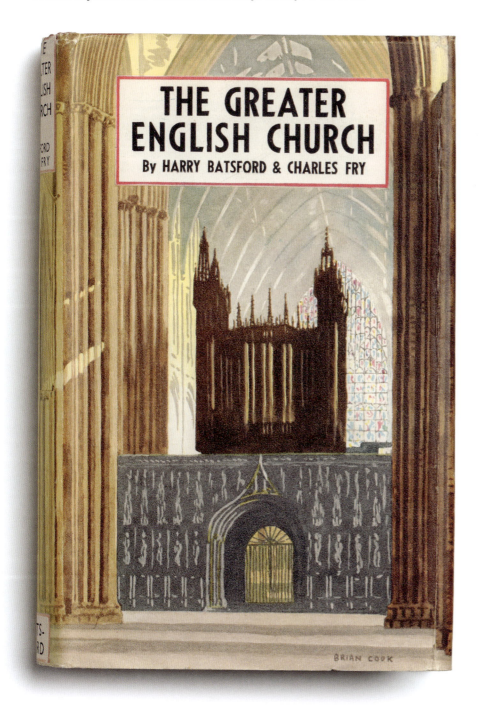

Brian Cook

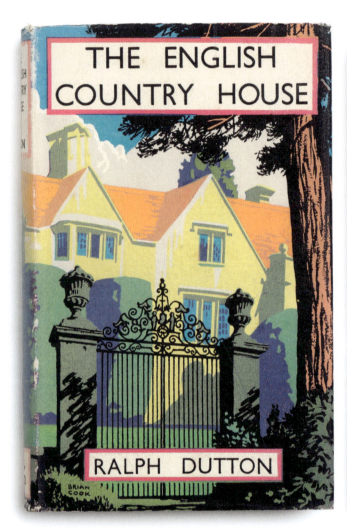

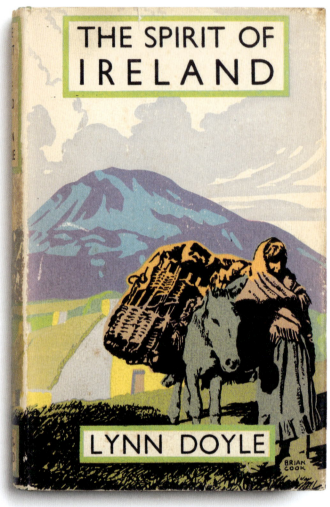

The English Country House
Ralph Dutton, 1935
—

In this book, the author traces the architectural development of the country house from embattled small hall to stately nobleman's seat of late-Georgian times, giving glimpses of life at every age. The book has 131 photographs, most by Will F Taylor. In a foreword, Osbert Sitwell emphasises the author's treatment of houses not purely as objects but as 'exquisite and appropriate shells' of various manners and methods of living. Brian Cook contributed a drawing of a manor plan and the jacket.

The Spirit of Ireland (revised third edition)
Lynn Doyle, 1939
—

Humorist and banker Leslie Alexander Montgomery used the pseudonym Lynn Doyle, taken from a bottle of linseed oil he saw in a grocer's. Retiring from banking in 1934, he wrote the first edition of this book the following year. In his preface, the author writes that this is not a guidebook, but his introduction targeting the English visitor stresses the effect of history and tradition on the Irish character. The jacket by Brian Cook is based on a photograph in the book of a Kerry girl with the description 'The maids along the hill-side have ta'en their fearless way'.

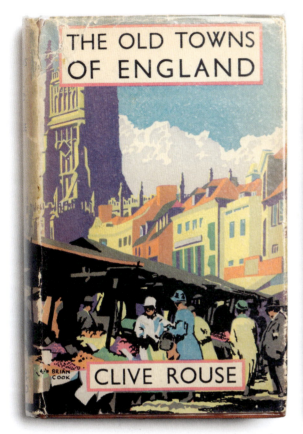
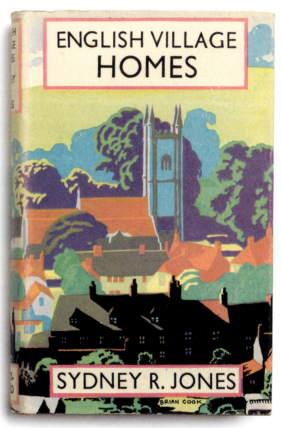
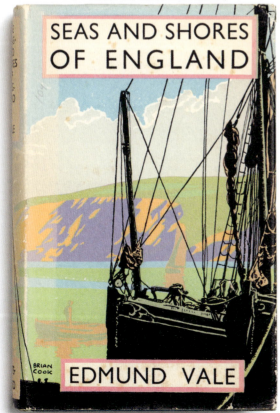

The Old Towns of England
Clive Rouse, 1936

English Village Homes
Sydney R Jones, 1936

Seas and Shores of England
Edmund Vale, 1936

Brian Cook

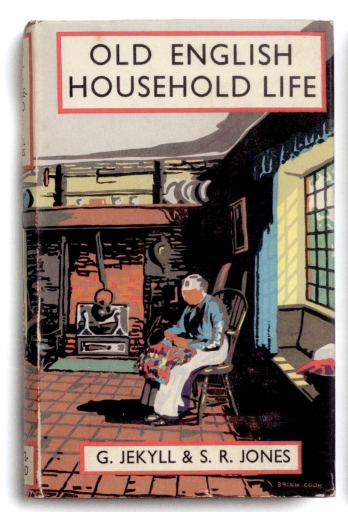

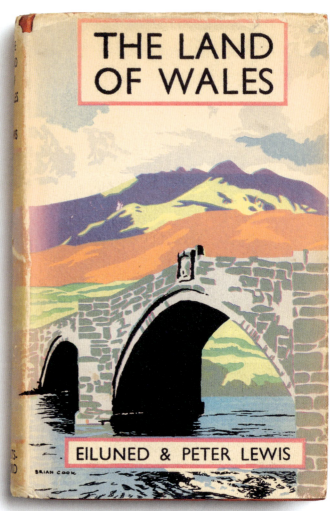

Old English Household Life
G Jekyll and Sydney R Jones, 1936

The Land of Wales
Eiluned and Peter Lewis, 1937

—

This book by brother and sister Eiluned and Peter Lewis was an attempt at a complete review of the national origins, outlook, life and culture of Wales, the Welsh scene never before having been depicted so vividly and graphically as in the 130 illustrations. The authors expressed their appreciation of the chance to write for the English-speaking public about the land of Wales. The colour frontispiece was from a painting of Arenig Fawr in North Wales by J D Innes.

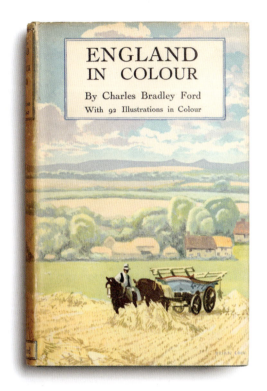

England in Colour
Charles Bradley Ford, 1939

—

The author draws on material in his earlier *The Landscape of England* (then out of print), but rather than amend or rewrite it he undertook this fresh coverage of the subject, with the unique advantage of this being the first volume of its sort illustrated entirely from colour plates ('at first my publishers were doubtful in view of the comparative novelty of the medium, whether sufficient material existed from which to make a choice'). In the event, 92 plates were included, from Dufaycolor photographs reproduced in colour photogravure, including a frontispiece of *Autumn Tints at Burnham Market* by J E Archibald. Opinion in *Country Life* was that 'This is the kind of book which, in the course of time, will be demanded by the public, who will desire to have all subjects illustrated in their natural colours'.

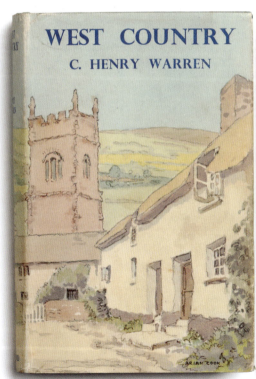

West Country
C Henry Warren, 1938

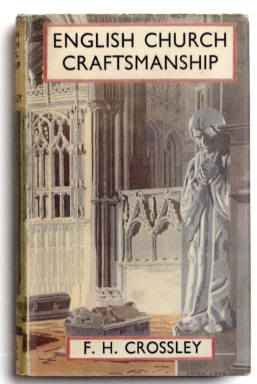

English Church Craftsmanship
F H Crossley, 1941

Brian Cook

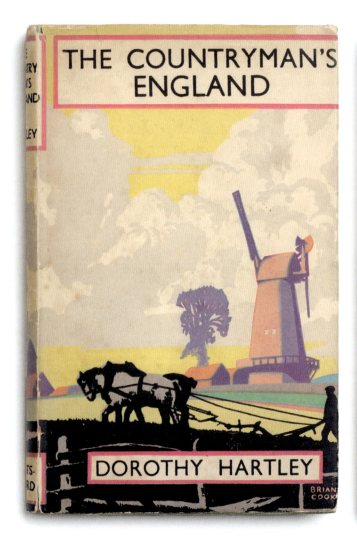

The Countryman's England
Dorothy Hartley, 1942

The Home Counties
Stuart Petre Brodie Mais, 1942–43

—

A prolific writer, journalist and broadcaster, the author wrote in a prefatory note 'Never before in our long history has the word "home" meant so much to us … in the meantime to buoy us up for the struggle it is good to conjure up visions of the woods and downs, the heaths and commons, little rivers and village greens of the counties that we know as home'. The book was in the Face of Britain series and included Middlesex, Surrey, Kent, Hertfordshire and Essex. It was illustrated by 99 plates, some in colour, including a frontispiece of *A Surrey Lane* from a watercolour by Myles Birket Foster.

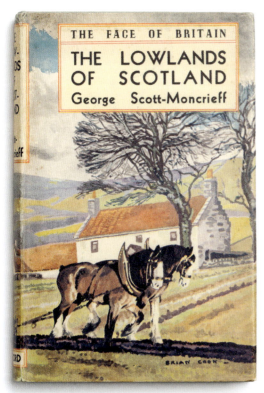

The Lowlands of Scotland (second edition)
George Scott-Moncrieff, 1947

—

The author was a novelist and writer on Scotland, who also wrote for Batsford *The Stones of Scotland* (1938) and *Edinburgh* (1947). This was revised from the pre-war 1939 edition to bring certain passages up to date and was published in the Face of Britain series. Illustrated by 115 photographs, including a Dufaycolor frontispiece of *The Eildon Hills from near Ancrum* by Neill McGregor.

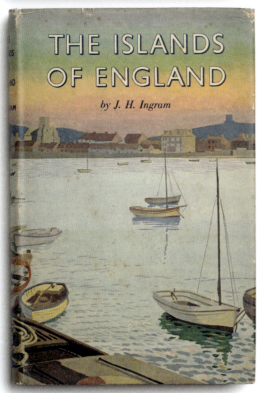

The Islands of England
J H Ingram, 1952

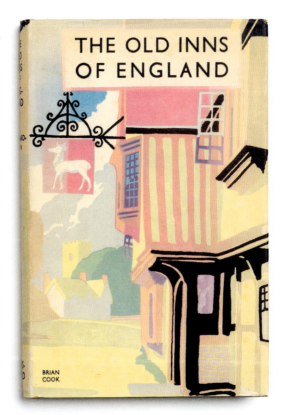

The Old Inns of England
A E Richardson, 1952

Index

Adams, Maurice Bingham 24
Addison, William 124, 136–7
Allen, Gordon 26
Anderson, William 33
Armstrong, Ronald 152
The Arts Connected with Building 22
Ashby, Thomas 33
Atkinson, James 153
Atkinson, Thomas Dinham 100–1
autobiography 142–5
aviation 48–9

Bagley, John Joseph 156
Baldick, Robert 151
Bale, Stewart 57
Barker, Ralph 109
Batchelor, Denzil 107
Batsford, Bradley 59
Batsford, Bradley Thomas 59
Batsford, Brian 31, 164
Batsford, Harry 8, 59, 68, 76, 81
 Albert Richardson 28
 Arthur Stratton 37
 Brian Cook 164
 Charles Fry 48, 166–7
 Edwin Lutyens 85
 How to See the Country 80
 James Kellaway Colling 10
 Lewis F Day 18
 London: Work and Play 114
 Margaret Jourdain 38
 Marjorie and Charles Quennell 44
 Mary Stratton 25
 Richard Glazier 21
 William Henry Ward 24
Batsford, Herbert 8, 10, 28, 31, 59, 68
A Batsford Century 8–9
Batsford's Pictorial Guides 58
Baume, Eric 91
Beaton, Cecil 72–5, 86, 87, 88, 90, 162

Beckingsale, B W 157
Bell, Adrian 62
Bell, David 130
Bennett, Geoffrey 151, 157
Bett, Dr Henry 112
biography 156–9
Blake, George 57
Blomfield, Reginald 32
Bolitho, Hector 8, 18, 59, 90, 91, 97
Boulenger, Edward George 62, 63
Bouquet, Alan Coates 131, 132
Braddock, Joseph 116
Bradley, W F 52
Brahms, Caryl 77
Brandon, Raphael and Arthur 10
Brandt, Bill 69
Braun, Hugh 84
Briggs, Martin 99
Brightwell, Leonard Robert 99
Bulley, Margaret Hattersley 57
Burke, Thomas 84, 99
Busch, Harald 122

Carrington, Noel 128
cars 52–9
Casteels, Maurice 46
Chandler, David 159
Chapuis, Alfred 139
Clarke, John Smith 64
Clarke, Winifred M 68
Clutton, Cecil 53, 54
Cobb, Gerald 68
Collier, Basil 150
Colling, James Kellaway 10
Colman, Jeremiah 108
Cook, Brian 30, 32, 37, 40, 41, 42, 47, 48, 52, 57, 62, 63, 64, 68, 76, 77, 80, 81, 82, 84, 105, 110, 114, 118, 125, 126, 135, 146, 162, 164–73
Course, Edwin 51
Crace, John Dibblee 24

Crane, Louise 33
Crossley, Fred H 68, 171

Daiken, Leslie 105
Daniell, David Scott 148, 149
Day, James Wentworth 116
Day, Lewis F 17, 18–19
Devenish, Dorothy 110
Dinsmoor, William Bell 33
Disher, Maurice Willson 65
Ditchfield, Peter Hampson 22
Dolmetsch, Heinrich 25
Doyle, Lynn 168
Dresser, Christopher 15
Droz, Edmond 139
Dunlop, Ian 42
Dutton, Ralph 41, 43, 110, 124, 130, 153, 168

Ebbetts, Daniel John 11
Eberlein, Harold Donaldson 28
Edlin, Herbert L 118–19
Edmondson, John Ludlam 29
Elliot, Margaret 30
Entwisle, Eric Arthur 140
Eyston, George 48, 52

Falkener, Edward 11
Fawkes, Frank Attfield 14
Fedden, Robin 40
Fleming, Rachel 28
Fletcher, Banister 12–13, 20, 59
Fletcher, Banister F 20
Flight, Claude 47
Foord, Jeanie 17
Ford, Charles Bradley 165, 171
Frostick, Michael 55
Fry, Charles 8, 48, 60, 72, 81, 88, 89, 164, 166–7
Fry, Roger 14, 57

Garmondsway, G N 162
Garner, Thomas 37

Gathorne-Hardy, Robert 62, 78
Gaunt, William 83, 155
Gawthorp, T G and W E 20
Gibbs-Smith, Charles Harvard 49
Gifford, Denis 163
Gilbert, Geoffrey 58
Giraud, Byng 16
Glazier, Richard 21
Glover, Michael 150, 159
Glynne-Jones, William 143
Goldman, Joan M 142
Gordon, Seton 62, 79
Gotch, John Alfred 36, 124
Gray, Milner 152
Greene, Vivien 122

Handbook of Coloured Ornament 15
Hanneford-Smith, William 8, 59, 164
Hardie, Martin 160–1
Harrison, Godfrey 135
Hartley, Dorothy 30, 172
Harvey, John 98, 103, 117
Haskell, Arnold L 65
Hattrell, W S and Partners 154
Heal, Ambrose 26, 27
Hearn, Bertie 128
Heaton, E W 133
Henry, Paul 142
Hibbert, Christopher 147
Hobhouse, Christopher 82
Hole, Christina 92–5
Holland, Vyvyan 122
Hoyningen-Huene, George 76

Ingram, J H 173
Irving, R L G 124

Jekyll, Gertrude 85, 170
Jenkinson, Denis 54
Jeremiah, Keith 110
Jones, Chester Henry 47

Jones, Sydney R 22, 85, 169, 170
Jourdain, Margaret 38–9
Jowitt, Robert Lionel Palgrave 126

Kauffer, Edward McKnight 58, 96
Kelly, Felix 99, 116
Kelly, Francis 30, 68
Kent, John 156
Klemantaski, Louis 55
Knight E 16

La Farge, Henry 96
The Lady Lever Art Gallery Collections 35
Lamb, Lynton 92, 93, 113, 142
Lambert, Margaret 111
Laver, James 70–1, 90
Lee, Ruth Webb 125
Lees-Milne, James 99, 124
Lenygon, Francis 39
Lewin, Ronald 159
Lewis, Eiluned and Peter 170
Little, Bryan 126
Lohse, Bernd 122
Lutyens, Edwin 'Ned' 36, 59, 85
Lyndon, Barré 52

McAllister, Gilbert and Elizabeth 84
Mais, Stuart Petre Brodie 172
Mankowitz, Wolf 134
Manning-Sanders, Ruth 120–1
Maré, Eric de 83, 155
Marshall-Cornwall, James 158
Marx, Enid 111
Massingham, Harold John 62, 76, 77, 90, 166
Mawson, E Prentice 31
Mawson, Thomas Hayton 31
Merriam, Frederick Warren 49
Messel, Oliver 64

Meyer, Franz Sales 16
military 146–51
Miller, Terence G 125
Montgomery, Leslie Alexander 168
Moore, Doris Langley 102
More, Jasper 40
Morris, Christopher 103
Mould, Daphne Desiree Charlotte 140
Muir, Percy 138

Nash, John 56, 62, 78, 91
Needham, A 66–7
Nicholson, Joan 129
Nock, Oswald Stevens 50

O'Donoghue, John 144, 145
Ogawa, Hiroshi 153
Oliver, Basil 37
Olivier, Edith 88, 89, 90, 110
Osborne, Arthur Leslie 135

Parker, Eric 134
Parry-Jones, Daniel 113
Payne, Arthur E 152
Pearce, Cyril 30, 104
Piggott, Sir Francis 23
Pitt, Frances 62, 78, 81
Pope-Hennessy, James 69, 115
Porter, Evelyn 64
Posthumus, Cyril 54

Quennell, Charles Henry Bourne (CHB) 44–5
Quennell, Marjorie 44–5, 132
Quennell, Peter 44, 74
Quinlan, David 163

railways 50–1
Reed, Alec 139
Reeve, F A 83
Reiniger, Lotte 163
Reynolds, Arthur Graham 155
Richardson, Albert Edward 8, 28, 139, 173

Riddell, James 43, 144
Rodaway, Angela 143
Rolt, Lionel Thomas Caswell 114
Rosenwater, Irving 109
Rouse, Clive 169
Russell, Percy 127
Ryves, Reginald Arthur 37

Scarfe, Laurence 129
Schwabe, Randolph 30
Schweinfurth, Philipp 131
Scize, Pierre 104
Scott-Moncrieff, David 54
Scott-Moncrieff, George 173
Seaton, Albert 157
Selby, John 158
Seldes, Gilbert 162
Shell guides 56
Shore, W Teignmouth 34
Simpson, Jacqueline 162
Sitwell, Sacheverell 42, 60–1, 90
Smyth, J G 106
Spiers, Phené 33
sport 106–9
Stanford, John 53
Steegmann, John 82
Stein, Gertrude 86–7
Stratton, Arthur 37, 46
Stratton, Mary 25, 42
Strzygowski, Josef 37
Sugden, Alan Victor 29
Sutcliff, Rosemary 140
Swarzenski, Hanns 122
Symonds, Richard Wemyss 27, 123
Symons, Geraldine 142
Synge, Patrick M 155

Talbot-Ponsonby, J A 108
Taylor, Gladys 115
Terraine, John 146
Thomas, Bernard 135
Thomas, Nicholas 117
Thomas, R H G 51
Townsend, William 126

travel 40–7
Treece, Henry 141

Vale, Edmund 76, 81, 169
Vallance, Aymer 47
Venables, Bernard 107

Wade, Aubrey 146
Wallace, Doreen 80
Ward, William Henry 24
Warner, Oliver 146, 147
Warren, C Henry 62, 171
Waugh, Norah 102
Weaver, Sir Lawrence 22
Whistler, Laurence 90
Whistler, Rex 8, 14, 60, 62, 75, 88, 89, 90
Wickham, A K 37, 164
Wiggin, Maurice 108
Wild, Hans 115
Williamson, Henry 62
Worthington-Williams, Michael 55
Wymer, Norman 96, 97

Yarwood, Doreen 154

Acknowledgements

My appreciation first is to Polly Powell and John Stachiewicz for their discerning avowal of creative design in Batsford's unique history and to their team for their encouragement from the early stages of our thinking about this book. Among sources of inspiration over the years have been erudite traders in our book towns, to those more distant, from Harrisburg to Brussels to Jimbōchō in Tokyo, from whom some repatriation of Batsfords was possible. I am indebted to the team at the Northamptonshire Archives Service for their help in research into the John Alfred Gotch papers. Planning for the book could not, however, have got off the ground without the creative craft of the Batsford excogitators: Art Director Eoghan O'Brien, Publishing Manager Nicola Newman, many unseen hands, and especially Senior Editor Bella MacConnol, who guided me so patiently and helpfully through the process. I am so grateful to our brilliant photographer Michael Wicks for his temporary custody of these appealing books. And of course my deep thanks go to Carolyn for her support over our whole Batsford project.

First published in the United Kingdom
in 2025 by
Batsford
43 Great Ormond Street
London, WC1N 3HZ

An imprint of B. T. Batsford Holdings Limited

Copyright © B. T. Batsford Ltd 2025
Text copyright © Paul Dimond 2025

Photography by Michael Wicks
Layout design by Tony Seddon

Typeset in:
Din 2014 designed by Vasily Biryukov
Abril designed by José Scaglione and Veronika Burian

All rights reserved. No part of this publication may be copied, displayed, extracted, reproduced, utilized, stored in a retrieval system or transmitted in any form or by any means, electronic, mechanical or otherwise including but not limited to photocopying, recording, or scanning without the prior written permission of the publishers.

About the Author

Paul Dimond CMG is a former British diplomat. He was a language student in Tokyo in the 1960s and served for 16 years in Japan, including as Commercial Counsellor in the Embassy. He was later Deputy Ambassador at The Hague, HM Consul-General at Los Angeles and HM Ambassador at Manila. A collector of vintage Batsford books for 35 years, he has been a Fellow of the Royal Society for the encouragement of Arts, Manufactures and Commerce since 1980. He was Deputy Chairman of DAKS Simpson Group plc 2007–17 and Hon Secretary of the Anglo-Netherlands Society 2012–24. He and his wife Carolyn live in London.

ISBN 978 1 84994 948 4

A CIP catalogue record for this book is available from the British Library.

10 9 8 7 6 5 4 3 2 1

Reproduction by Rival Colour Ltd, UK
Printed by Dream Colour, China

This book can be ordered direct from the publisher at www.batsfordbooks.com, or try your local bookshop.

Distributed throughout the UK and Europe by Abrams & Chronicle Books, 1 West Smithfield, London EC1A 9JU and 57 rue Gaston Tessier, 75166 Paris, France

www.abramsandchronicle.co.uk
info@abramsandchronicle.co.uk

BATSFORD